THE DIARY OF FRIDA KAHLO

An Intimate Self-Portrait

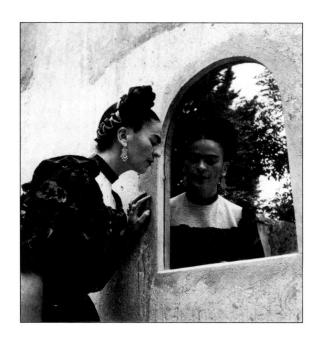

Project Director: CLAUDIA MADRAZO Editor: PHYLLIS FREEMAN

Designer: JUDITH MICHAEL

Jacket designer: MARK LaRIVIERE

Translators: BARBARA CROW DE TOLEDO and RICARDO POHLENZ

Page 1: The Two Fridas. c. 1944–45. Photograph © Lola Alvarez Bravo
 Page 6: Frida Kahlo in bed. Coyoacán. 1952. Photograph © Bernice Kolko
 Page 32: Frida Kahlo. Coyoacán. 1952 Photograph © Gisèle Freund
 Page 288: Frida Kahlo in bed painting My Family. 1950 Photograph © Juan Guzmán

ACKNOWLEDGMENTS

I would like to express my grateful thanks to colleagues and friends Karen Baji, Susan Felleman, Elena Poniatowska, E.E. Smith, Carla Stellweg, and Edward J. Sullivan for their steadfast support and helpful comments. Sincere thanks go also to Phyllis Freeman for her thoughtful editing, and to Rachel Tsutsumi for her patient help.

S.M.L.

The Library of Congress cataloged the original edition as follows: Kahlo, Frida.

The diary of Frida Kahlo: an intimate self-portrait/introduction by Carlos Fuentes; essay and commentaries by Sarah M. Lowe.

p. cm

Includes bibliographical references and index.

ISBN 978-0-8109-5954-5

1. Kahlo, Frida Diaries. 2. Painters – Mexico – Diaries. 3. Surrealism – Mexico. I. Title.

ND259.K33A2 1995

759.972 - dc20

[B] 94-45994

The diary of Frida Kahlo copyright © 1995 Banco de México, as a trustee for the Diego Rivera and Frida Kahlo Museums. Avenida 5 de Mayo número 2, Col. Centro, C.P. 06059, México, Distrito Federal.

Reproduction authorized by the Instituto Nacional de Bellas Artes y Literatura

(Institute of Fine Arts and Literature), México

Texts by Carlos Fuentes and Sarah M. Lowe copyright © 1995 Harry N. Abrams, Inc., New York, and La Vaca Independiente S.A. de C.V., Ciencias 40, Col. Escandón, México D.F., 11800, México

This 2005 edition published by Abrams, an imprint of ABRAMS, in association with La Vaca Independiente S.A. de C.V. All rights reserved. No portion of this book may be reproduced, stored in a retrieval system, or transmitted in any form or by any means, mechanical, electronic, photocopying, recording, or otherwise, without written permission from the publisher.

Printed and bound in China 20 19 18 17 16 15 14 13 12

Abrams books are available at special discounts when purchased in quantity for premiums and promotions as well as fundraising or educational use. Special editions can also be created to specification. For details, contact specialsales@abramsbooks.com or the address below.

CONTENTS

INTRODUCTION BY CARLOS FUENTES

page 7

ESSAY BY SARAH M. LOWE

page 25

FACSIMILE OF THE DIARY OF FRIDA KAHLO

page 33

TRANSLATION OF THE DIARY WITH COMMENTARIES

page 201

CHRONOLOGY

page 288

SELECTED BIBLIOGRAPHY

page 293

INDEX

page 294

PHOTOGRAPH CREDITS

page 296

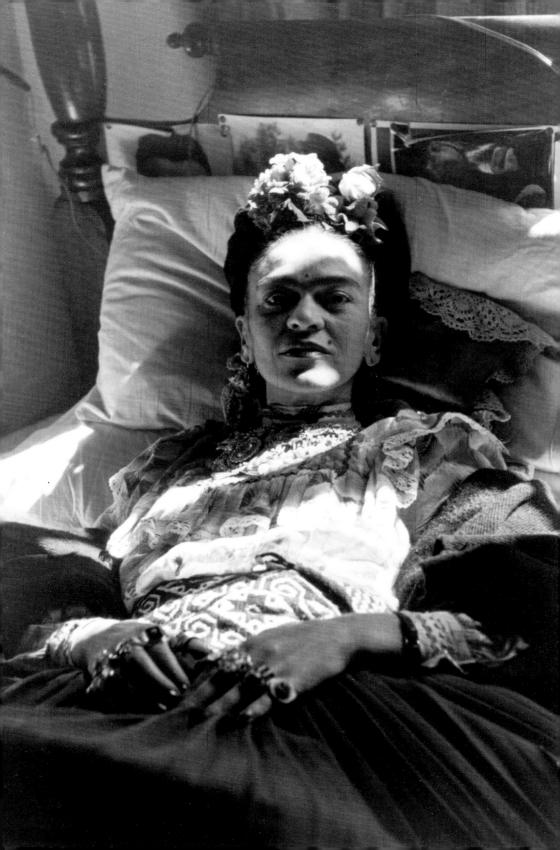

INTRODUCTION

By Carlos Fuentes

only saw Frida Kahlo once. But first, I heard her. I was at a concert in the Palacio de Bellas Artes—the Palace of Fine Arts—in the center of Mexico City, a construction begun under the administration of the old dictator Porfirio Díaz in 1905 and very much in tune with the tastes of the Mexican elite at the turn of the century. An Italianate mausoleum in white marble, fashioned in the purest wedding-cake style, it remained in a state of physical and aesthetic suspension during the following thirty years of civil strife in Mexico. When it was finally inaugurated in 1934, the ornate, frozen meringue of the exterior had been thoroughly denied by the Art Deco interior—yet another bow to the fashion of a new day. The streamlined, sweeping staircases, balustrades, and corridors shone with burnished copper and beveled glass, while the walls were decorated with the angry, sometimes strident murals of Orozco, Rivera, and Siqueiros.

The auditorium itself was the supreme sanctuary of Art Deco, culminating in a magnificent glass curtain by Tiffany depicting the guardian mountains of the valley of Mexico: the volcanoes Popocatépetl, the Smoking Mountain, and Ixtaccíhuatl, the Sleeping Woman. A subtle play of lights permitted the spectator, during intermissions, to go from dawn to dusk, from *aurora* to *crepusculum*, in fifteen minutes.

All of this in order to say that as Kahlo entered her box in the second tier of the theater, all of these splendors and distractions came to naught. The jangling of sumptuous jewelry drowned out the sounds of the orchestra, but something beyond mere noise forced us all to look upwards and discover the apparition that announced herself with an incredible throb of metallic rhythms and then exhibited the self that both the noise of the jewelry and the silent magnetism displayed.

It was the entrance of an Aztec goddess, perhaps Coatlicue, the mother deity wrapped in her skirt of serpents, exhibiting her own lacerated, bloody hands the way other women sport a brooch. Perhaps it was Tlazolteotl, the goddess of both impurity and purity in the Indian pantheon, the feminine vulture who must devour filth in order to cleanse the universe. Or maybe we were seeing the Spanish Earth Mother, the Lady of Elche, rooted to the soil by her heavy stone

helmet, her earrings as big as cartwheels, her pectorals devouring her breasts, her rings transforming her hands into claws.

A Christmas tree?

A piñata?

Frida Kahlo was more like a broken Cleopatra, hiding her tortured body, her shriveled leg, her broken foot, her orthopedic corsets, under the spectacular finery of the peasant women of Mexico, who for centuries jealously kept the ancient jewels hidden away, protected from poverty, to be displayed only at the great fiestas of the agrarian communities. The laces, the ribbons, the skirts, the rustling petticoats, the braids, the moonlike headdresses opening up her face like the wings of a dark butterfly: Frida Kahlo, showing us all that suffering could not wither, nor sickness stale, her infinite variety.

THE SCHISM OF THE BODY

The body of Frida Kahlo, first of all. Seeing her there, in the opera box, once the clanging had stopped, once the silks and bracelets had rested, once the laws of gravity had imposed a stillness on the grand entrance, once the flares of the procession had died and the ceremonial halo, Aztec and Mediterranean, rabidly un-Anglo, that surrounded Kahlo had dimmed, one could only think: The body is the temple of the soul. The face is the temple of the body. And when the body breaks, the soul has no other shrine except the face.

What a mysterious sisterhood, I thought as I resumed hearing the *Parsifal* Overture once the entrance of Frida Kahlo had upstaged everything and everybody, what a mysterious sisterhood between the body of Frida Kahlo and the deep divisions of Mexico during her early years. It all came together in this place, the Palace of Fine Arts, and this woman, the artist Frida Kahlo.

The Palace was conceived during the Pax Porfiriana, the thirty years of self-proclaimed Order and Progress under General Porfirio Díaz, which had come to an end in 1910, three years after Frida's birth. Before that, the epic of Mexican history unfolded very much as in the murals of Kahlo's husband, Diego Rivera. In linear succession, Mexico had gone from Indian empire to Spanish vice-royalty to independent republic. But in Mexico nothing is strictly linear. Within each period, a form of turbulence, an inner spiral, wounds and disrupts the political life of the country, crushes, petrifies, or exiles its symbols.

The Aztec world, a sacrificial theocracy, wanted to wed the promises of peace and creativity symbolized by the Feathered Serpent, Quetzalcóatl, with the bellicose necessities demanded by the bloodthirsty god of war, Huitzilopochtli. Therefore the starkly ambiguous character of the Aztec universe: great artistic and moral achievements side by side with execution, blood rites, and terror. Ancient Mexico became victim of both myths when the Spanish captain Hernán Cortés arrived on the day foreseen for the return of Quetzalcóatl but proved to be as bloody as Huitzilopochtli. But more than the Aztec divinities, Cortés reassembled his own Renaissance model, the *condottiero*, the Machiavellian prince, and conquered Mexico with a mixture of wile and force.

Mexico is a country that has been made by its wounds. A nation enslaved,

forever stunned by the flight of the gods, sadly yet eagerly sought out its new divinities and found them in the father figure — Christ, the crucified God who did not exact sacrifice from men, but sacrificed himself for all, and Guadalupe, the Virgin who restored pure motherhood to the orphaned Indian, ashamed of the betrayal of La Malinche, Cortés's mistress.

During the Colonial period, Mexico created a *mestizo* culture, both Indian and European, baroque, syncretic, unsatisfied. Independence, in 1821, liberated the country in the name of freedom but not of equality. The lives of the great masses of Indians and mestizos, mostly peasants, remained unchanged. The laws did change, but had nothing to do with the real life of real people. The divorce between ideal laws and stubborn realities made the nation ungovernable, prey to uninterrupted civil war and foreign invasion. A dismembered, mendicant, humbled Mexico, forever at the foot of foreign creditors, foreign armies, plundering oligarchs: This is the external, dramatic, perhaps obvious Mexico painted by Rivera.

Two foreign traumas — the loss of half of the national territory to the United States in 1848, the French invasion of 1862 and the phantom crown of Maximilian and Carlota - made the schism of the body of Mexico unbearable. The nation reacted through the Liberal revolution, the character of Benito Juárez, and the creation of a national state, secular and under the rule of law. Porfirio Díaz perverted the republic of Juárez, gave priority to development over freedom, and placed a mask on the face of Mexico, proclaiming to the world: we are now reliable, progressive, modern. The peasant armies of Pancho Villa and Emiliano Zapata rose from the land to say no, we are these dark, wounded faces that have never seen themselves in a mirror. No one has ever painted our portraits. Our bodies are broken in half. We are two nations, as Disraeli said of industrial England. Always two Mexicos, the gilt-edged, paper elite and the downtrodden millions of the earth. When the people rose in 1910, they rode the breadth of Mexico, communicating an isolated country, offering themselves the invisible gifts of language, color, music, popular art. Whatever its political failures, the Mexican Revolution was a cultural success. It revealed a nation to itself. It made clear the cultural continuity of Mexico, in spite of all the political fractures. It educated women like Frida Kahlo and men like Diego Rivera, making them realize all that they had forgotten, all that they wanted to become.

YOUTH: A STREETCAR NAMED RAPE

Rivera and Kahlo. He paints the cavalcade of Mexican history, the endless, at times depressing, repetition of masks and gestures, comedy and tragedy. In his finest moments, something shines behind the plethora of figures and events, and that is a humble beauty, a persevering attachment to color, form, the land and its fruits, the sex and its bodies. But the internal equivalent of this bloody rupture of history is Frida's domain.

As the people are cleft in twain by poverty, revolution, memory, and hope, so she, the individual, the irreplaceable, the unrepeatable woman called Frida Kahlo is broken, torn inside her own body much as Mexico is torn outside.

Rivera and Kahlo: has it been sufficiently stressed that they are two sides of the same Mexican coin, almost comical in their Mutt and Jeff disparity? The elephant and the dove, yes, but also the blind bull, in so many ways insensitive, rampaging, immensely energetic, poured towards the outside world, and married to the fragile, sensitive, crushed butterfly who forever repeated the cycle from larva to chrysalis to obsidian fairy, spreading her brilliant wings only to be pinned down, over and over, astoundingly resistant to her pain, until the name of both the suffering and the end of the suffering becomes death.

How much more than this was in Kahlo, was Kahlo, her *Diary* now shows us: her joy, her fun, her fantastic imagination. The *Diary* is her lifeline to the world. When she saw herself, she painted and she painted because she was alone and she was the subject she knew best. But when she saw the world, she wrote, paradoxically, her *Diary*, a painted *Diary* which makes us realize that no matter how interior her work was, it was always uncannily close to the proximate, material world of animals, fruits, plants, earths, skies.

Born with the Revolution, Frida Kahlo both mirrors and transcends the central event of twentieth-century Mexico. She mirrors it in her images of suffering, destruction, bloodshed, mutilation, loss, but also in her image of humor, gaiety, *alegría*, that so distinguished her painful life. The resilience, the creativity, the jokes that run through the *Diary* illuminate the capacity for survival that distinguishes the paintings. All together, these expressions make her fantastically, unavoidably, dangerously, symbolic—or is it symptomatic?—of Mexico.

A prancing, cheerful child stricken by polio and stung by the peculiar Mexican capacity for malice, for ridiculing the other, especially the infirm, the imperfect. Beautiful little Frida, the striking child of German, Hungarian, and Mexican parenthoods, little Frida, with her bangs and her billowy ribbons and huge headknots, suddenly becomes Frida the pegleg, Frida pata de palo. The taunting screams from the recess playground must have followed her all her life.

They did not defeat her. She became the joker, the sprite, the feminine Ariel of the National Preparatory School at the time when Mexico, intellectually, was discarding the rigid philosophical armor of Scientific Positivism and discovering the indiscreet, if liberating, charms of intuition, children, Indians. . . .

Mexico, Latin America were then very much under the influence of French culture. France was a way of avoiding two undesirable proximities: the cold, materialistic, Protestant, and overpowering North—the U.S.A.—and the chaotic, Catholic, torrid, powerless South—Spain, ourselves. Auguste Comte and his philosophy of rational, inevitable scientific progression towards human perfection were shed in 1910 in favor of Henri Bergson and his philosophy of the vital élan, intuition, and spiritual evolution. The philosopher Antonio Caso, the novelist Martín Luis Guzmán (who rode with Villa and chronicled the guerrilla leader as a force of nature), the educator José Vasconcelos (who wrote the frankest autobiography Mexico had ever read, candidly revealing his sexual and emotional nakedness), all promoted their version of the Bergsonian vital impulse. Only Alfonso Reyes, the greatest writer of his generation, voted for a sort of Attic detachment. But the arts, more and more, discovered the native, peasant, Indian roots hidden by the marble facades of the Porfiriato.

Kahlo the young, disguised in manly clothes, a Saint Joan of the liberating culture of the Revolution, an armed footsoldier of the Mexican legions of Bergsonism, was part of a group known as Las Cachuchas — The Caps — proud and defiant in their denim clothes and proletarian, urchin-like cloth caps, making fun of all solemn figures (including the above-mentioned philosopher Caso, whose classes they turned into sheer turmoil), roaring and ripping through the halls of academe, planting banana peels at the foot of the statues of Scientific Order and Progress, stealing streetcars as in a Buñuel film yet to come.

How close this prankish spirit was to the aesthetics of the revolution in Mexico: Frida Kahlo admired Saturnino Herrán, Dr. Atl, the liberators of Mexican form, landscape, and color from academic restrictions. She is a lover of Brueghel and his belching popular carnivals, full of innocent monsters and perverse gluttons and dark fantasies offered like our daily bread, in bright colors and open sunlight. Fantasy with realism, internal darkness under midday lights. These became fundamental influences on the art of Kahlo.

Without knowing then, she and her friends replayed the outrageous jokes of Dada and Surrealism, but her sources were closer to home. Sighed a former guerrilla turned bureaucrat, "This revolution has now degenerated into a government." The degeneration is chronicled in a few novels and films, but most especially it became the butt of satirical skits staged in the *carpas*, the popular tents in proletarian barrios, from which the great comedians of Mexico—Soto, Medel, Cantínflas—would emerge. The *carpas* became the safety valve of a society caught between the promises of the Revolution, its actual achievements in education, health, communications, and its persistent perversions in corruption, undiminished strife, and political authoritarianism.

Mexico City, today the world's largest metropolis, was small then, with no more than 400,000 people. The Revolution, said Kahlo, left Mexico City empty, one million Mexicans having died at war between 1910 and 1920. It was a lovely, rose-colored city of magnificent Colonial churches and palaces, mock-Parisian private mansions, many two-story buildings with big painted gates (*zaguanes*) and wrought-iron balconies; sweet, disorganized parks, silent lovers, broad avenues and dark streets. And crystalline, unpolluted air.

Throughout her life, Kahlo went out in search of the darker city, discovering its colors and smells, laughing in the *carpas*, entering the *cantinas*, searching for the company she could relate to, for Frida Kahlo was a lonely woman in need of comradeship, groups, and very close friendships, Las Cachuchas first, Los Fridos later, the need to be part of a human grenade, closely stuck, to protect her from the rampant cannibalism of Mexican intellectual life. *Defenderse de los cabrones*, "Protect oneself from the bastards." That was one of her lifetime slogans. "It is unbelievable," she once said of Diego Rivera, "that the lowest insults . . . should have been vomited in his own home, Mexico." Not unbelievable at all.

Yet the city she both loved and feared struck at her without pity. In September of 1925 a streetcar crashed into the fragile bus she was riding, broke her spinal column, her collarbone, her ribs, her pelvis. Her already withered leg now suffered eleven fractures. Her left shoulder was now forever out of joint,

one of her feet crushed. A handrail crashed into her back and came out through her vagina. At the same time, the impact of the crash left Frida naked and bloodied, but covered with gold dust. Despoiled of her clothes, showered by a broken packet of powdered gold carried by an artisan: will there ever be a more terrible and beautiful portrait of Frida than this one? Would she ever paint herself—or could she paint herself other than—as this "terrible beauty, changed utterly"?

The pain, the body, the city, the country. Kahlo. Frida, the art of Frida Kahlo.

SUFFERING: MURDERED BY LIFE

In her great work on the body in pain, Elaine Scarry lucidly notes that the pain of others is but a transitory fact in our own consciousness.

Is pain something you cannot share?

Even more, is pain something that can be said at all?

It is undescribable, writes Virginia Woolf. You can know the thoughts of Hamlet, but you cannot truly describe a headache. For pain destroys language. Philoctetes, the Greek warrior bitten by a snake, is abandoned on the island of Lemnos to his fetid wounds and his horrifying screams of pain. His speech is punctuated by animal screams and grunts, by the monosyllables of inarticulate suffering. And when Conan Doyle, in one of his eeriest stories, sends a scientific expedition down to the very center of the earth, all that the explorers receive, when they touch the planet's core, is a terrifying scream which almost makes them lose their minds.

Pain, writes Scarry, resists becoming an object of language. So pain is best expressed by those who do not feel it but speak in the name of pain. In a famous page, Nietzsche says that he has decided to call his pain "Dog." "It is equally faithful, unobtrusive and shameless, equally fun to be with . . . and I can scold it and vent my evil tempers on it. . . ."

Frida Kahlo had a Dog called Pain, more than a Pain called Dog. I mean, she directly describes her own pain, it does not render her mute, her scream is articulate because it achieves a visible and emotional form. Frida Kahlo is one of the greatest speakers for pain in a century that has known, perhaps not more suffering than other times, but certainly a more unjustified and therefore shameful, cynical and publicized, programmed, irrational, and deliberate form of suffering than ever. From the Armenian massacres to Auschwitz, from the rape of Nanking to the gulag, from the Japanese POW camps to the nuclear holocaust in Hiroshima, we have seen pain, we have felt horror, as never before in history. How could this all happen in our own modern, progressive, civilized times?

The bloodshed of the Mexican Revolution is small beer indeed next to the executions ordered by Hitler and Stalin. Frida Kahlo, as no other artist of our tortured century, translated pain into art. She suffered thirty-two operations from the day of her accident to the day of her death. Her biography consists of twenty-nine years of pain. From 1944 on, she is forced to wear eight corsets. In 1953, her leg is amputated as gangrene sets in. She secretes through her

wounded back, "smelling like a dead dog." She is hung naked, head down, from her feet, to strengthen her spinal column. She loses her fetuses in pools of blood. She is forever surrounded by clots, chloroform, bandages, needles, scalpels. She is the Mexican Saint Sebastian, slinged and arrowed. She is the tragic embodiment of Plato's very forthright description: The body is like a tomb that imprisons us much as the oyster is caught within the shell.

She reminds one of the Aztec goddesses of Birth and Earth, but even more of the flagellant deity, Xipe Totec, Our Lord of the Flayed Skin, the dualistic divinity whose skin was never his own, whether he wore that of the sacrificial victim as a macabre cloak, or whether he himself was shedding his own skin, as a serpent does, to signify a rite of renewal, even of resurrection. (The gods of Mexico have this ambiguous quality: the good they promise is inseparable from the evils they bestow. Xipe Totec, symbol of resurrection, Spring deity, also inflicts sacrifices, blisters, and festering on his human devotees.)

In *The Broken Column* or in *Tree of Hope*, Kahlo portrays herself as this flayed skin, this bleeding, open skin, cut in half like a papaya fruit. As she lies naked in a hospital bed in Detroit, bleeding and pregnant, Rivera writes: "endurance of truth, reality, cruelty, and suffering. Never before had a woman put such agonized poetry on canvas. . . ." For what she lives is what she paints. But no human experience, painful as it may be, becomes art by itself. How did Kahlo transform personal suffering into art, not impersonal, but shared?

ART: LIONS IN THE BOOKSHELF

Her pain. Her body. These are sources of Kahlo's art, but not sufficient, not the only. There is Guillermo Kahlo, her father, a photographer of German- and Hungarian-Jewish descent, whose work is close to the rigidity of the posed nineteenth-century portrait. Guillermo Kahlo was much in demand for calendar pictures, probably still caught in the astonishment of being able to give *everybody* a face. The camera robs the court and even the bourgeois painter of their privilege. Not only the rich, not only the powerful, have a right to own a face. You need no longer count on Velázquez or Joshua Reynolds to immortalize your unique, irrepeatable, but alas, mortal features. Now, the inexpensive camera frees you from anonymity.

Then there is the Mexican church *retablo*, the humble *ex-voto* painted on wood or metal by anonymous and equally humble hands, recounting a terrible happening, an accident, an illness, a painful loss, and thanking the saints, God, the Holy Virgin, and their local manifestations—the Virgin of Zapopán, the Holy Child of Atocha—for saving our life, our health, our resilience to loss, illness, pain. Thanks for the Miracle.

And then there is José Guadalupe Posada, the marvelous Mexican graphic artist of the turn of the century, who drew and printed broadsheets informing the voiceless and the untutored of the happenings, big and small, that concerned their curiosity and even their lives: scenes of murder, suicide, strangulation, mayhem in the streets, brawls in cantinas, monstrosities, and revolutions. Death, whether riding a bicycle or wearing a Lillian Russell hat, presides over

the news. It presides over time and history. Only dreams, including nightmares, seem to have an autonomous, liberated spirit.

But Posada descends from the artistic parentage of Goya, the Spanish universalizer of the eccentric and the marginal from the medieval roundelays of pestilence and death, the *danse macabre*, and from Brueghel and his rendering of popular life in colorful, minute detail. And to them all, Kahlo adds two favorites, one from the past, one from the present: Bosch and Magritte. They teach Frida that fantasy requires a realistic brush.

She is capable of coming back to her original sources and transforming them. She animates her father's photographs, while retaining some of their stilted flavor. She also takes his calendars and fills them with an interior time, a subjective experience of night and day, summer and fall. "September" is her "September," not the ninth month — birth, perhaps miscarriage — of a successive year. Time stands still only to go underground and reappear tinged with the personal images of Frida Kahlo. Not a painter of dreams, she insisted, but a painter of her own reality. "I paint myself because I am alone. I am the subject I know best."

Her reality is her own face, the temple of her broken body, the soul she has left. Like Rembrandt, like Van Gogh, Kahlo tells her biography through her self-portraits. The stages of passion, innocence, suffering, and finally, wisdom, are as evident in the Mexican as in the two great Dutch self-portraitists. But the aura of strangeness, displacement, of objects and dislocation of sceneries, as well as her spontaneous irrationality, have sometimes associated her, as well, with Surrealism.

A ribbon around a bombshell is how André Breton described her art, paraphrasing, in a way, Lautréamont's celebrated definition of art as "the chance encounter of a sewing machine and an umbrella on a dissection table." She is not foreign to the spirit of Surrealism, to be sure. She adores surprises. She would like to see lions come out of bookshelves, instead of books. There is perhaps a marvelous innocence in all of this. Luis Buñuel visited Breton on his deathbed. The old pope of Surrealism took the great filmmaker's hand and said: "Do you realize that no one is surprised any more?"

It is a fitting epitaph on the twentieth-century vanguard's penchant for shocking the bourgeoisie.

Yet Frida Kahlo remains (along with Posada) the most powerful reminder that what the French Surrealists codified has always been an everyday reality in Mexico and Latin America, part of the cultural stream, a spontaneous fusing of myth and fact, dream and vigil, reason and fantasy. The works of Gabriel García Márquez and what has come to be labeled "magical realism" are the contemporary images of this truth. Yet the great contribution of the Hispanic spirit, from Cervantes to Borges, and from Velázquez to Kahlo, is the certainty that imagination is capable of founding, if not the world, then certainly a world.

Don Quixote, Las Meninas, the Caprichos of Goya, The Aleph by Borges, the paintings of Matta, Lam, or Tamayo, One Hundred Years of Solitude, add something to reality that was not there before. This is a project far more conscious and acute in societies where reality itself finds scarce political representation.

The artist then gives to the society what a repressive authoritarian system takes from, or deprives the society, of.

Miguel Angel Asturias, the Guatemalan writer, and Alejo Carpentier, the Cuban novelist, witnessing the Surrealist Revolution of the 1920s in Paris, soon realized that what Breton and his friends were legislating in France was already the law of life and the imagination in Latin America. Pre-Columbian myth, Afro-American rites, the Baroque hunger for the object of desire, the masks of religious syncretism, gave Latin America its own patent for Surrealism with no need to submit, in the name of anti-Cartesian freedom of association, to very Cartesian rules on what dreams, intuitions, and prosody should properly be like. The French Surrealists, while advocating automatic expression, would still write like eighteenth-century court diarists. Breton's prose is as correct and elegant as that of the Duc de Saint-Simon. Luis Buñuel and Max Ernst, the greatest Surrealists, found their sources, as well as their power to alter and criticize the world, in their own national cultures. Buñuel's films are a single, anarchical, corrosive revision of the very Catholic Spanish culture that nurtured him, while Ernst is the last descendant of the Brothers Grimm and the fantastic fairy tales of the dark German forests: thanks to this tradition, he makes visible the obscurest recesses of dream and nightmare.

This is Kahlo's brand of Surrealism: a capacity to convoke a whole universe out of the bits and fragments of her own self and out of the persistent traditions of her own culture. A vast culture, as I have pointed out. From Bosch and Brueghel to Posada, photography, *ex-votos*, and perhaps film. Kahlo loved comic film. Laurel and Hardy, the Three Stooges, Chaplin, the Marx Brothers, were her great entertainments. And who and what were these comedians? They are anarchists, perpetually at odds with the law, pursued by the fuzz, answering the demands of law and order with pratfalls, custard pies, and an undefeatable innocence.

Yet no matter how many strands and strains we find in Kahlo's artistic family tree, there always remains a shining, solitary, untransferable question for the artist: How and why did she create such good art? She herself would give a number of answers. Her love of surprise (lions in the bookshelves), her sense that frankness and intimacy were inseparable, her will to eliminate from her paintings all that did not originate in her own interior, lyrical impulses. My themes, she said, are my sensations, my states of mind, my reactions to life. There is Mexico, of course, a country where everything is (or used to be, B.P.: Before Plastics) art, from the humblest kitchen utensil to the loftiest Baroque altar.

All of this, nevertheless, does not account, item by item, for an art which is fused through and through by beauty. What sort of beauty? we have a right to ask. Is this beauty, this terrifying sequence of open wounds, blood clots, miscarriages, black tears, *un mar de lágrimas*, indeed, a sea of tears?

Frida Kahlo understood, as a part of both her European and Mexican heritage, this simple fact: It is one thing to be a body, and another thing to be beautiful. Kahlo managed to establish a distance from ugliness only to see what was ugly, painful, or cruel with a clearer eye, discovering her affinity, if not with

the current model of beauty (Memling, thin? Rubens, fat? Parton, bust? Bardot, derrière? Mae West or Twiggy), then with the truth about her own self, her own face, her own body. Through her art, Kahlo seems to come to terms with her own reality: The horrible, the painful, can lead us to the truth of self-knowledge. It then becomes beautiful simply because it identifies our very being, our innermost qualities. Kahlo's self-portraits are beautiful for the same reason as Rembrandt's: They show us the successive identities of a human being who is not yet, but who is becoming.

This manner of conceiving beauty as truth and self-knowledge, as becoming—devenir—requires unblinking courage and is Kahlo's great legacy to the marginal, the invisible men and women of an increasingly faceless, anonymous planet, where only the "photogenic" or the "shocking," as seen on the screens, merits our vision.

Socrates, famous for his ugliness, asked us to close our eyes in order to see "our own internal beauty." Kahlo goes beyond the Socratic demand to close our eyes and open them to a new way of seeing. Sight is the clearest of all the senses, writes Plotinus, yet it is incapable of seeing the soul. And this is so, he adds, because if we were able to see the soul, it would awaken in us a terrible love, an *intolerable love*. Only beauty has the privilege of looking at the soul without being blinded.

This is Kahlo's privilege. Her art is certainly not an absolute way of discovering the inner self and its identification with beauty in spite of external appearances. Far more than that, it is an approximation of self, of becoming, of *not yet*, never a fulfillment, always an approach, a search for form which, when found, achieves the Yeatsian aesthetics I evoked a few pages back: "All changed, changed utterly. A terrible beauty is born."

POLITICS: A BOMB WRAPPED IN RIBBONS

There is an anecdote in Hayden Herrera's famous biography of Kahlo. A frustrated young North American dilettante, Dorothy Hale, committed suicide in 1939 by jumping from a high floor in the Hampshire House building in New York. Her friend Clare Boothe Luce asked Kahlo to paint an homage to the unfortunate and beautiful young woman. The result horrified Luce. Instead of an image of piety and respect-for-the-dead, Frida came up with a startling, sequential yet simultaneistic narrative picture of the suicide itself. We see Hale jumping, in midair, and finally crushed, lifeless and bleeding, on the pavement, staring at the world—at us—with eternally open eyes.

Luce admits that she wanted "to destroy the painting with a pair of library scissors, and I wanted a witness to this act." However, she was finally contented when the "offensive legend" saying that she had commissioned the painting was rubbed out.

"Rubbed out": this underworld term, so often heard in Hollywood gangster films, reveals and recalls two facts of Mexican art in relation to U.S. culture. For if the culture of Mexico, as implied in Clare Boothe Luce's censorship of Kahlo's painting, is violent, so is that of Anglo-Saxon America. The genocide of the

native Indians, the rape and robbery of their lands, Black slavery, wars against weaker nations, territorial annexations, robber barons, capitalist exploitation, all of this, right down to the urban violence of our own days: this great violence has been generally rubbed out of U.S. history in favor of more epic or idyllic visions. But the culture is then left without appropriate, cathartic, lasting, and even beautiful images of its own violence.

The question, then, is not, when did the U.S.A. lose its innocence? but rather, was the U.S.A. ever innocent? And in consequence, if North American violence is ugly, factual, and lacking in an aesthetic imagery, is it the destiny of Mexico to provide the U.S.A. with beautiful, lasting images of death — including violence?

I am not belittling the great beauty of many films, paintings, novels, poems, from Hawthorne to Warhol, from Poe to Peckinpah, which express the violence of the U.S.A. I am merely trying to establish a relationship, a questioning, probably a Mexican self-delusion, in relation to the U.S.A.: is it the destiny of Mexico to provide its northern neighbor with beautiful, lasting images of violence, including death?

"Rubbed out": is it not significant, in this sense, that Mexican art in the U.S.A. should constantly have been censored, picketed, hung down, rubbed out (and also, to be just, courageously defended)? The Siqueiros mural in Olvera Street, Los Angeles. The Rivera murals in Rockefeller Center, Detroit, and the New School. The Orozco mural at Pomona College, California, where a penis-less Prometheus resists the torture of vultures pecking at his body. Have the birds of prey cannibalized, Bobbitt-like, his dick? The vendetta of the student body at Pomona against the censorship imposed on Orozco by the academic authorities is a graffito under the mural: "Prometheus, you must hang it out before you slip it in."

What is this fear, objectively demonstrated in acts of censorship, of the Mexican symbol—sexual, political, or otherwise—in the Anglo-American mind?

A ribbon around a bombshell, answered André Breton, defining the art of Frida Kahlo, its explosive or, even better, as Breton would have it, its *convulsive* beauty. The political dimension of this sentence is of course closely related to the Surrealist nostalgia for unity recovered. The internal, oneiric, psychic revolution should be inseparable from the external, political, material, liberating revolution. The marriage of Marx and Freud. But in Kahlo's truly subversive mind, perhaps this would turn out to be the marriage of Groucho Marx and Woody Allen. In an interview several years ago, my wife asked Eugène Ionesco who the two most intelligent and most foolish men of modern times had been. Ionesco answered: Marx and Freud, on both counts. They were rabbis of genius, but foolish rabbis, for they were talkative and betrayed the rabbinical wisdom of silence.

The conflict between the two revolutions, the internal and the external, has pursued all of the writers and artists of the twentieth century. Surrealism shared with Marxism the dream of a humankind liberated from alienation and returned to its pristine origin, the age of gold, when all things belonged to all men, and no one said: This is mine. The Surrealists, furthermore, were the final

heirs to the last great all-encompassing European cultural movement, Romanticism. And Romanticism preached, also, a return to the wholeness of man, the unity of the origin, fractured by the history of greed, oppression, alienation. In this, again, Marxists and Romantics could shake hands.

Milan Kundera is perhaps (because of his Czech education) the first writer to have explained that Communism exerted a great attraction on young people everywhere, not because of its abstruse materialist philosophy or even because of Marx's deep and lasting critique of the economy, but because it offered an idyll of purity, of return to original humankind. This was the political culmination of the Romantic dream. Stalin certainly put an end to this illusion, but in the Mexico of the 1930s, Trotsky's exile gave hope to many that the Stalinist perversion could still be corrected and a true worker's state set up, sometime, somewhere.

Frida Kahlo lived in the political Mexico of the revolutionary one-party state, the system of the PNR (National Revolutionary Party), grandparent of the present, endless PRI (Party of Revolutionary Institutions). In the name of furthering the conquests of the Revolution, the Party demanded unity and subservience. There was no other way of combating the foes of the Revolution, i.e., the internal reactionaries (the Catholic Church, the expropriated landowners) and the external reactionaries (the government of the U.S.A. and the companies it protected in Mexico). In exchange for unity, the government would give Mexicans economic development and social peace. But not democracy, since political freedom would diminish the supreme value of National Unity against foes internal and external.

Nevertheless, the revolutionary governments did push through agrarian reform, public education, a national health and communications system. The aura of revolutionary progress in Mexico attracted many foreign radicals to our country. Frida Kahlo knew Julio Antonio Mella, the founder of the Cuban Communist Party, and his equally radical paramour, the Italian photographer Tina Modotti — he assassinated on a Mexico City street by agents of the Cuban government, she by his side.

Closer to home, Frida's first and great love, the student leader Alejandro Gómez Arias, was unmasking the Mexican government's revolutionary pretensions and calling for the nation's youth, "the Mexican Samurais," to challenge the one-party system. So did the philosopher José Vasconcelos, himself the first Education Minister of the Revolution, our Lunacharsky, the philosopher-statesman who gave the public buildings over to the mural painters. In 1929, Vasconcelos starred in an ill-fated attempt to win the presidency in a rigged election. Also in 1929, Kahlo saw the young revolutionary dandy Germán de Campo, a wonderful orator, fall in a public park as he spoke, killed by a government bullet. The Revolution, like Saturn, was eating her own children. Revolutionary generals opposed to the ruling generals, and uprisings of disaffected military abounded.

Lázaro Cárdenas, president between 1934 and 1940, attempted to reconcile national unity and authentic social progress. It was Cárdenas who admitted Leon Trotsky to Mexico, saving him, for a time, from Stalin's assassins. Diego

Rivera received Trotsky, offered him hospitality and protection, and weathered the blistering attacks of the Mexican Communists. Frida's politics, such as they were, could not be separated from the personality and the actions of Diego Rivera.

First an exciting young Cubist in Paris, Rivera discovered the epic thrill of Renaissance painting (particularly Uccello) and allied it to the nativist lines of Gauguin in Tahiti. His "Mexican" vision—quite legitimately so—owed its techniques to European art, more than to Mexican Pre-Columbian aesthetics or, even, to Mexican popular art (Frida was much closer to this than he). Nothing new here. The other muralists were also, formally, more European than they cared to recognize. José Clemente Orozco was a German Expressionist and David Alfaro Siqueiros an Italian Futurist. Maya or Aztec artists they certainly were not, and could not be. Their Mexicanist themes required the new, universal forms of the European vanguard in order to be artistically relevant.

A clue to the Mexican artists' love affair with the modern is supplied by Rivera's admiration for modern industry. He surprised many North American and European intellectuals by his glorification of steel and smoke, even praising the beauty of the bank vault. This was the alienation denounced by the likes of Chaplin in *Modern Times*, and before him by the solar-plexus novels of D. H. Lawrence, and of course, at the very beginning of the Industrial Revolution, by Blake when he spoke of industry's "dark Satanic mills."

That a contemporary Mexican Marxist, so enamored of the humble Indian and the exploited peasant, should also espouse the idyll of industry and materialism only serves to underscore the apparent contradictions of the whole Mexican process, so captured between its native impulses, the Zapata syndrome, and its modernizing impulses, the Ford syndrome. I think that for Rivera there was no contradiction between the two. The great staircase murals at the National Palace in Mexico City actually describe his chiliastic vision of history. The Indian panel culminates with the Emperor and the Sun. The Colonial panel with the Church and the Cross. The Republican panel, with the Red Flag and Karl Marx. All, finally, are millenarist visions of the Church triumphant, not civil or civic proposals.

But when all is said and done, what Rivera, Kahlo, and all the artists of the Mexican Revolution were really discovering, without fully realizing it, was that Mexico has an unbroken, generous, all-encompassing culture in which the past is always present. On this basis we should be able to create an inclusive, not an exclusive, modernity. This, I believe, is the true goal of Latin America, a continent that cannot hope to be explained without its Indian, Black, and European (Mediterranean, Iberian, Greek, Roman, Arab, Jewish) roots.

Frida, then, saw politics through Rivera. And Rivera was an anarchist, a mythomaniac, a compulsive liar, and a fantastic storyteller. How were these qualities (or defects, if you wish) to blend with dogmatic Communism? I have a suspicion that many Latin American Communists are really lapsed Catholics in need of reassurance. Having lost the Catholic roof, they yearn for the Communist shelter. After all, Saint Peter's was a relic of the past, the Kremlin a harbinger of the future. Today when religions resurrect and Marxism is

pronounced dead, it is interesting to hark back to the 1930s and try to understand both its illusions and loss of the same. Perhaps our premature burials and resurrections will also be severely judged someday.

Frida and Diego: She admitted that she had suffered two accidents in her life, the streetcar accident and Diego Rivera. Of her love for the man there can be no doubt. He was unfaithful. She reproached him: How could he consort with women unworthy of him or inferior to her?

He admitted it: "The more I loved her, the more I wanted to hurt her." She riposted with many lovers, both men and women. He tolerated the women who loved Frida, but not the men. She absorbed it all in her almost pantheistic, earthmother, Coatlicue and Lady of Elche, cleansing-vulture manner of love. She wanted to "give birth to Diego Rivera." "I am him," she wrote, "from the most primitive and ancient cells . . . at every moment he is my child, my child born every moment, daily from my self."

Such a love, for such a man, in such conditions, could only lead to both sexual fulfillment outside of the child-marriage and to political allegiance within it. Perhaps Frida attempted to bridge both fulfillment and allegiance through her love affair with Leon Trotsky. But Trotsky and Rivera were so different that the arrangement could not hold. The formal, rationalist, disciplined, authoritarian, extremely Old World, European Trotsky was like ice to the fire of the fibbing, sensual, informal, intuitive, taunting, and joking, very New World Rivera. Lev Davidovich the dialectician. Diego María the anarchist. Never the twain could meet, and the final rupture between the two men made the woman follow her true, unfaithful, magnificent, torturing, and tender lover: Diego Rivera.

Rivera himself had his eternal love affair with Communism. In and out of the Party, to the extent of firing himself from it, or receiving the heretic Trotsky in Mexico, he withstood the constant assaults of the *apparatchiks*. What kind of revolutionary was this Rivera, painting murals in Mexican public buildings and American capitalist citadels, receiving money from reactionary Mexican governments and gringo millionaires? Rivera must have had a good laugh: here he was, called a tool of Communism by the millionaires and a tool of capitalism by the Communists. In a sense, it was the best of both worlds! But Frida was right: like many lapsed Catholics who on their deathbeds ask for a priest to confess them, Rivera needed the final rites of the Communist Party.

He was finally readmitted to the political church in 1954. (Frida had dutifully also sought readmission.) Marx, Lenin, and Stalin began to appear in her iconography with the same regularity that Christ, the Virgin, and the saints appear in the Catholic *ex-votos* that so influenced her art. Marx, Lenin, Stalin. They were the new mediators. Thanks to them the new miracle would occur.

The Cold War sealed these political positions. Not everyone was capable of humor as the Strangeloves held sway in Washington and Moscow and taught us to fear the bomb. I remember the day of Stalin's death, March 4, 1953. My friends and I held a party (Dzhugashvili's Wake) at the loft of the painter and poet Salvador Elizondo in an old Colonial palace on Tacuba Street, where we drank and celebrated the passing of the Man of Steel around a celebrated clipping from that day's edition of a Mexican newspaper, sporting Stalin's effigy

framed in black and the supremely pithy headline: "iya!" ("DEAD!" "GONE!" "NO MORE!"), surrounded, as the church *retablos*, as Frida's own paintings, by votive lamps. "I lost my balance with the death of Stalin," Frida wrote.

But were we not all together again, united in July of 1954, by the overthrow of the democratic government in Guatemala by a CIA-organized coup? The Good Neighbor Policy was over. The years of Franklin Roosevelt were over. Now, John Foster Dulles pronounced the Guatemala adventure "a glorious victory for democracy." Guatemala sank into forty years of unending dictatorship, genocide, torture, and suffering. Perhaps Frida and Diego grossly overestimated the Communist promise. They did not underestimate the menace of U.S. foreign policy in Latin America.

Such were the parameters of our political life as my generation struggled to find a level of reason and humanity between the Manichean demands of the Cold War and its frozen inhuman warriors—the Berias, Molotovs, and Vishinskys on one side, the Dulleses, Nixons, and McCarthys on the other. The manifestation for Guatemala was Frida's last appearance in public. She now began her cruel decline towards final suffering and death.

But was there not a deeper sense to her politics than Rivera, Marxism, the Cold War? A glance at her art tells us the truth: Frida Kahlo was a natural pantheist, a woman and an artist involved in the glory of universal celebration, an explorer of the interrelatedness of all things, a priestess declaring everything created as sacred. Fertility symbols—flowers, fruits, monkeys, parrots—abound in her art, but never in isolation, always intertwined with ribbons, necklaces, vines, veins, and even thorns. The latter may hurt, but they also bind. Love was the great celebration, the great union, the sacred event, and Frida's love letters to Alejandro Gómez Arias seem written by Catherine Earnshaw to Heathcliff in a Mexican *Wuthering Heights*, where great romantic passion is driven by the necessity to reunite the whole of creation:

Deep down, you understand me, you know I adore you. You are not only something that is mine, you are me myself.

No wonder that to the demands of revolutionary realism in art she could only answer, truthfully, privately, in her *Diary*: "I cannot, I cannot!" Her iconographic tokens are there. Her art is elsewhere, engaged not in bowing to reality, but in convoking yet another, a further, an invented reality.

DRESSED FOR PARADISE

There is a humor in Kahlo that transcends politics and even aesthetics, tickling the ribs of life itself. The *Diary* is the best example of this ribald, punning, dynamic genius for humorous language that makes Kahlo such an endearing and, finally, happy figure, in spite of all the suffering. Her voice, all who knew her tell us, was deep, rebellious, punctuated by *caracajadas* — belly laughs — and by *leperadas* — four-letter words.

To be obscene means to be out of stage, un-scene, un-seen, and Kahlo filled the cup of her moments outside the scene of art and the stage of her highly theatrical persona with jokes both practical and linguistic. The irreverence dated back to the Cachucha days, the stealing of streetcars, the mocking of professors, her ability, in spite of polio, to jump off and onto streetcars, her final mutilation by a streetcar, her love for *carpas* and *cantinas*, her joy in singing and hearing Mexican love songs, ballads, and *corridos* — history as recalled and sung by the people, yet another link with the art of Posada and the *ex-voto*. Her immense love of friends, her *cuates*, her *cuatachos*, her *cuatezones*, that is, in an Aztec derivation which is extremely popular in Mexico, her friends seen as her twins, her comrades, her brethren.

She could sing the beautiful couplets of *La Malagueña* with a perfect falsetto. She got along with carpenters, bartenders, shoemakers, anarchists, servants, budding artists. She had the Mexican knack of turning all words into diminutives, charming the words, babying them, caressing them, discovering, as it were, the clitoris of pleasure in each word: *chaparrita* for small women, *chulito* for her male friends, *doctorcito*, even *doctorcito Wilsoncito*, for her many doctors, signing herself *chiquita*, *chicuita*, tiny one, the smallest one, *Friducha*, little ol' Frida, herself.

Mexican diminutives are a form of defense against the arrogance of the rich and the oppression of the Mexican authoritarian tradition. Diminutives fake courtesy and submission before the powerful, they anesthetize the arrogant. Then, one day, like Kahlo on her bed of pain, Mexico starts "shooting my way out of the hospital and starting my own revolution." As an artist of great merit and popularity, she was also conscious of the critical cannibalizing which is a permanent characteristic of Mexican intellectual life, where bevies of frustrated dwarfs have their machetes ready to decapitate anyone who stands above them. Her humor, her language, her own very personal *chutzpah*, were ways of defending herself against the bastards — *Defenderse de los cabrones*.

She applied her humor, as well, to the U.S.A., all the time admitting that the Rockefellers fired you while showing their faces, while Mexicans practiced the stab in the back. Like Rivera, nevertheless, she was baffled by gringo faces and could not paint them. They seemed colorless to her, like half-baked rolls, she said. And the American women who tried to imitate her ended up looking like "cabbages."

But in the U.S.A., as in Mexico, Kahlo and Rivera loved to puncture pretension and defy prejudice. She descended from Hungarian Jews, he from Sephardic exiles of the Spanish Diaspora of 1492. What better way of entering the U.S.A., when some hotels were barred to Jews, than announcing (ten years before Laura Hobson's *Gentleman's Agreement*) as they registered at the front desk, that they, the Riveras, were Jewish? What greater fun than sitting at dinner with the renowned anti-Semite Henry Ford and inquiring: "Mr. Ford, are you Jewish?"

Necklaces, rings, white organdy headgear, flowery peasant blouses, garnet-colored shawls, long skirts, all of it covering the broken body. Yet dress was a form of humor, too, a great disguise, a theatrical, self-fascinated form of

autoeroticism, but also a call to imagine the suffering, naked body underneath and discover its secrets. Rivera said that women are more pornographic than men, for they have sensuality in every part of their body, whereas men have their sexual organs "in just one place." Perhaps Frida pretended to agree and tried not to disappoint Rivera. But in some of her descriptions of her Frog Prince of a husband, she shows us how aware she was that men have as many erogenous zones as women.

The clothes of Frida Kahlo were, nevertheless, more than a second skin. She said it herself: They were a manner of dressing for paradise, of preparing for death. Perhaps she knew that the ancient masks of Teotihuacán, beautifully wrought in mosaic, were meant to cover the faces of the dead, so as to make the corpses presentable in their trip to paradise.

Perhaps her extraordinary regalia, capable of drowning out a Wagner opera when she entered the theater, was but an anticipation of her shroud. She took to her clothes, writes Hayden Herrera, as a nun takes to her veil. She feared ending like the old king Tezozomoc, who was put inside a basket, all wrapped in cotton, for the rest of his days. Her luxurious dresses hid her broken body; they also permitted her to act in a ceremony of ceremonies, a dressing and undressing of herself as laborious, regal, and ritualistic as those of the Emperor Moctezuma, who was helped by several dozen handmaidens, or the *levée* of the French kings at Versailles, which was witnessed by practically the whole court.

While death tiptoed towards her, she dressed in full regalia to lie in bed and paint. "I am not sick," she would write. "I am broken. But I am happy to be alive as long as I can paint." But as death approaches, the tone changes. "You are killing yourself," she realizes, as drugs and alcohol both alleviate and condemn her increasingly. But she quickly adds: "There are those who will no longer forget you. . . ."

Her death comes in Mexico, from Mexico, on July 13, 1954. Our difference from the European conceptions of death as finality is that we see death as origin. We descend from death. We are all children of death. Without the dead, we would not be here, we would not be alive. Death is our companion. Frida had the sense of fooling death, of fooling around with death, using her powers of language to describe death as *La Mera Dientona*, Old Buck Teeth; *La Tostada*, The Toasted One; a euphemism for *La Chingada*, the Fucked One; *La Catrina*, The Belle of the Ball; *La Pelona*, The Hairless Bitch, like her beloved *izcuintli* puppy dogs. She also spoke of death as *La Tía de las Muchachas*, The Girls' Aunt, a curious reference to the Spanish title of the Brandon Thomas farce of 1892, *Charley's Aunt*, where one of the male characters has to disguise himself in lace and crepes as a ponderous old maid, Charley's aunt from Brazil, "where the nuts come from."

Humorous and companionable as death may be, it is important, it is Henry James's "the distinguished thing." Kahlo says almost the same, calling death "an enormous and very silent exit."

Incinerated, she sits bolt upright in the oven, her hair on fire like a halo. She smiles at her friends before dissolving.

KEYS: KAYS

FK, Frida Kahlo, Franz Kafka. Two of the greatest symbolic figures of the twentieth century share their initials, their pain, perhaps even their positions in the world. Kafka sees himself as an animal hanging over an abyss, his hind legs still stuck to his father's traditions, his forelegs finding no firm ground. Kahlo, tortured, hung, mutilated, cut up in bits and pieces, eternally metamorphosed by both sickness and art, could say along with her brother Jew from Prague: "There shall be much hope, but not for us": Prague, "the little mother," has claws. So does Mexico City. They do not let go. Kafka's Kahlo, Franz's Frieda: The heroine of *The Castle*, Kafka's Frieda, is both the way to salvation and the agony of romantic love. For them both, the K of Prague and the K of Mexico, Nietzsche memorably wrote, "Whoever has built a new heaven has found the strength for it only in his own hell."

In the measure that her hope was her art and her art was her heaven, the *Diary* is Kahlo's greatest attempt to bridge the pain of their body with the glory, humor, fertility, and outwardness of the world. She painted her interior being, her solitude, as few artists have done. The *Diary* connects her to the world through a magnificent and mysterious consciousness that "we direct ourselves towards ourselves through millions of beings—stones—bird creatures—star beings—microbe beings—sources of ourselves."

She will never close her eyes. For as she says here, to each and every one of us, "I am writing to you with my eyes."

Mexico City, January 1995

ESSAY

By Sarah M. Lowe

Reading through Frida Kahlo's diary is unquestionably an act of transgression, an undertaking inevitably charged with an element of voyeurism. Her journal is a deeply private expression of her feelings, and was never intended to be viewed publicly. As such, Kahlo's diary belongs to the genre of the *journal intime*, a private record written by a woman for herself.

The impulses and purposes of a diary are perplexing and sometimes paradoxical. Is it really an autobiography or is the text transformed when it comes to light? Does it retain its integrity when read by another or published? How should a woman's private journal be read, and by extension, what can be learned about Kahlo by reading her diary?

Throughout history, diarists, both men and women, have chronicled their lives framed by their times or by particular historical events. In contrast, the predominant subject of the *journal intime*, and Kahlo's own diary specifically, is the self. Kahlo's motivation has less to do with communication than with negotiating her relationship to her self, and thus the conundrum — why write if no one else will see the text? — is in part answered.

If Kahlo's diary is understood as an *journal intime*, then the roughly fifty-five self-portraits Kahlo painted (nearly a third of her entire *oeuvre*), which were intended for public consumption, may be seen as constituting "autobiography." In the self-portraits painted with forethought, Kahlo carefully constructs herself in a variety of settings, creating an artistic persona with an audience in mind. The paintings are provocative and aggressively audacious both in subject matter and in intent. Before Kahlo, Western art was unused to images of birthing or miscarriage, double self-portraits with visible internal organs or cross-dressing, as subjects for "high" art.

No one questions the capacity of a self-portrait by Rembrandt to convey the anguish of an aging artist facing mortality or the power of one by Van Gogh to express the torment of an isolated and misunderstood artist. Such feelings are considered applicable to all "mankind." Kahlo, too, painted her own psychic

states of mind in a flamboyant and sometimes irreverent manner, but her work was deemed so excessively personal and self-referential that it was thought incapable of expressing universal emotions or the human condition. In time, her self-portraits, though they never cease to shock, have overcome some of the prejudices against women painting their own lives.

Yet there is an uncanny restraint evident in Kahlo's self-portraits, a false honesty, an omission in almost every one. She referred to herself as "la gran ocultadora" ("the great concealer"; plate 125), and the masklike features of her visage in many of the self-portraits are a manifestation of this very self-control. "Pure" revelation was further impeded by the fact that Kahlo was a slow painter and her canvases were mediated by time and contemplation. In contrast, her journal entries—the written passages as well as the drawings—convey the immediacy of firsthand sensations transcribed and recorded, a disclosure lacking in her paintings.

The fact that Kahlo included artwork in her diary makes it almost unique among *journaux intimes*. Yet it differs from the typical artist's sketchbook, which is usually a place for preparatory drawings or working out solutions in a small format to be applied to large works. Only once did Kahlo transform an ink drawing from the diary into a full-scale painting (plate 73). And unlike the classic intimate journalist, Kahlo is inattentive to day-to-day goings-on, and uses her journal (as did Virginia Woolf) as a repository for feelings (and images) that do not fit anywhere else. Thus, these pages must be approached with some trepidation; the portrait Kahlo paints here, with color and lines, with prose and poetry, is an image of the artist unmasked.

Kahlo began her diary in the mid-1940s, when she was thirty-six or thirty-seven. Her recent emotional life had been extraordinarily turbulent. Her father had died a few years earlier; she had been divorced from Diego Rivera in late 1939 and remarried him a year later. Kahlo had come to the unavoidable conclusion that she would never bear the child she longed to have, and was plagued by her inadequacy. She had undergone numerous medical and surgical interventions, for miscarriages and spinal problems. As she approached the age of forty, she could no longer ignore the signs that her health was deteriorating.

Much of the trauma Kahlo experienced she used in the formulation of her art. By 1944, she had produced about one hundred paintings, and she had met with a number of successes in her artistic career. In the early thirties, she traveled with Rivera to the United States, where her work was first exhibited at a public institution. In 1937, four of her paintings were included in a group show in Mexico City. Kahlo's decisive shift from amateur to professional painter, however, came in 1938, when she sold her first paintings (four to film star Edward G. Robinson) and showed twenty-five works at the Julien Levy Gallery, in New York. Levy's interest in Kahlo coincided with his abiding preoccupation with Surrealism, and subsequently, she came to be seen as a Surrealist artist. This association was cemented by her association with André Breton, self-proclaimed "Pope of Surrealism," who came to Mexico in early 1938. He wrote an important essay on Kahlo's work for the Levy exhibition, and arranged for a show in Paris in March 1939. Breton also had a hand in the

organization of the International Exhibition of Surrealism in Mexico in 1940, in which Kahlo showed her two largest canvases.

The guiding principle behind the Surrealist impulse that emerged in France in 1924 was rebellion, a revolt against all conventions, and in their place, the privileging of the supernatural, the antisocial, the international, and most important, the irrational. Kahlo's association with Surrealism as a movement, and with Breton as her supporter, is ambiguous, in large measure because of Breton's compulsive need to arbitrate what exactly might be considered Surrealism—ironic in light of his movement's anarchic founding ideas. Kahlo was unmoved by Breton's charismatic self-importance, in part because of the predominantly intellectual and abstract cast of his notions. While Breton was inspired by what was alien to the rational world of the white European male—madness, women, the exotic—Kahlo's creative impulse came from her own concrete reality.

Kahlo's paintings, her public work, shared with Surrealism a number of characteristics: an interest in the unconscious; disquieting, often inchoate imagery; and unorthodox subject matter, all traits of the second phase of French Surrealism, when the imagists, such as Salvador Dalí, René Magritte, and Yves Tanguy, were ascendant. Their work generally relied on realism, however distorted, and on spatial constructions called "landscapes of the mind."

Paradoxically, Kahlo's diary has more affinity to the tenets of the first Manifesto of Surrealism, in which psychic automatism or automatic drawing was used to bypass the rational mind and unlock the unconscious. This concept derived from Breton's reading of Freud's analysis of dreams and dreamwork, and among the artists who subscribed to this practice were Max Ernst, André Masson, and Joan Miró.

Nearly every drawing in Kahlo's diary is spontaneous and unplanned. Kahlo's automatic drawings were springboards to images that lurked in her unconscious, visions she teased out and then elaborated. After allowing herself the freedom to doodle, Kahlo put (at least part of) her rational mind to work, and from her vast lexicon of images, real and imagined, her biomorphic forms developed into faces, body parts, animals, and landscapes. Her visual sources were extensive: she was a voracious reader, a habit fed during the many periods when she was bedridden.

Kahlo relished the element of chance in these drawings, and she coaxed a number of figures from ink spots, stains resulting from deliberately spilled and splattered ink, some pressed onto the opposite page, others so thick they soaked through to the next sheet of paper (plates 33–35 and 61–62, for example). She used a variety of mediums—colored pencils, inks and washes, crayons and Contés, and gouache—and her choice at any one point also influenced her imagery. Although the most obvious case is Kahlo's list of colors and their meanings (plate 15), throughout the diary, Kahlo let the utensil she picked up dictate to her.

Adding to the sense of serendipity in many of the images are the caption-like remarks Kahlo often added, comments that express her own surprise at the final outcome: "The unforeseen phenomenon" (plate 42) she titles one page, and "Who is this idiot?" (plate 81) she questions another. Indeed, rarely do the texts

that accompany the drawings illuminate their significance; rather, they are ruminations that are as evocative and complex as the images.

That Kahlo's diary is at all decipherable is a measure, not of her desire to communicate, but of an almost obsessive return to a handful of themes. One, of course, is Kahlo's devotion to and love for Rivera, as evidenced by long, ardent love letters and the many pages that bear dedications to him. She expresses myriad emotions, from her sexual desire to a maternal nurturing to a mystical account of their union. Kahlo is endlessly inventive in her casting of their roles in their complementary and symbiotic relationship. Among the most interesting is her envisioning of their connection through art: in several passages she refers to "auxocromo" and "cromóforo," the yin and yang of color. He, auxocromo, captures color; she, cromóforo, gives color. Rivera is ever-present in the journal.

Throughout Kahlo refers to elements of Mexican culture that date back to a Pre-Columbian origin. Traces of the Pre-Conquest culture turn up in her modern world, for example, in Kahlo's habitual wearing of indigenous costume and braiding her hair with brightly colored wool cords or fabrics into a headdress known as a *tlacoyal*. Kahlo made an even more direct connection with her past by adorning herself with rings, necklaces, and earrings of gold, jadeite, beads, and shells, many of which incorporated Aztec symbols or glyphs. In much the same way, Kahlo's journal is sprinkled with words from Nahuatl, the Aztec language; many such words have made their way into everyday Mexican vocabulary (plates 26 and 117).

Kahlo also saw herself as heir to an incredibly rich source of fantastic imagery through her Mexican ancestry, less strictly biological and more cultural. The civilizations of the Olmecs, Aztecs, and Toltecs, as appropriated, reformulated, and even idealized by Kahlo, composed her personal past. The gods and myths, the figurines and codices, the pyramids and temples of the ancients provided her with a genealogy that linked her with the greatness of Mexico, as it did for many of her peers. Her response to ancient Mexico was quite different from that of the European Surrealists, who sought "unfamiliar" myths and artifacts to help revitalize their art. The invocation of Aztec civilization reverberated as political gesture at a time when the growing interest in indigenous art coincided with a keener sense of nationalism.

The double-page spread on plates 114–15 makes the connection between politics and the ancient roots of Mexican culture clear. Kahlo pairs the symbols of Communism with those of the Aztecs, and calls attention to her politics and her commitment to social causes. Kahlo had been sympathetic with Communism since her youth: she joined the Young Communist League in 1927, when she was twenty, and throughout her life threw her support behind causes which were sponsored by the Party. She claimed to have read widely in its literature and to have a clear grasp of dialectical materialism. But by the mid-forties Kahlo's interest in Communism moved beyond social conscience and became an epistemological, perhaps even religious, search for "pillars" that could support her faith. Her thousand-year Mexican heritage offered solace. By combining Communism with this conviction, Kahlo fashioned an ideal that was uncomplicated by the realities of the two regimes, for neither the bloodthirsty,

class-divided aspects of the Aztecs, nor the authoritative, regimented practices of Stalin are considered. Kahlo distills and purifies her vision of her two faiths, honoring them as idealized powers that gave her strength, especially as she saw her life drawing to an end.

Kahlo kept this diary for the last ten years of her life, and it documents her physical decline. Dated pages are sporadic, and thus it is difficult to discern the chronology. But an awful progression — regression — is unmistakable, as Kahlo faces the loneliness and terror of her illnesses. Even as a child, she was familiar with the role of patient. She contracted polio when she was seven years old; eleven years later she had a near-fatal accident and suffered a broken spine, collar and pelvic bones, crushed right leg and foot. Kahlo's chronic pain, however, and her encasement in orthopedic corsets and plaster casts for months at a time, the trophic ulcers she suffered on her right foot (which led to its amputation shortly before her death), and the roughly thirty-five operations she is said to have undergone may have been caused by a congenital malformation of her spine, a condition called spina bifida. Her diary chronicles her quest for cures, her resigning herself to the dictates of her medical advisers, and her often stoic response to their failures.

Part of Kahlo's preoccupation with the details of her infirmities springs from her youthful interest in physiology and biology. Before her fateful accident, Kahlo was taking science courses as prerequisites for becoming a doctor; even as she convalesced, the thought of combining her interest in art and science by becoming a scientific illustrator came to her. Indeed, these studies provided Kahlo with potent visual analogies and metaphors, which she marshaled in her paintings and used throughout her diary: internal organs and processes were often seen outside her body, while she used x-ray vision to picture her broken bones and spine. Of all her biological and botanical metaphors, Kahlo made the most effective use of roots and veins, tendrils and nerves, all routes for transmitting nourishment or pain.

Despite the pain and anguish Kahlo freely and openly expressed in her diary, her unquenchable thirst for life reveals itself. Her wit and *alegría*, her sense of irony and black humor all emerge here. "She had invented her own language, her own way of speaking Spanish, full of vitality and accompanied by gestures, mimicry, laughter, jokes, and a great sense of irony," a student of hers recalled.² The self-portrait we find in the diary makes more human "*la gran ocultadora*" of her paintings, and replaces the implacable mask with intimate—at times horrifying—details of affliction and despair. But Kahlo also shows her great strength, the resolve only intense suffering confers. "Anguish and pain," she writes, "pleasure and death are no more than a process" (plates 77–78). Kahlo's diary dramatically and explicitly conveys this process, and is a testimony to her vigilant recording, in words and pictures, of her inexorable path toward death.

¹Herrera, Frida Kahlo: The Paintings: 36-37.

²Herrera, Frida: A Biography: 329.

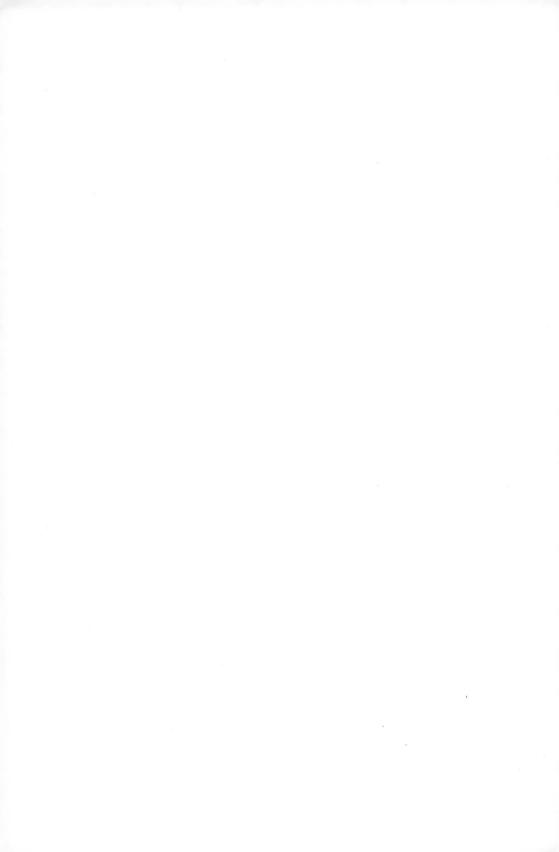

THE DIARY OF FRIDA KAHLO

An Intimate Self-Portrait

PINFDE 1916

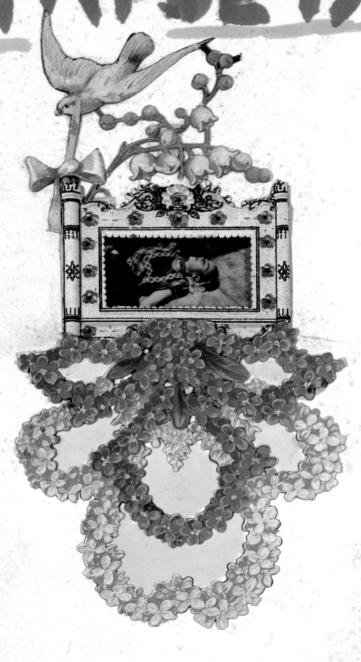

ne, luna, sol, diamante, manosyema, punto, rayo, gasa, mar. verde pino, vidrio rosa, ojo. mina, goma, lodo, madre, voy. = amor amarillo, dedos, util niño flor, deseo, ardid, resina. potrero, bismuto, santo, so sera. gajo, año, estaño, otro potro. puntilla, maquina, arroyo, soy. me Fileno, quasa, cancer, risa. gorjeo - mirada - cuello, viña pelo negro seda nina viento = padre pena pirata saliva sacate mordaja consumo vivaz onda - rayo - Fierra - rojo - soy. Abril. dia 30.. nino- cuajo, suyo, rey, radio negroalamo sino busco - manos . hoy? Olmo. Olmedo. Violeta. canarió zumbido. pedrada. blancor del gris. Camino - sibueta - ternura Corrido - gangrena - petrarca Mirasol : siniestros arules aquedo Romeros - ambages - basuras - ayer regazo. Tumbando. arrimo. visiones. iluso. dornida. pelar.

columnas amigas - frumores a jo abusos - cercanos - mentira - pasion. areano - millares - dinero - vigor. empalme conciencia - pirnja palmar. la fuerza - marina - joroba control miradas que digo - ajado cubil mikado - martirio - gorjeado senil. = cuadrado lucero cogiera, al rojo primor - al verde mentira derumbe angose sin silla place. primero - diesmado - pomposo agriado precoz . infamias hermosas garganta naranja rotunda que cosa, panteon. granizo lunera cantado. Grillante ademán alerta - candado - romano ordiente. cajita. lo sinto, maton. niño - niñito - niñote mi gris corazon. nevada graciosa. burbuja de Avión Jacia milano. corriendo jarana sin cuento razon. gran prisa espejosas nuneca carton.

Retrates agudos con tierna emocion. buscaba-risuena-morena-boton. gerundio gerona germana gorrion gualdada garganta 902ada pasion. Abeja - cariño - perfume - Cordon migaja marmaja - saltante miron. Soldado soltura - solsticio grion. Cuadrante morado. abierto ropon. materia micrada martirio memorillo metralla micron. Ramas, mares, amargamente en-Traron en los ojos idos. Osas mayores. voz. callada vida. Flor. 2 Mayo. 4 mayo. 7 mayo. no ve el color. Tiene el color. Hago la torma. no la mira. No da la vida que Fune. Tiene la vida. Tiene la vida. Tibia y blanca es su voz. Se quedo sin llegar nunca. me von.

A STATE OF THE PROPERTY OF THE Verdad es, muy grande, que ipo no quisiera, ni hablar, ni dormir ni oir, ni querer. S'enterme encerrada, sin miedo a ta sangre, sin Timpo nimagia, dentro de Ju mismo miedo, g dentro de Au gran angustia, y D'en il mismo mido de Au corazon. Toda esta locura : si te la pidiera. 70 se que seria, para Tu silencio, Solo Furbación. . Te pido violencia, en la sintazon, of tes, pue das gracia, tu lux y Calor. Pintarte quisiera, pero no hay co-lores, por haberlos tantos, en mi confusión, la forma concreta de mi gran amos. Cada momento, il es mi nino, mi niño nacido, cada ratito, diario, de mi misma.

Tasaba rumbosa: lasaba rumbosa: asunto monton assents montes, Furrera Cortina grabado moreno grabalo morino Mudazo zumbon mitores alada motores alada fulgencia simada fulgencia sumada silueta bailon silveta vailon sufrido cantanto Suprido cantando sombreado, sembra sutil aguijon sutile agringe velado colon del mismo celas amarillo. amarrada soltura. mision del viento. maraga giron curiosa manana pajaro limon. morena mortaja rodando bastira contaba pisadas al vuelo robado. devietto grown omo, ropajes antignosel gruso cellular del corazon.

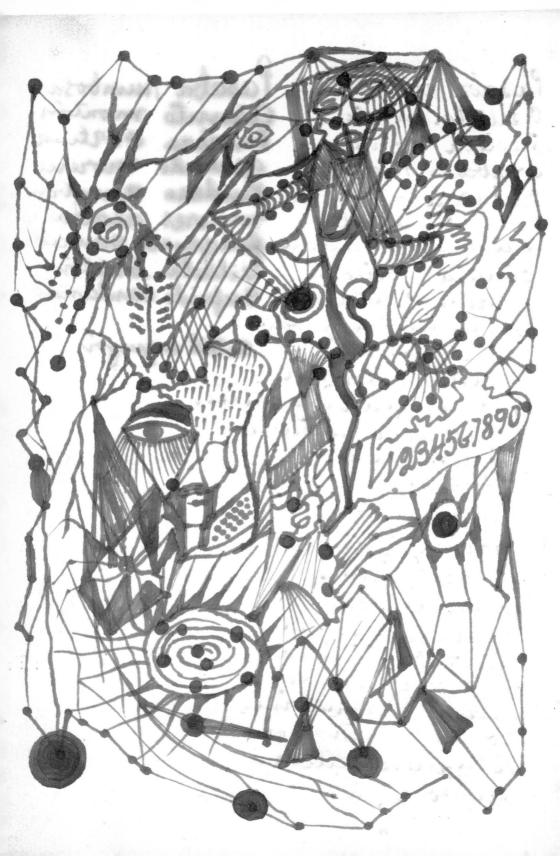

Carta:

Desde que me escribiste, en aquel dia tan daro y lejano, le querido explicarte, que so puedo irme de los dias, ni regresar a tiempo al otro Tresupo. no te he olvidado- las noches son largas y dificiles. El agua. El barco y el muelle y la sida, que te frée haciends tan chica, desde mis ojos, encar celado en caquella ventana redonda, que tri mirabas, para quardarme en Tu corazón. Todo eso esta intacto. Despues, vinieros los dias, mieros de Ar. Moya guisiera que mi sol te to-cara. Te digo, que fu nina es mi nina, los personajes teteres, arreglados en su gran cuarto de Hario, son de las dos. Es trago el huipil con listones Solleines. mias las plazas rujas de Fu Paris, sobre todas ellas, la maravillora - Des Vosges. tan dvidada y Fan firme. Los caracoles y la munica-novia, es tuya tambili. es decir, eres tri. Su vistido, es el mismo que no grizo quitarse el dia de la 60da con nadie, cuando la en-Contramos casi dormida en el piso sucio de una calle. mis faldas con dans de encaje, y la blusa antiqua que siem Are macin el retrato austrite, de una Sola persona. Pero el color de tu piel, de tus ojos y tu pelo Cambia con el viento de me-Marie Minister Marie Mar lo que mes o os ven a que toco con migo misma, disde todas las distancias, es liego. La caricia de las telas, et color del color, los

alambres, los nervios, los lapices, las hojas, el polvo, las células, la guerra y el sol, todo lo que se vive en los minutes de los no-relojes y los no-calendarios. M de las no-miradas vacias, es el. Tu la sentiste, por eso dijaste que me trajera el barco desde el Havre, donde Fri nunca me dijiste adios. Te seguire escribicado con mis 0,00, siempre. Besa a Maria la ninalle

My Tumeros, la economia, AN AMERICA No la farsa de la palabra, de la palabra, de los nervios axules son. No sé porqué - tambien rojos, Zo 12 / pero llenos de colos. MAN Por les números redonais you los nervios coloridos p Mylas estrellas estan he chas MAMMY MANNESSON Sonido. ?. Many ni la menor esperanza? todo se mueve al compas MAN de la que encierra la panja

Monte sommedium frame framente. parto infinite que mira sum-pre ordelante: El verde - luiz Aibia y buena Sollerino - arteca TLAPALI vieja ; Milliam Sangro de tuna, el mas vivo y antiguo Vim color de mole, de hoja que se va locura enfermedad mildo electricidad y purera amor.
nado és negro-realmente nado
hojas. Fristera, ciencia, Alemania entera es de este color mas locura y misterio todos los fantasmas usan trajes de este color, o cuando menos reparinterior. MIII monthe Color de anuncios malos. distancia Tambien WWW. la Terniva puede ser de lete anul... sangre? Pues, quien sale!

And die Minister fort withing and des Months fort monthlight word Look minister fift mon myter Sound to commission due Assas. Und der Hility er hat zähne und die traat en ihm gesicht und der macky hat ein messer doch das messer sipt mant ment matterns und der Heifisch er hat Zähne, und die tragt er Upm gesicht, und der Macky hat ein messere doch das messer sikt moin night. - Milliam Milliam mexico. O Cogracian. Paris. new Jork. MININA

Diego: Mary horse nada esmparable a tus manos ni nada igual al oro-verde de 148 0/08. Ini enerps se lleva de ti por dias y dias. eres et espejo de la noche. la lux violenta del relampaço. la humedas de la tierra. El hueco de Tus axilors es mi reprosio. mis yemas tocan to sangre. Toda un alegria es sentis brotas la vida de to fuenti-flor que la mua Juarda grara llenas todos es caminos de nues nervos que son los Tuyos. Mojas. novajas. armarus. gomon Vendo todo en nada: no creo en la ilusion. Funas un horror humo. Marx. La vida. el gran vacilor. nada Tiene nombre. go no miro formas. Il papel amor. querras. grenas. jarras. garras. aranas sumidas. vidas en alcohol. nino son los dias y hasta Many 2 - I divinis ment Ja llega. mi mans. mi roja! vision. mas grande. mas suya. martirio del vidrio. La gran Sinragon. Columnas y valles. les dedes del viente. les minos sangrantes. La mica micron. no se lo que piensa mi suemo burlon. La tinta, la man cha. la forma el color. 304 ave. soy todo sin mas turbacion. Todas las campanas. las reglas. las tierras. la grande arboleda. la mayor ternura: la inneusa marea. basura. Tinaja. cartas de carton. dados dedos duos debil esperanza de haces cons Trucción las telas. la reyes. Tour touto. mis unas. Il hils y el pelo, el nervio zumbon ya me voy connigo. un minu ne voy llorando. Es un vacilon.

auxocromo- Cromoforo. Diego Aquella quiddleva el color. Desde get are de 1922 Hasta todos les alas. Ahora en 1944. Después de Todas las rovas vividas. Siguen les vecto. res su dirección primera. nada los detiene. Sur mas Consciments que la viva emocion. Sin mas deses que seçuir pasta encontrarse. Leutemente. Con enorme inquietus pero con la certeza de que todo lo rige la sección de oro. Hay un acomodo celulas. Hay in movimientes Hay luz. Todos les embres por les mission. Le locusto no friste. Somo los minument que ya luino y sere mos Son contar con el estresido destino. Minimo municipalmente de la contar con el estresido

Mi Diego: ripejo de la noche. Tus ojos espadas verdes dentro de mi carne. ondes entre mues Todo tri en el espacio lleno de sonidos - en la sombra y en la luz. Tu Te llamaras AUSO-CROMO el que capta el color. Yo CROMOFORD. la que da el color. Tu eres todas las combruaciones de la numeros. La vida. mi deseo es entender la linea. la forma la sombra el movimilnto. Tu llenas y yo recibo. Tu palabra recorre todo el espacio y llega a mis celulas que son mis astros y va a las Tuyas que son mi luz. Museum municipal de la constante de la constan

auxocromo - cromotoro Era sed de muchos auos retenida en muestro enerpo. Palabras encadenadas que no pudimos decir sino en la labios del sue no. Todo lo rodeaba el milagro segetal del paisaje de tu cuerpo. Sobre tre forma, a mi tacto respondieron las pestanas de las flores, los rumores de los ris. Todas las frutas habia en el jugo de tui labiós, la sau gre de la granada, el tramento del morney y la piña acrisola da. Te oprimi contra mi pecho y el prodigio de tu forma penetro en toda mi sangre por la yema de mis dedos. Olora bsencia de poble, a recuer do de nogal, a verde aliento. de fresno. Horizontes y paisa Jes = que recorri con el beso. Un olvido de palabras forma ra el idioma exacto para

entender las miradas de muestros yos cerrados. = Estas presente, intangible y eres todo el universo que · formo en el espacio de mi cuarto. Tu ausencia brota temblando en el ruido del reloj, en el pulso de la luz; respiras por el espejo. Desde Ai hasta mis manos, recorro todo tre cuerpo, y estoy con tigo un minuto y estoy con migo un momento. I mi sangre es el milagro que va en las venas del aire de mi corason al trujo. 1 A MUJER. WHAT WAR THE WAR. EL HOMBRE. HE HELLENNING. El milagro vegetal del paisaje de mi cherjos es en ti la ma Turalesa entera. yo la re-

corro en vuelo que acaricia con mis dedos los redondos cerros, penetran mis manos los um bris valles en ansias de posesion y me cubre el abrago de las ramas suaves, verdes y frescas. Vo penetro el sexo de la tierra entera, me abrasa su calor y en mi cuerpo todo roza la frescura de las ho jas tiernas. Su rocio es el su f dos de amante siempre muera. no es amor, ni ternura, ni carino, es la vida entera, la mia, que encontre al verla en très manos, en tu boca y en tus serso. Tengo en mi boca el sabor almendra de tus la bin. Truestro mundos no han salido nunca fuera. Solo un monte conoca las entranas de otro monte. Por momento flota In presencia

Como envolviendo todo mi ser en tina espera ausiosa de manana. I noto que 12 try contigo. En este mornen to lleur aun de sensacione, tengo mis manos hundidas en naranjas, y mi enerpo se siente rodeado por tus mente rodeads for tan

la vida callada dadora de mundos, lo que mas juporta esta no ilusión. la manana nace.

2 rojos amigos las actuos

3 pajaros funderos de la finación de la surray se del canto de la surray se de la surray se del canto del canto de la surray se del canto de la surray se del canto de coragon - que so tumen nine = dulce xocolate del mérico antique, Hormenta en la sanged que entra por la boca - convelle augurio, risa y diente finas la hujas de perta, para algunisagalo de un siete de pelio, lo pido, me llega, canto. Cantado, Cantare desde hoy nuestra magia-amor.

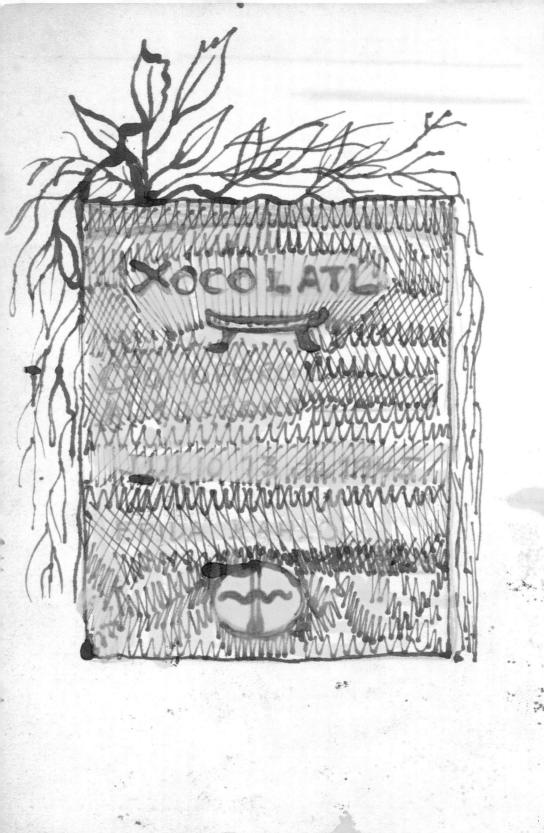

A a A a A a A a A Adalgisa augurio aliento aroma amor - antera abe abismo - altura - amiga - azul arena - alambre - antiqua astro axila abierta amarillo Alegria - Almircle - Alucema Firmonya. America - Finada agua. Ahora - Aire - Ancla Antista acacia - asombro-asi aviso- agata - ayer - aurea alba - apostol - arbol - atar ora - alta - acierto - abeja arca pirosa forma-alla

の年に SAMEN 公司 S C C S ZEN 292

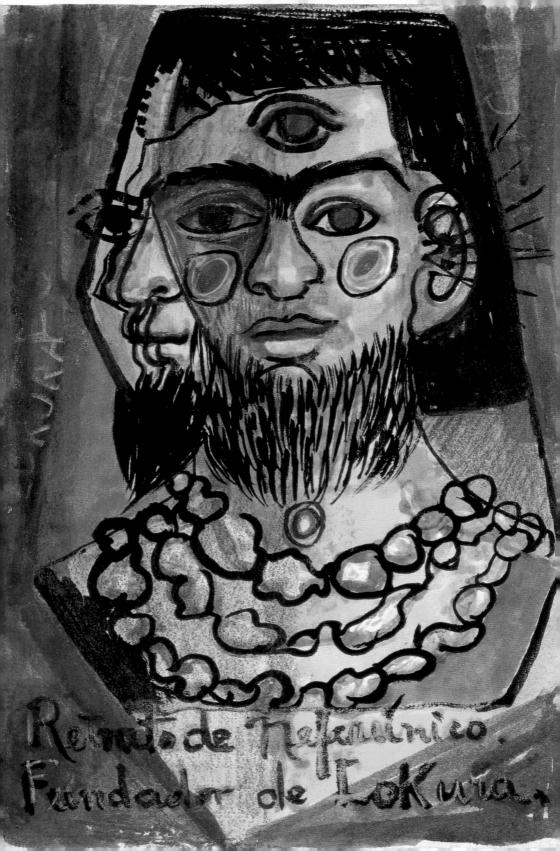

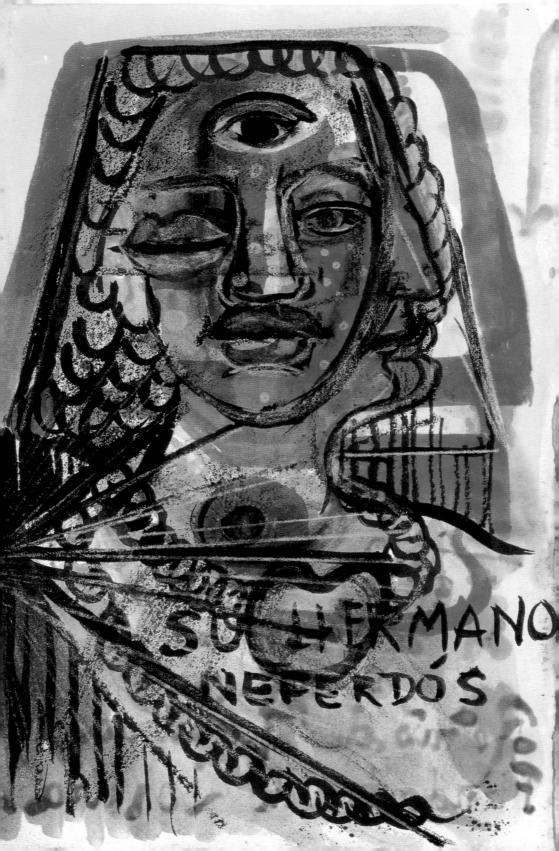

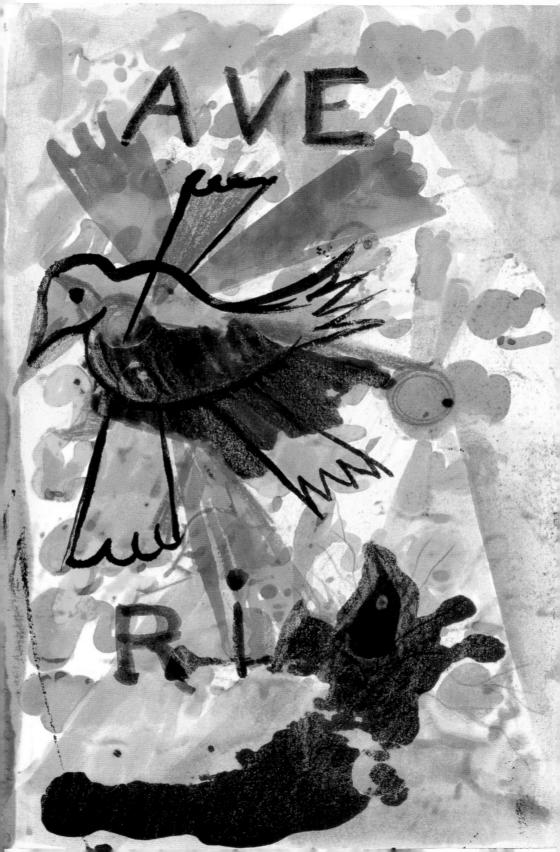

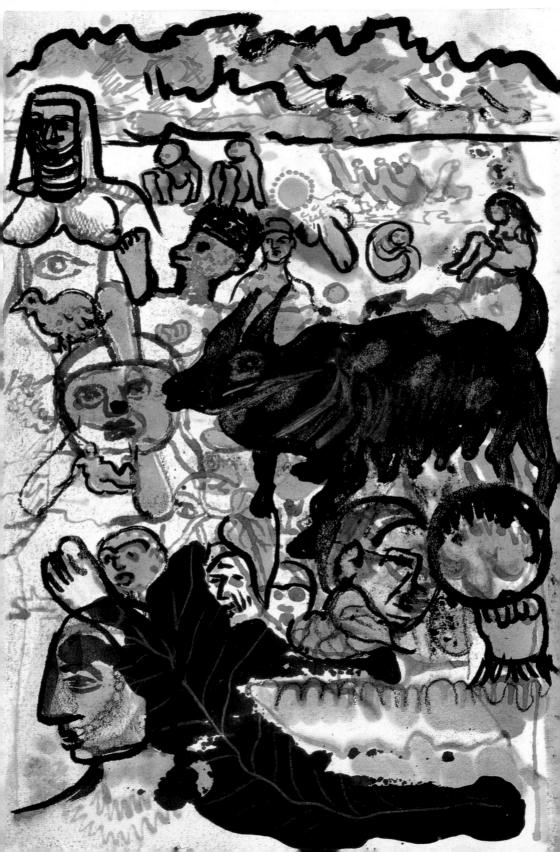

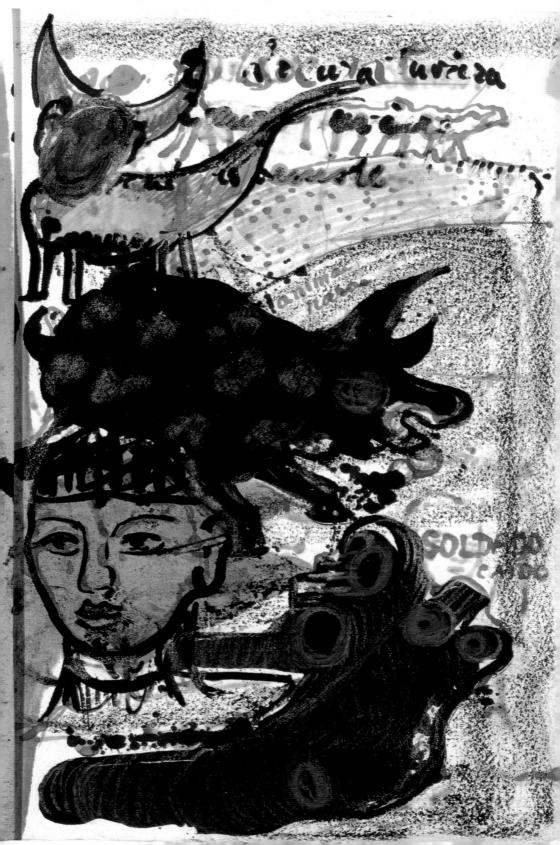

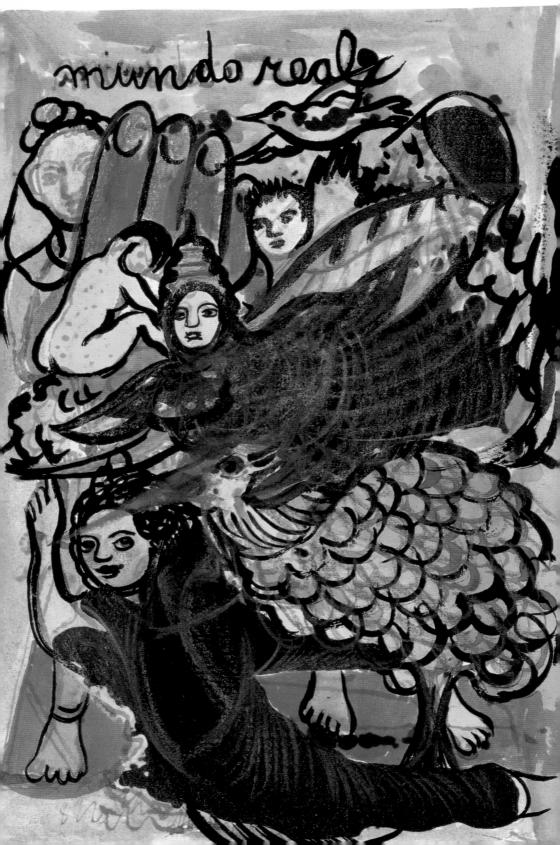

danza al

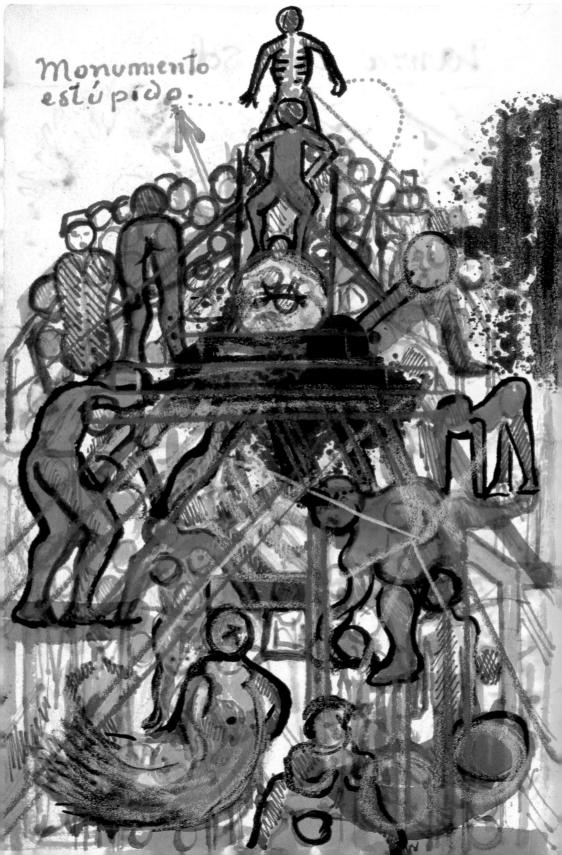

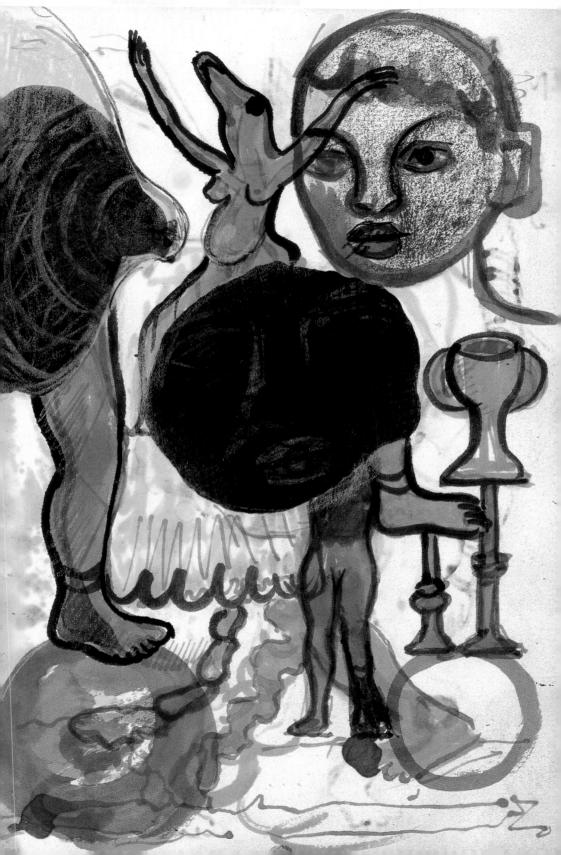

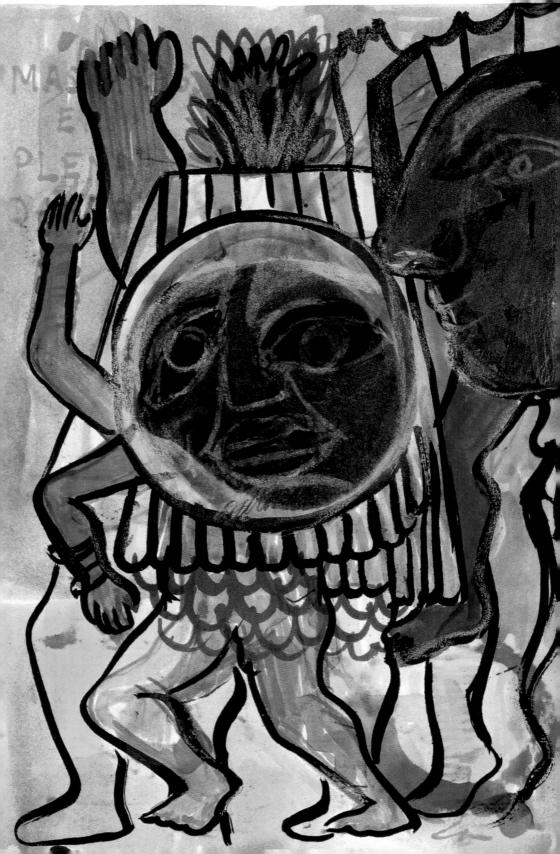

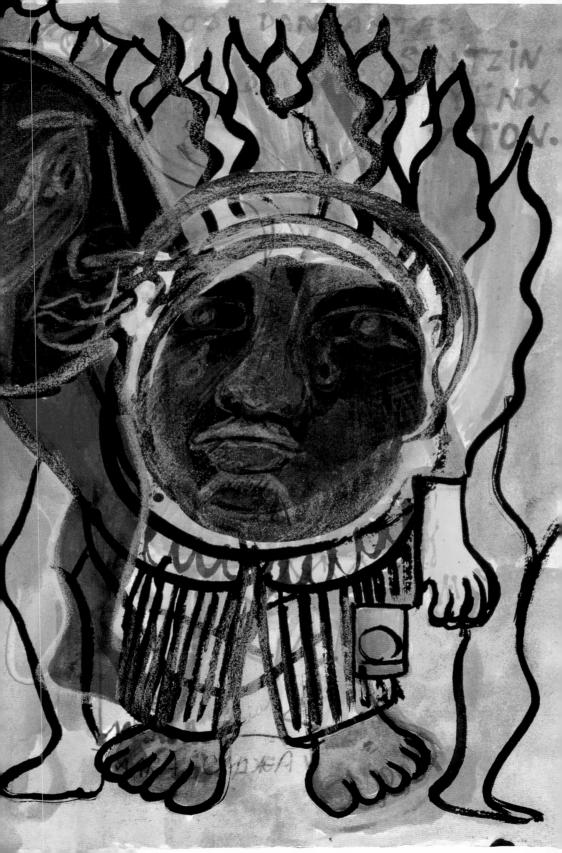

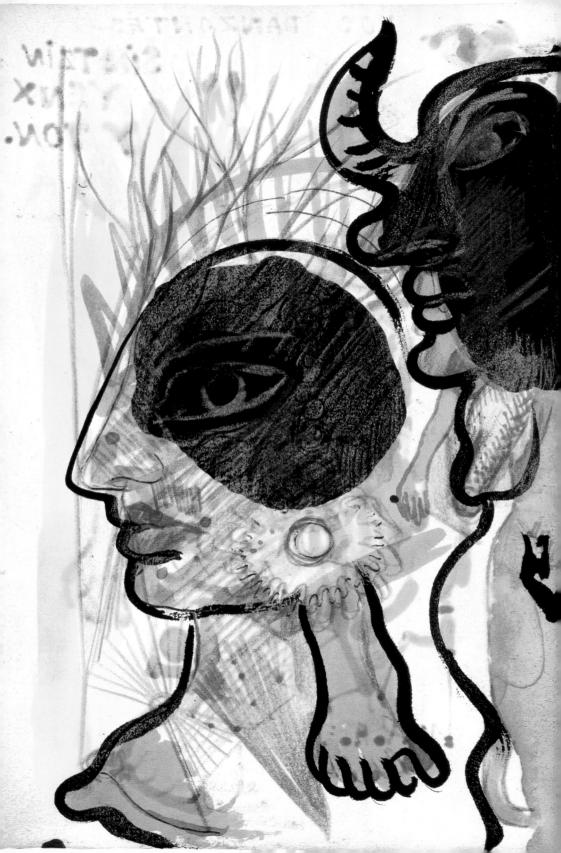

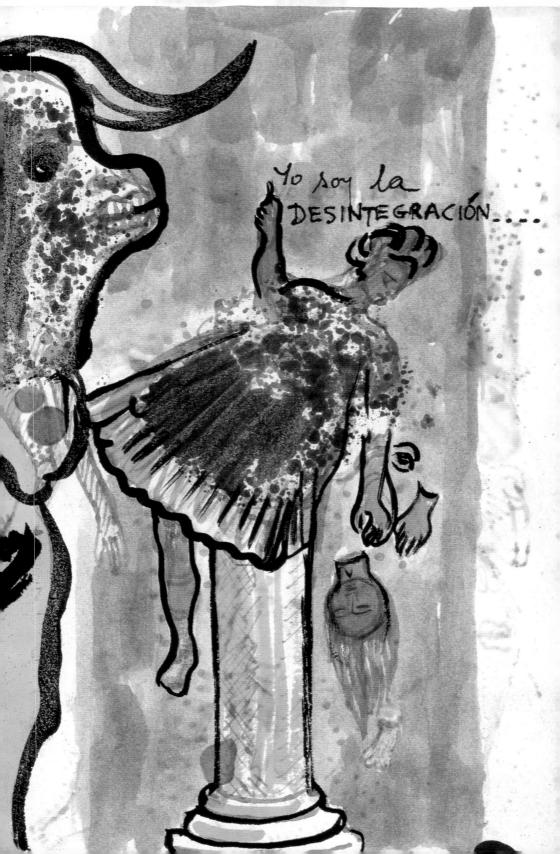

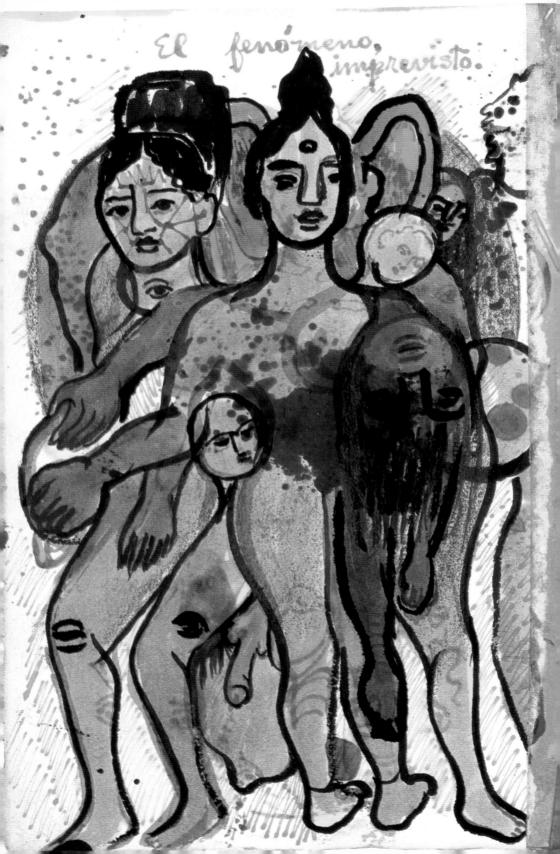

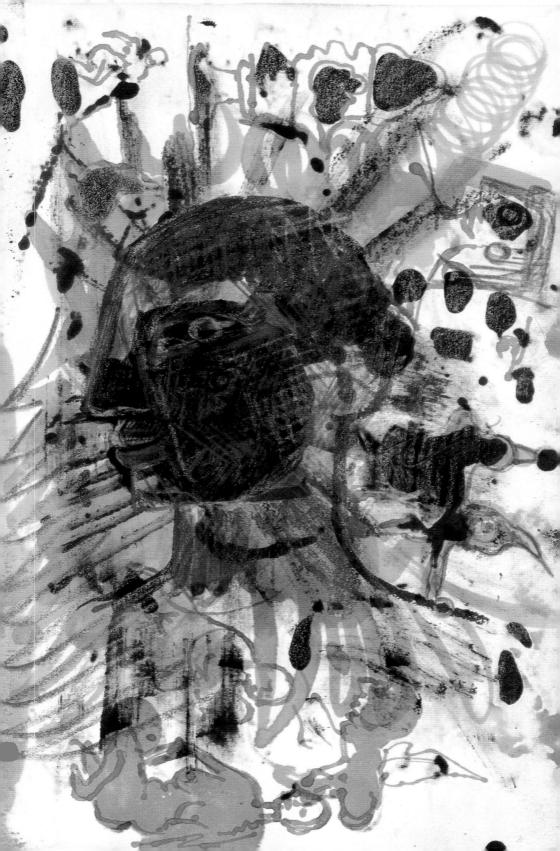

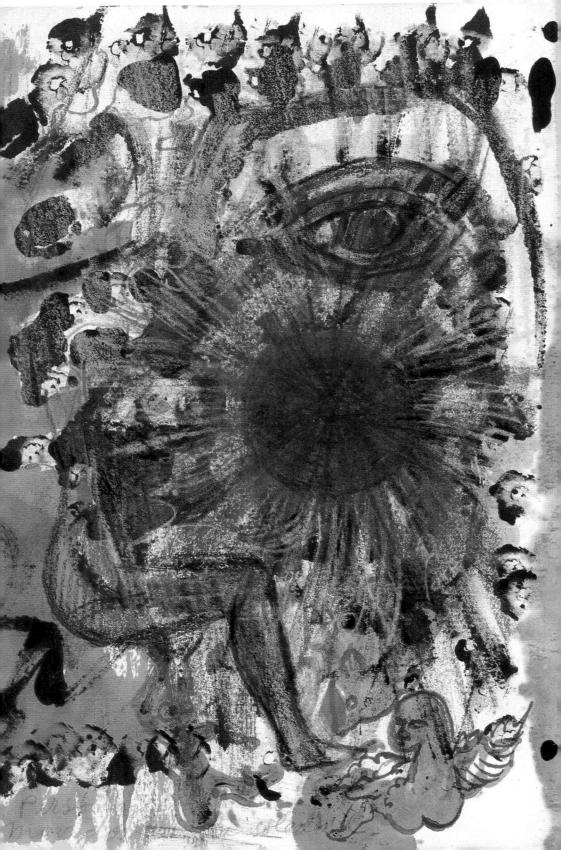

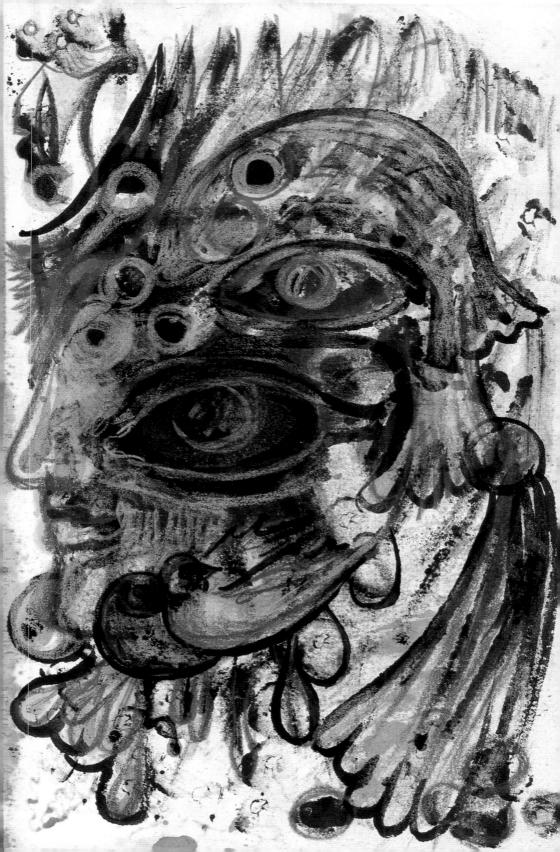

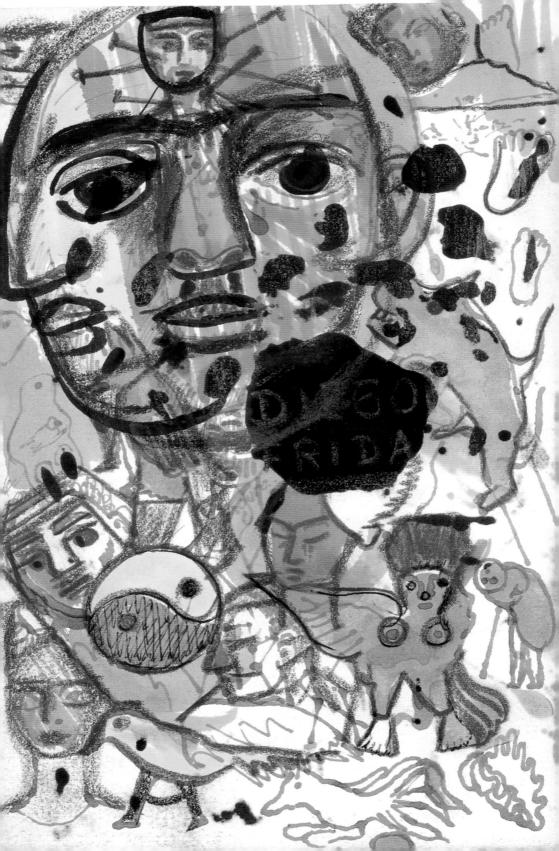

i Junen deres pue las manchas viven y ayudan a vivrs? I unta, sangre, olor no se jue tinta uspra, que quere dijas su miella ental forma Reseto ka unstancia y har cuantes puelle for huis de mucho ententados. Lierra libre y mia. Soles lejanos que me lamas porque forms parte de su mieles. Fonteries. & Sue hariayo Sin lo absurdo y lo fugar? 1953 en siendo ya hace mucho are la d'alietra materialista.

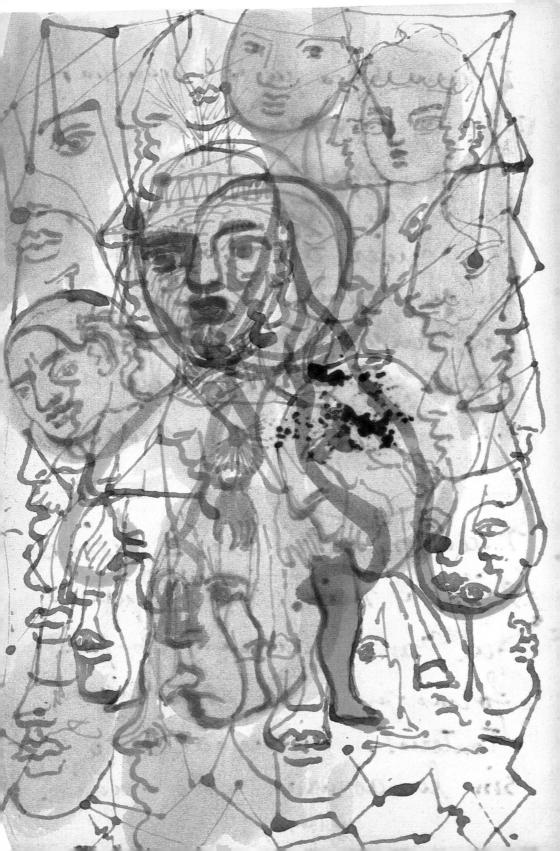

ue se padir as assina che su orda eldera move a nadie

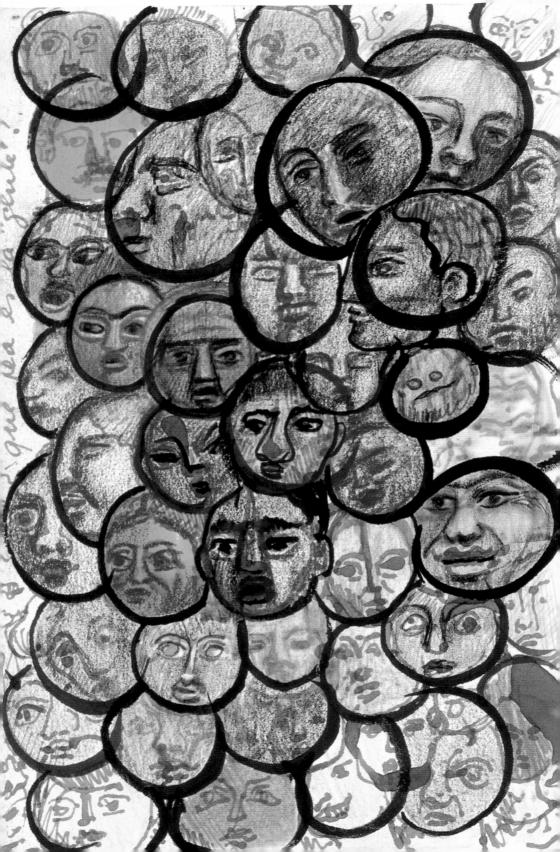

Septiembre de noche. Aqua deste el cielo hermedad de Tro Ondaz en tus manos materia en mis of o. calina, violencia de ses. de uno, que son dos, sus querer aislance. lanta lago - ave rosa de Cuatro vientos. Sanga pro arina, sol canto bero ruina. la crimas hermanas, hara Bomprensia. Asi sera vida. Vaso - magla mar. Deloware y manhattan Norte valle sueno luz canto oro Sueno nino seda des canto naso. resa. Todo es el ella. elles. 40 . somos line luce una sola ya (STALIM (1953) MALENHON SE free 4 Sept or

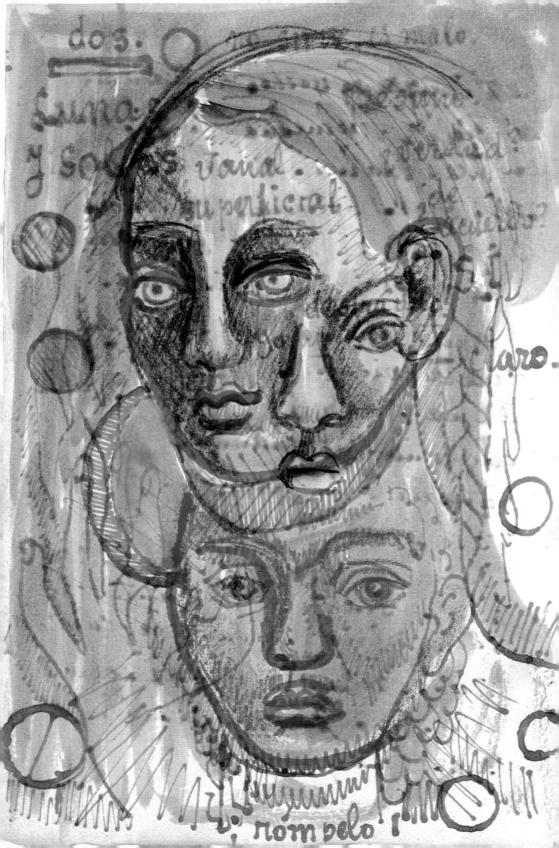

le la intendes Todo. La union bias besa ries. Hacuns para mismo . Cuerer desque y aniar lo descabirto delle Ca el dolor de Silvapre perdedo. Eres bello. In belleza yo to la doy. Suave en tu envirene très legar Amargura surgle. Arma Contre to do lo pue no te lebra. Kebelion en todo lo pue te encadena. 14 arras. Juiereme como centro, yo como a Gi. no lograre was for un recierdo prodigioso de que Jue pasaste por mi bita dejanos goyas que no recojeré sino Cuanos te hayas ido . No hay acariciame con to lo que buoças y con la Como toda la Concum mirade

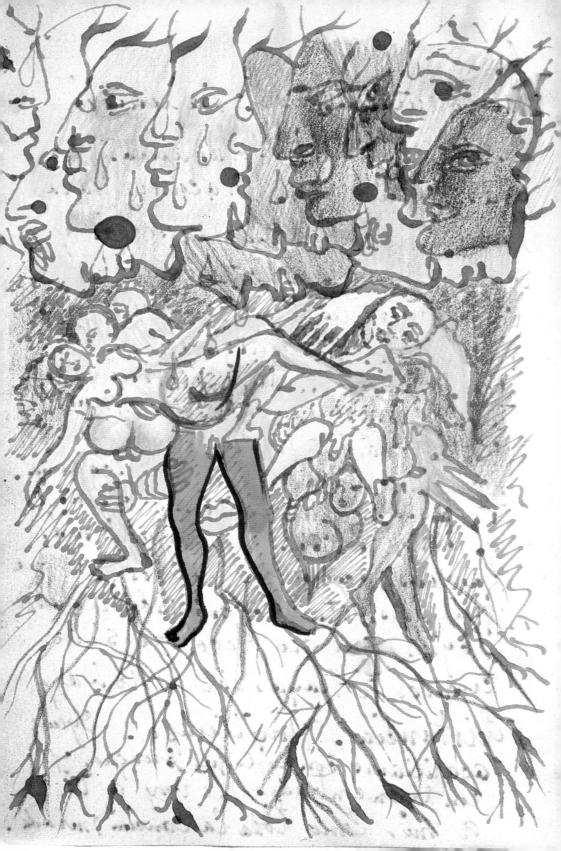

Hoy microned 22 de Louiso 1947 The naw linewes - 40 to ciclo! Tri, la fimadie: la nesiere la voice - and quit mine in madre y rents and to entress mi mural you wanted one considers of the must reverse so the til a given armo hoy. = te asur con todos los axiones te dare el bosque de l'aparente de l'aparente l'aparent mi construcción, la vivias Contente - 40 quero que tre veras contento. Arenque yo te de surgre ven Solected abserved y la mono - tonia de tora mua complejari ma diversidat de amores. E los principiis y tri anna te after madre.

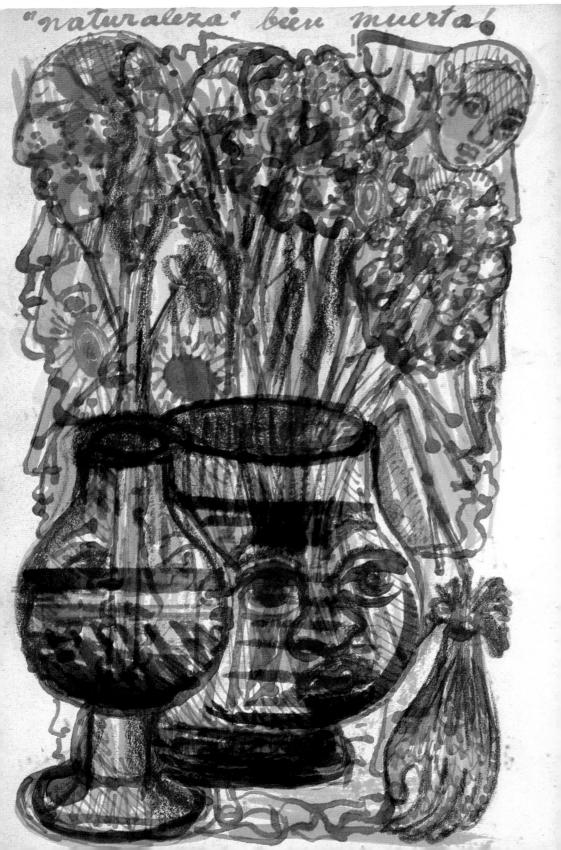

nadie Salvia jamas como punes.

6 Diego: 100 punes pue mada la hiera o que hada la molest of la puite energia pur el secont Vivi Como a el se le de la juna Pintal, ver. auxa, comes, doruns, sen taise solo, senterse a compa-na de pero numera qui su na que extensera triste. do 40 terier Falero. Jusiero darsela toda. tora, la portre tomas. no soy solomente tou -madre

soy el embrios, el. princes, la princes ce Cula pri = en poten cia : la engendro Soy il dod das mas primitivas ... ry las mas anteguas Celulas, pour con el "hempo" se volmen el Manual Man 2 Maria 2 Ma Maybelland Mark 1987 W. Monday Million Million Shine

MANDENNI . - MANDEUMINEUM DEMANDE AND STREET PROGRAMMENTED When the manufacture of the second second second = Sentidon = afortunadanserte las alabras se fuero has-cuento. Lucio les dis la resead absoluta? note hay absolute. Todo & Cambre, toll Se muere, todo reisluciona - todo vuelac y vego. industions in the Millions.

Tre go principio Que Constructor me mine Diego. Doces - my morro Prego - me coin ante Pacco - "my caposo." Pier - mo graige. mi madre pego -· pri pagre. 10 hope 1000 5 3 11 DIE = /0 > Universe. Diviersidad en la Unidad.

Muca fru, ni sera mio. Es de el mismo. Cotriendo a Fodo dar

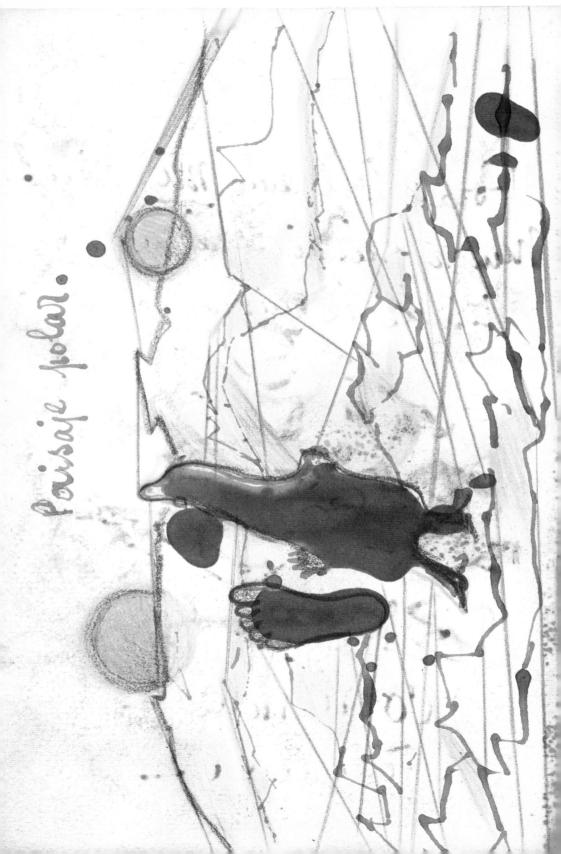

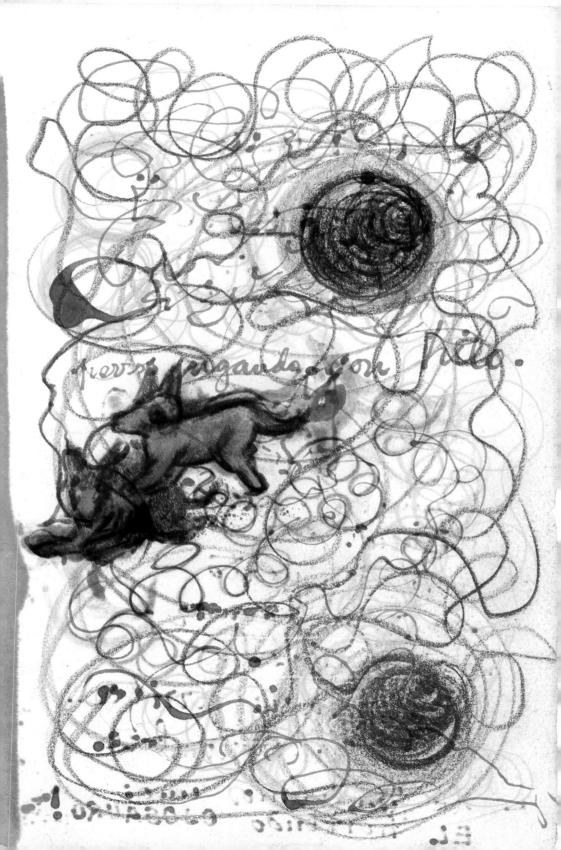

El horrendo Ojosaylo Animal Currents

St que do muerto Joan Incadenser las Crencias. Thura hacia arriber. y no tune nombre. El horrendo Ososauro.

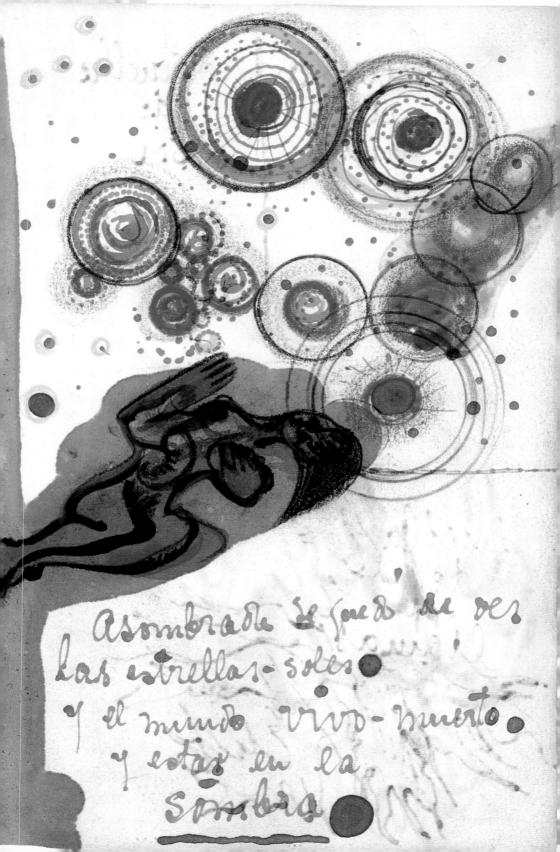

huella.

El clas sin (Lehas)

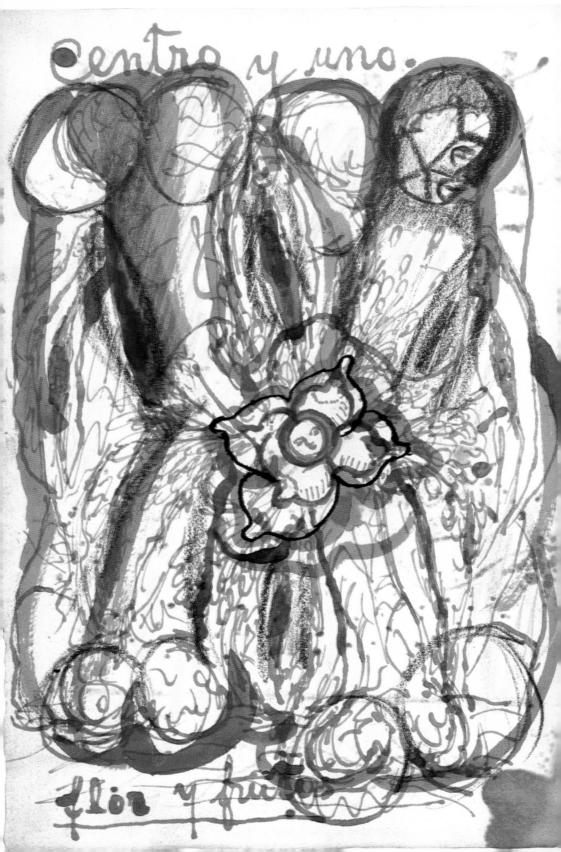

nada vale mas que la risa molndenpreción. Es querza vir. y abandonarse. Ser termelinge. ligero. La tragedia es lo mas ridiculo que tiene "el hombre" pero estoy segura, de que los animales, annque sufreu, no exiben su joena en teatros" <u>abiertos</u>, ni "cerrados" (los "hogares"). I su dolor es mas cierto que cualquier magen que pueda cada hombre representar automa a semin como dolorosa.

ra villa ARBOL ed SOLQ TIO voy age Tame n'one.... gota, Osota, mota. MIRTO, SEXO, FOLO, LLAVE, SUAVE, BROTA LICOR mano dura AMOR silla firme GRACIA VIVA Dom WIVA PLENO LLENA

profess.

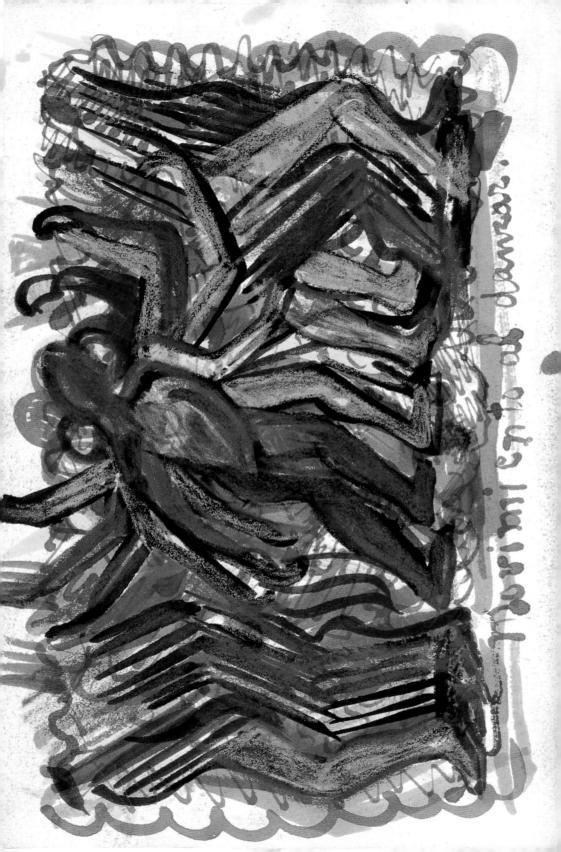

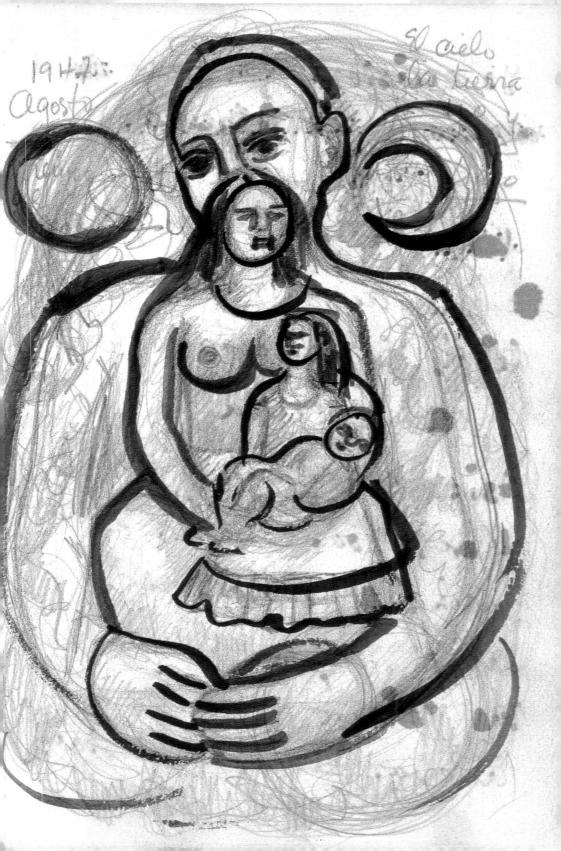

yo guessiera pun pung som LANGERSON = MANNENS MA Million - June haves le que e me de la sanode vais de la cortuis de "la focura Azi: arreglaria las flores, todo el dia, pintaria, el doloro el arnor y la Fermira, me perria a mis anchas de la estupider

de los otros y Todos derian: (30 bre 1000 mil reines de un estupos, Eonstruires mi mundo que muntras vinera, estars = de acuero = con todio la min dos Elder, o la hora o 22.

Ministe, que viviera.

Acrea mio y de Tolding the State of the state of the Me lacusa, no seria en escape al Trabajo -

para jue mie mantuoieran los Tro, con su labor? WARRING ON THE WARRING WARRING HAMILE SHEET ALKANIMING THE MENTILE WHEN THE PARTY OF T ANTHOROGOPHAN MONTHANION SASSER WASSERS DESCRIBERATION OF THE PARTY O White was the second of the se MINEMANNAMENT BY SOUTHWINDING Management Ministration Alle HOWEN MANNEN MANNEN

MANNAMON . La revolución de la formany del color. y Hodo; esta, y se mueve, baja lessa nadu estracto de nadumadie lucha por Si monsmod 111) Todo es Fodo y serve La angustiany

el dolor . el Places no to mar que un processo foaras Existes: Manna La lucha revolucionaria, en este processe es una puento abrista a la pertalossis on

Churcisans de la Revolución Fde novembre de 1947) Molde la Esperanza mantente livie la 190 te esperare - to Respondente à lu sentedo Con ta vog of estoy bleica de til leperano. pur lle gried that fulation of me haran crecery me lurificeran -

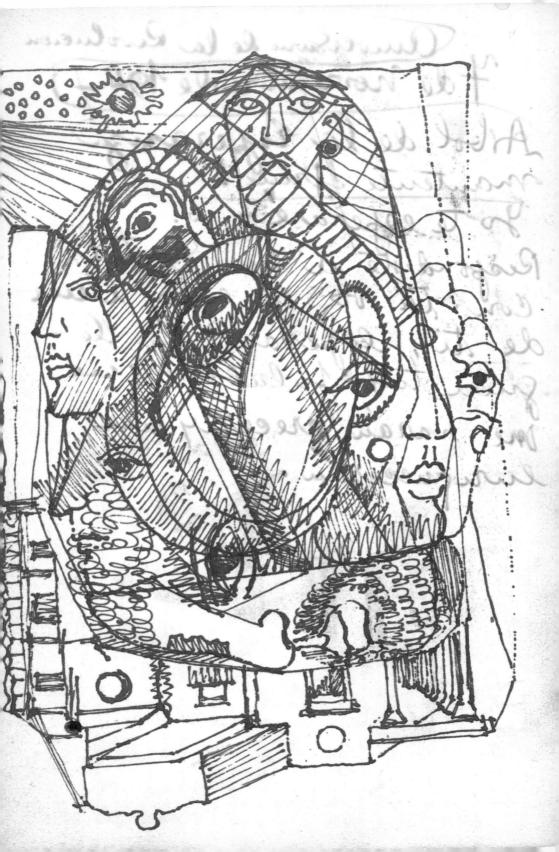

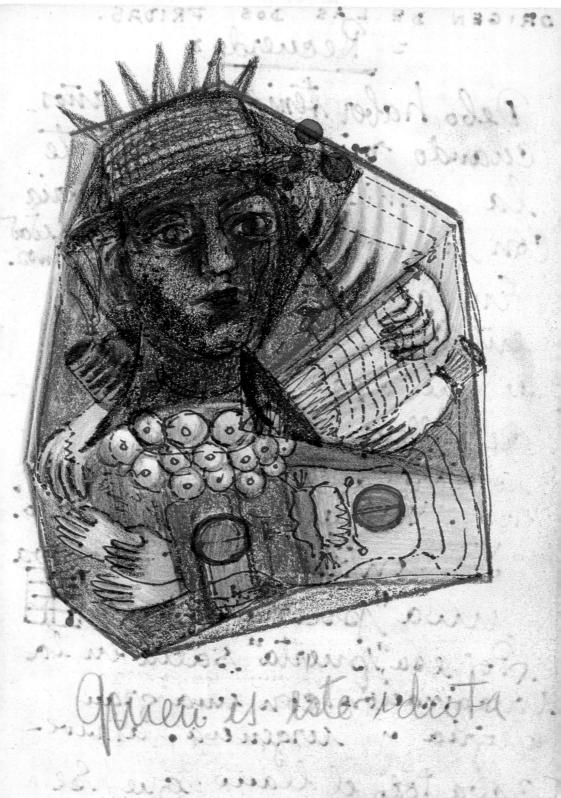

San De Carlotte Contraction de la contraction de

= Resuerdaz Debo haber tenido sais años Cuando vive intensamente La amistare. Umaginaria Con priva niva. de mi misma todos En la bidriera del mocent entonces era mi crearto, y que daba a la calle de Allende, sobre une de los primeros de la Velidarode. Husbur lecharber Abaho. The Son shodeder dibougaba grupa puerta sierta. maginación continua gran alegria y resgenera atrave-Zavatolo el leacto ne pe hosta misaba hasta llegar

de presidente le cherra que se Mariaba PINZON... Por la @ de PINZON entraba, y bajaba al interior de la therra, donde Wie amiga umagenaria " me Esperada Siempre. No re-Everdo Ste knoeger mi ste Color. Hero si se que era alegre & Se reia mucho. Sam Samaos. tena agel. of Cailaba Como Si mo Muvilsa pesonamqua. 20. La segura les todos sus movimientos y le contaba, mentras ella bailaba; mis problèmas secretos alla-

Salva por mis vos todannus cosas la cuado ya regre-sabasa la restentana estituaba por la misma puenta dutu jada en el cristal. ¿ Estando? I troy created tempo hatia totado Concella.? Mose . Piudo Ser un segundo o miles de ornon... Jo era felir Desdibujaba da puerta con la mons y desapareria Corrit con me secreto y mi alegria masta et tiltimo rincon del patio de mi lasa; Sreamste eler el mismo-lugær, delogo de sun orbol de cedron gritaba Me.

je sell Decurido tom vivoide. Hours pasado 34 anos tesde que vin esaidmistado magicaly casquever die la reciperdo se severaren se arrequeta motro yonas dentro do. le hu mindo fria. PH17 N1950 Trida Kahlu LAS! PINTON. DAS

no serve esta bluma para este papel. runda he visto Vernusa de grande que la crue Diego de - cuelony to report source Sud / escultural del Missionindio.

nadie et mas que un funcionamiento o parte de una función total. La vida pasa; y da caminos, que no se récorren vancamente. Pero nadre puede deterrerse "libremente" as jugar en el sendero, porque retrasa o transforma el viaje atomico y general; De de alli la desesperanza y la trestegn & Todos qui Sieramor son Kan James 4 no il estimato número. Los cambros y, la N lucha itos de consus tuos no aterian for county

tes y por ciertos, bus camos la Calma of la "par" horque nos anticipamos a la muerte que mortinos Cada segundo. Los opuesto se unew y nada nuevo ni avitmico des cubrimos. nos, quarecemos, nos alamos, en la viracional, en lo magier, en lo anormal, por medo à la extraordinaria belleza de lo cierto,

de la material y dialectico, de Co Sano y frærte -nos grusta ser enfer mos para protejernos. elguen algo - mos Protege siempre de la Verdad huestra propia ignorancia y nuestro miedo. Miedo a Fodo - miedo a Saber que no somos vectores que dirección construcción y destrucción para ser vivos, y

senter la angustia de esperar al minuto si quiente et partici-par en la corrienti Complija de no Salver que mos di-rigimos a mosotros Musmos, a traver de mullones de seres piedras-de sers ave-de seres astros-de seres microbin- de Seres fuentes a

nosotros mesmos variedad del pero. Mapaledar de leca par al dos - al tres para regresar al juno. Pero no a la suma Chamaga a vecis disa reces libertal a veces anier- no - Somos odio-and - madre hyo- planta tierraluz-rayo- ete-de Sempre- mundo dador de mundos — universos I color universis yan!

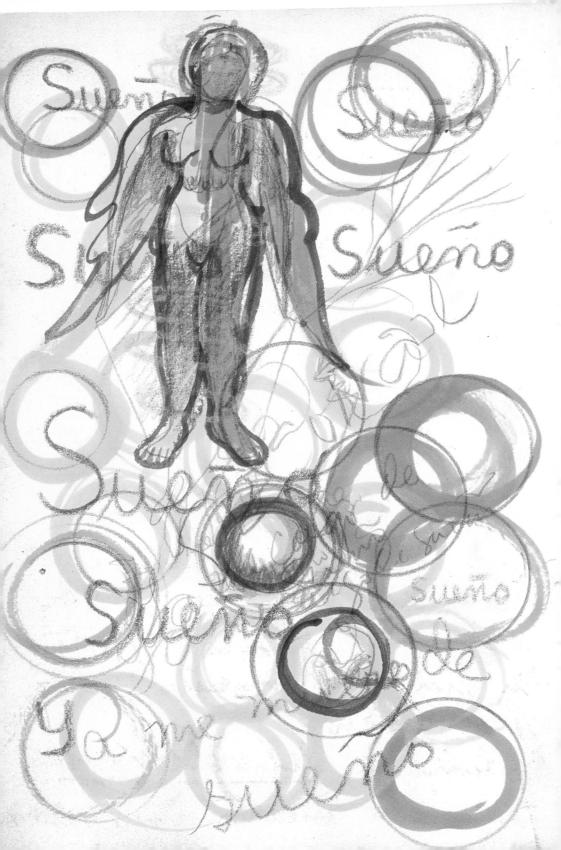

1ª Conviccion de que no estay de acuerdo con la contrarevolución - Imperiales mo-taxismo-religione. - Estu-pidez-capitalismo - y Food la gama de trucos de Pla Burque. gra - Heses De cooperar de la Revolución para la transforma ción del mundo en uno sin mejor para llegar de un ritano 20 momento ofortuno para Darificar e les aliabos de la Leer a Levin - Stales Aprender que yo no soy. sino una joinete parte de un movimiento revo-lucionareo. Siempre revolucionario runca murto, muca initil

1910-1953 En Foda mu vidu he tendo 22 Operació nes-quirurgieas-El'DY Quanto Farel a gruen considera un vertadero hombre de chercia y además mi ser hersoco pot que la pa-Tanto a los enfermos sur Jod un Enformo tambien para asimpuls Typodomieliti 1926 marchandeaste en cums

1950-51. He estado enjerma un ans. Siete operaciones en la columna vertebral. El Doctor Farill me Salvo. Me volois a da? alegria de vivis. Toda-via estoy en la silla de Junedas, y no se si pronto volvere a andal. Tenço el corset de geso que or plan de ser una lata pavorosa, me aguda a sentirme mejor de la spua. lo Tengo dolores. Solamente une Comsances de la. les ua oh, y como es natural muchas veres deserpe-

ración. Una desespe. ración que nungues palabra puede descri bis. Surembargo Tenjo ganas de vivis. Ja Cornencé « pintar. El cuadrito que voy a le-galarle al Di Farill y que estoy hacrend con todo mi carries pa ra el. Tengo mucha inquietus lu elasmito de mi jointura. Jobre todo por transfor marla Jara sue sea also util al movimien

to revolucionario comesista, pues hasta ahora no he puitade sins la expresion honrada de nu mema, per o alej ada absolutamente de la pue mi printera pueda servir al parties. Debo luchas con todas mis fuerzas para que la roca de positivo, sue mi Salud ane deje haver tea en dinección a ayudas a la resohueron. ha missa. Kazon kent para vivir.

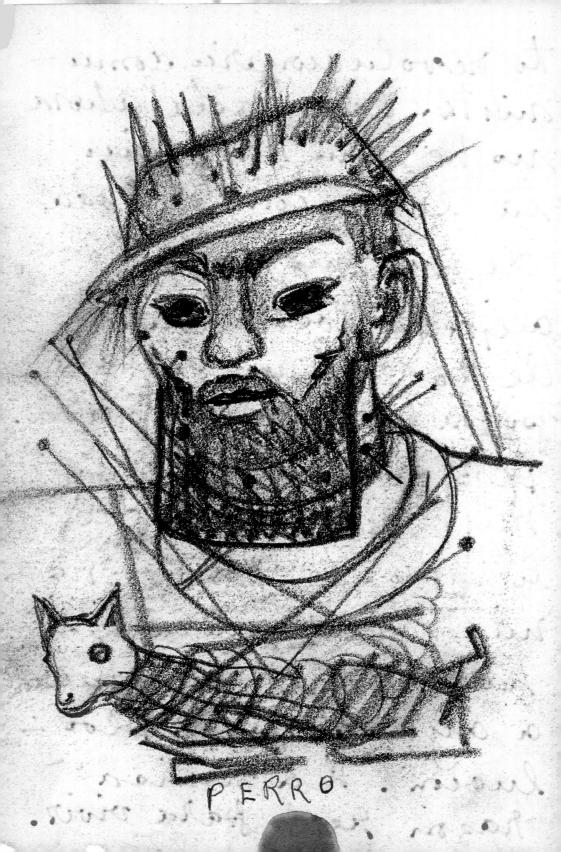

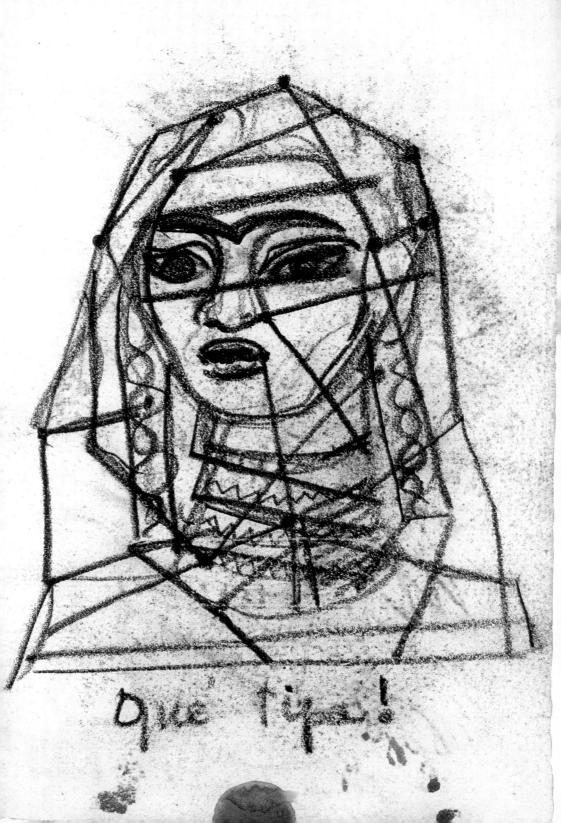

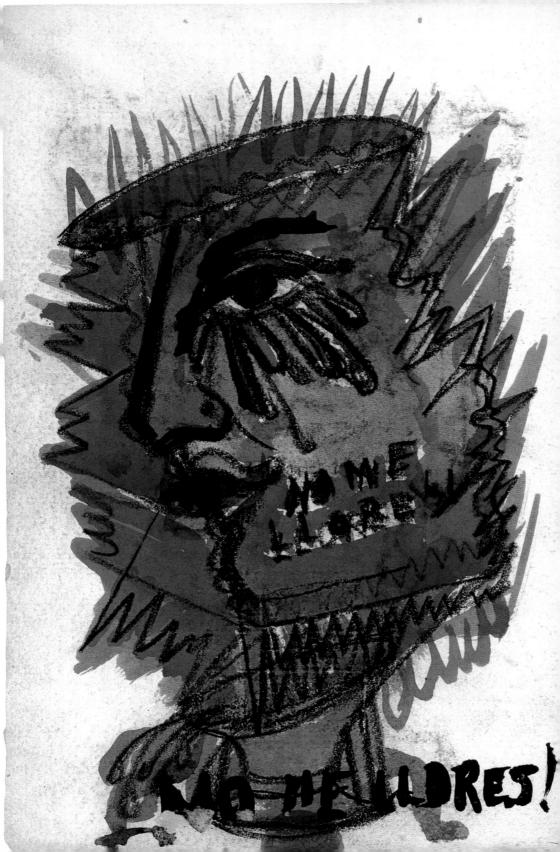

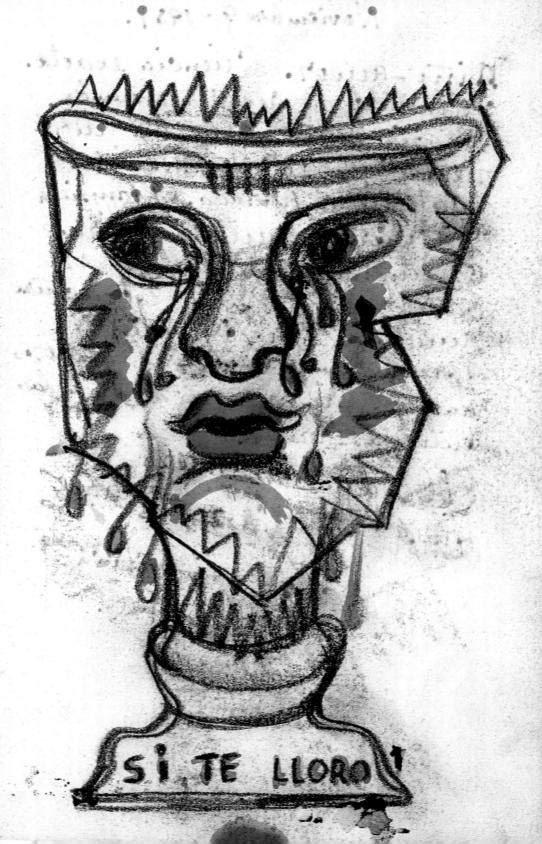

Noviembre 9 - 1959. Mirio-amor. Cuencia exacta. voluntant de resister viviends. alegria Sana. Gratitud enfivita. 0700 en llas manss 4 X tacto en la mirada. L'empieza y termera frutal. Enorme Columna wertebral que es base para todo la estructura Rumana. Ya veremo, 4a aprenderemes. Siempere hay cores mevas. Tempre ligadas a las Allado - mi Diego mi Sadza grenaisa. DEGU

1952 Novienbrett Hoy como nunca este compaj Wada: (Saus) Soy Jun Der you commiste sé I seldo distribunado mento Haden opaiges antquite the leide las Historia de mis pais y de cantodos los puebles. Comozer lemonicon Comprend de valuate Reproduction en Production de Alarkyte ngelty Soning Stalie guilla telabiga den or como a horafilous buly nuive mund Commenter Du Company entrode Trotato des es qui llego on Messis. To James fra Troble ma Berfaren gera le joste 300 y or splanente aliade torrestpolitensente haying us toman saar menseta que asture older proper any coleres out of realizations de la regal de la constante de the pay vida he semidale Dai de Sport Date from mentet allibedes por Almoso en Astonica Detapular clarific Energy Carpetal for Har Acrobion Porting castles algulton a vivi Phitomedhianinton The ho She declar st so

antenantia production denlepptelemal collede myt vaidurento revolucionarios

Pargrimonetares en mi Robup to expense segue in merida rela piatata sina thought devery welling la Liver of the Back of Stranger of the Back Robbids Replander times
1504 5 clarester times
lighterer des to the formation of the format

Cot - Chenos - checo-eslo veak whitemedite ass lesta figado a mu sangu Lindigerlande Heppertides Entrefrances mustides aniation traised are yests de statished for entry denogalamon of the sicator. modreda astronic population Coloro maty transpire des reducto destablisher son Restan lellerand Boto lay money Shor, tar hermon y Par vallentes. (mexica To A negro estantos sopregados Pot haige capitalesta Embred en Emi vælgn Elaparyens grante of treflecoundratus maray Dillo gazineros encuentros Eloma Washier Corners Theresup Prolipsed Tha To use the withing the dali sud free mileutar Mara president otros chististas

Peal menter asymbological

de britishers surgestingen Sensibili Dera potentiro del alemas quentes today kan Bolaloomator & Territable Salut mejore 15 de goury

de sesar de mi larga. extravadad telegorista

librio con da falta (la ida) Jo Bremane = OLLISE COMBERNA Marchael Marchael Lowe no hartwarten National Section

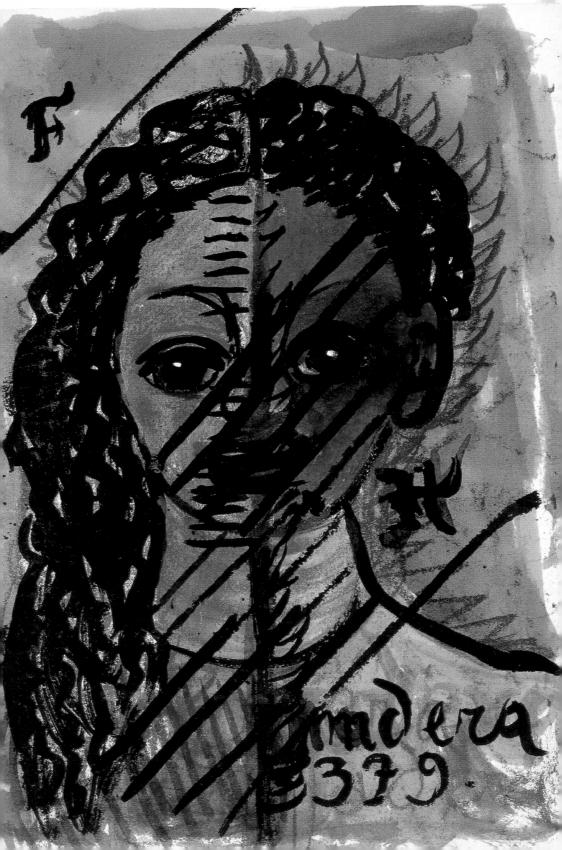

Camunant Bailarma Sama III Recolucioner. The Market VIVA STALIN WIVA DIEGO

MARZOSS Mi Diega. /a no estoy Recompa MAS. TO ME DUER MES YNEAVIVAS

ENG

LUNA

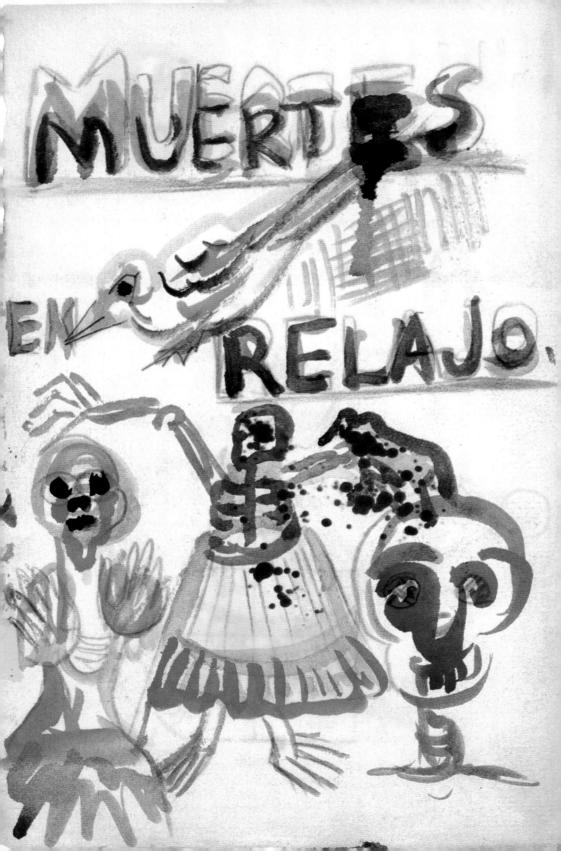

MADERA CITLALI AMOR CALOR* DOLGR RUMOR DADUR AMOREINE

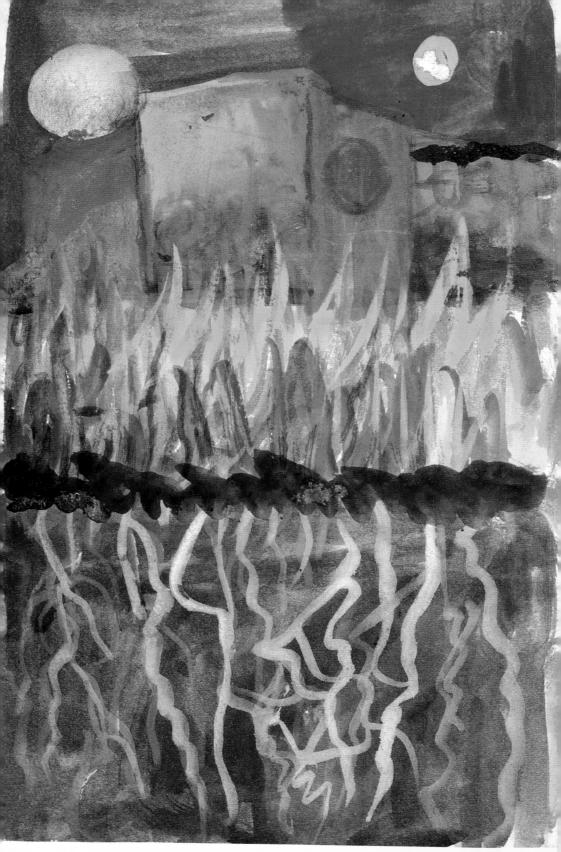

rabela Villaseron 11/10 Ele Theren Colorado

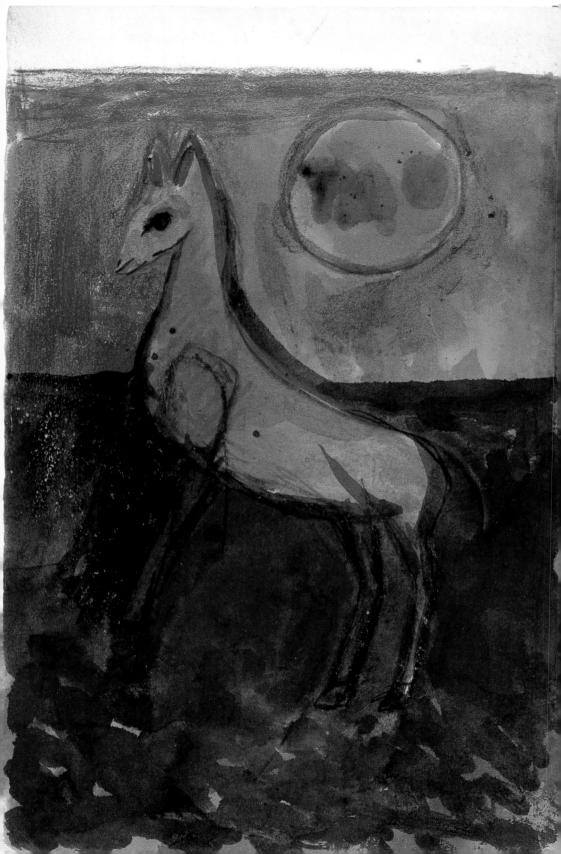

Viernes 13 de Marzo. 1953. 10 mos fruste, Chabela Villasend. Colorado Pero ty voz Tu electricidar tu talento enorme Colora do An poesia Como la sougre tulus que corre du cuardo matan In muterio a un Venado. In Olinka TOOR tu te quedas viva.

ISABEL HILLASENOR

SIEMPREVIVA! PINTORA POETA Seccion de ORO

PARA LA ANTIGUA OCULTADORA FISITA. I emple 4 volumenes iznales de llema de meso accide de linga vendo Roma Chesili : especia : acpara : acpar goma damor disuelta en agnaties y agna destilada. con deinfedante tomo: al deidico concentrado. /2 grano para un litro de agras. danson hilme non-agnamas I durante 8 limpion la 10 di as. Olema di la la Clara mung his. - Muelance con la ensulvier la com hire devea textura billante, aunity escument de domar, harta do Pi re derea enteramente mete anno tre el a qua hasta tres volimenes.

El Señor Xolott EMBAJADOR Describbles de la Republica Universal e ancillos Pleni poten-Ciario Aqui. How do you do mr Xolott. ?

June 1953, Indiamo Burnoz Kolko Me parice que es una gran artis. Fattrajes as mirablemente la 700 lidad (no es Comunista). Cue dadana horkamere lana - Judie Hingara: Dice rue estapol.

ROTAS

Mino mio. de la gran O cuetadora Don las seis de la mariana & 4 los quajolites cantan, E Calor de humana tornura Soledad a compartada_ 1 Damas, en toda la viola . E Olvidare strupresencia. 3 me acogiste destroyada & En esta tresas pequena tierra donde pondre la moiader? Tan in mensa lan Gratunda a sur hay hay hay hay hay very ya Solo realidado Lo que que, sur para sungré lo Ro que es son des rances pourantes que art la language dans la color so Creciendo don la Reguia/de &

Momba de Diego - Tronbre de amora no cleje que le te sed al.

arbol que tant to amo .

Par atisoro son semila .

par atisoro son semila .

a las seis abla hoan ana 8 de .

Prida 1938 edas 28 ang No defes que le de sed al arbol you del que eres sol, que atesoró ta semilla Es Diego" nombre de amos.

Dato que medio Diego Dieso vivio den Pares: 26 Rue du Départ, à ceté 21 de Mazzo, Primavera Tao. (6) MAO of Se Julio. Satga 1953 8 de Biciembre AMOR. Acabara el años de 1953 Ton una guerra interimperialista ? Lo mas proba-NOMBRE DE AGUA

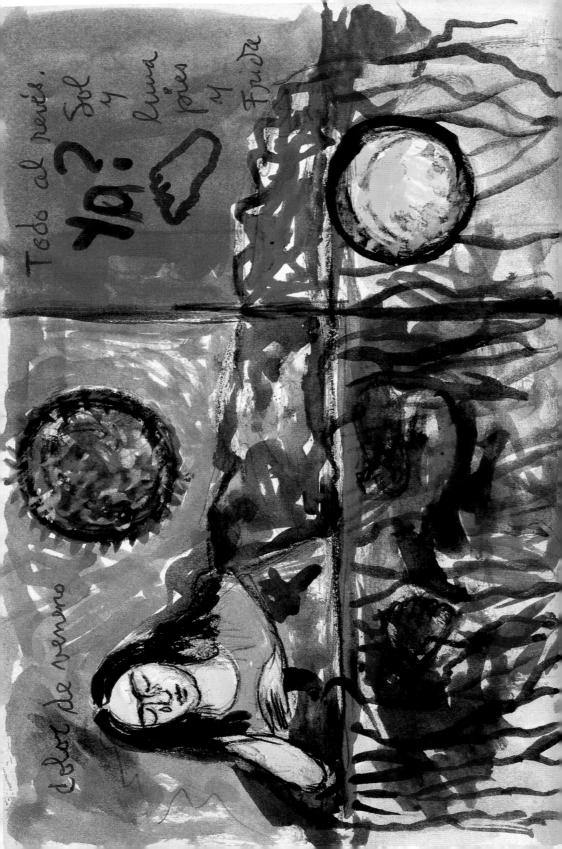

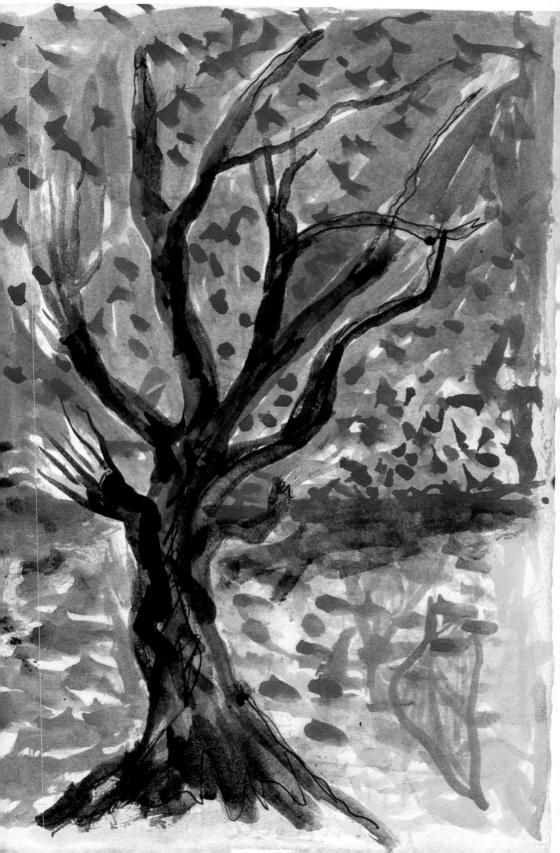

Many Company La vida callada... dadora de mundos. O Venados heridos M Rojas de Thantama Rayos, Admass, Soles La nina Mariana frutos ya muy vovos. 2 la murte se aleja lineas, formas nidos. Las manos construyen los ojos abiertos les Dieger Sentidos lagrinas enteras todas son muy claras Cosmicas verdades que viven som puidos. Arbol de la Esperanza mantente firme.

Meses despues - Para II. Calladamente, la pena Mui de somente el dolo. el veneno a eumilado__ me fue dejands et and. Mundo extratio ya era el miso de Silencios criminales de alertas ojos ajenos equivocando de los males. obstavidad en el dia las NOCHES no vivia. Te estas matandit TE ESTAS MATANDO Claries What has a state of the Con el cuchi lla mentiones de suita que están vigilando! La culpa la

tuve yo? admito culpa grande tan grande como el dolos era una Salida enorme por donde pasé, mi amor. Salish muy Silenciosa Vestaba tun olvidadi! que esta era mi mejos sairte Te estas mataud! TE ESTAS MATANDO Hay Grienes ya no Te olvidan 1. acepté su mans fuerte Aqui estoy, paraque Vivan Frod.

Esperar con la augustia quardada, la columna grota, y la umensa mirada, Sm andar, en el vasto Sendero Mayeranson Branger movieude mi vida cereada de ocero The seems who by the Merger Moure Andrew HASSING ANTICE STATE OF THE STA

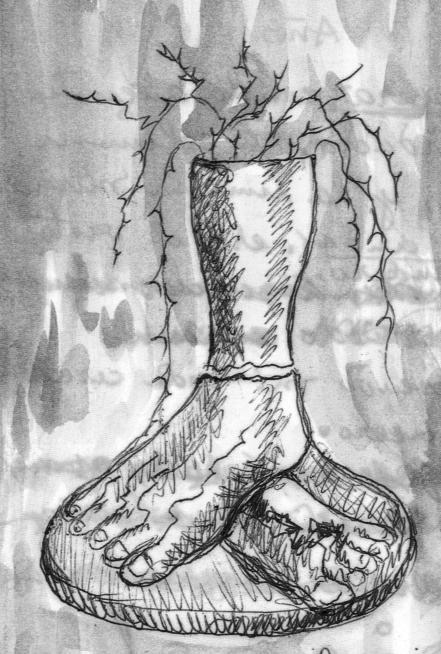

Pies para que los guero Si tengo alas pa' volar. 1953.

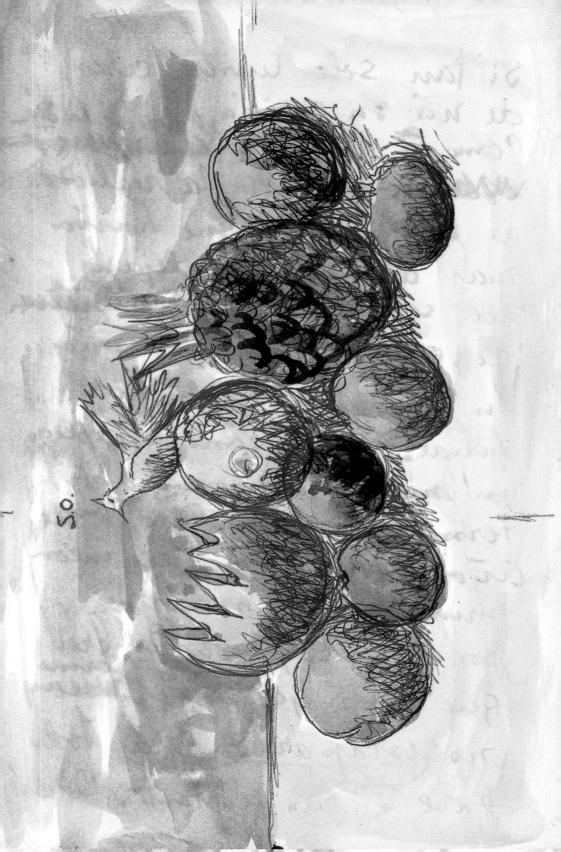

Si tan solo tuviera cerca de mi en caricia el aire se la di-Marian Mindowski la realidad de en persona, me haria mas alegre, me alejaria del sentido que me kommente. de gris. Nada ya seria en mi tan hondo tan final. Pero como le explico mi nice sida o enorme de termura! Mi soledat de arios. Mi estructura meon forme por inarmonica, gre es mejor suga, steray no escaparme. que todo pase en un instante « Ojala

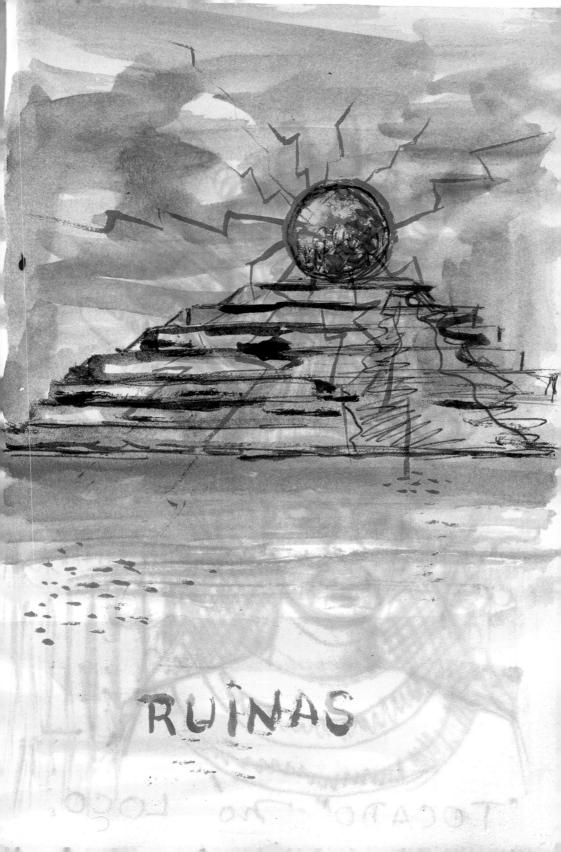

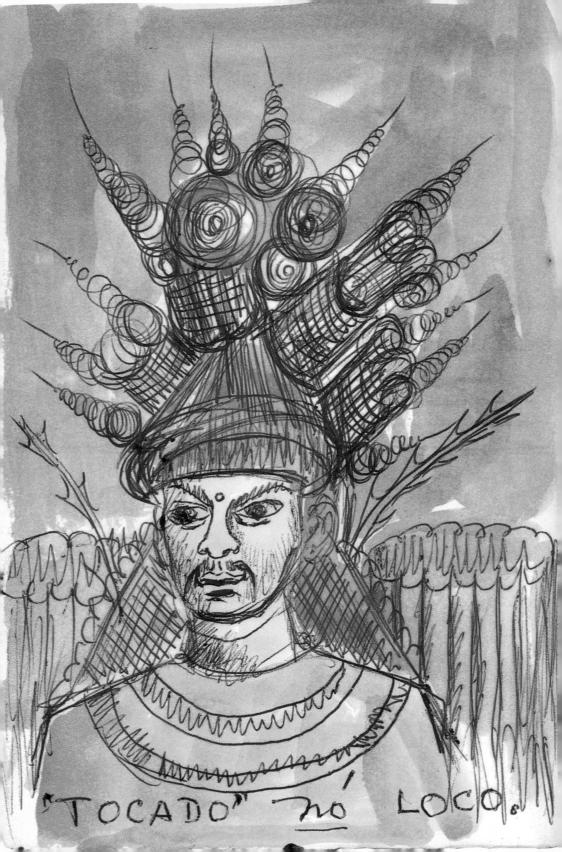

Puntos de apoyo. Cuernavaea. En mi ligura completa Solo hay uno; y quiero dos. Para tener yo los dos me trêner que cortar uno Es el uno que no tengo el que tengo que tener Para poder caminar el otro será ya muerto. A mi, las alæs me Sobran. que las costen.

HIERONYMUS BOSCH

MUNIO EN HERTOGEN BOSCH

AÑO 1516.

HIERONYMUS Aquen

aliai BOSCH.

Pintor maravilloso.

Quiza nació en Aachen.

me inquieta mucho que no se sepa casi nada de este hombre farstaistico de de genio. Casi un siglo de pries, (meno) virio el magnifico BREUGEL, EL magnifico BREUGEL, EL

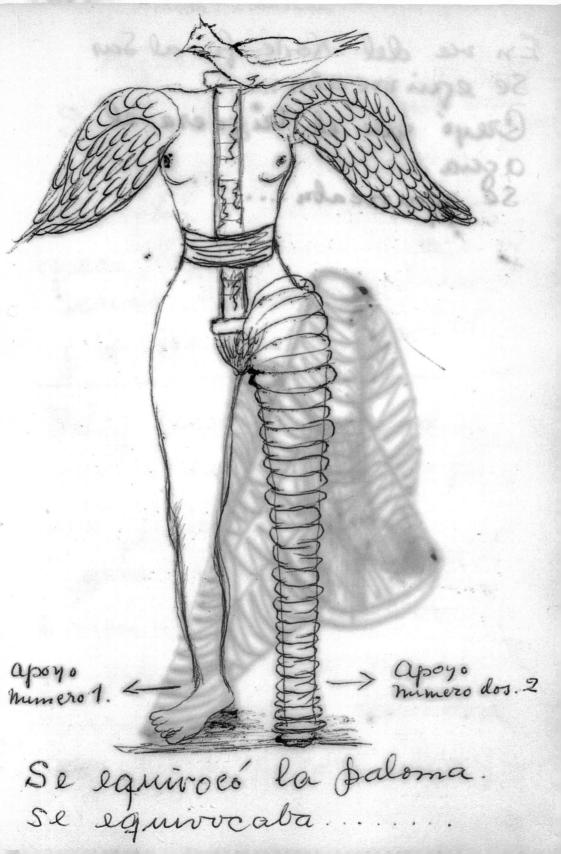

En vez del Norte fui al Sur Se equi voe aba... Creyó que el trigo era el agua. Se epiivoeaba...

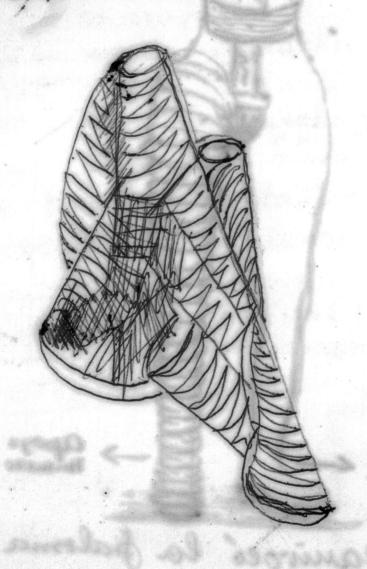

Agosto de 1953. Seguridad de que me van a amputar la pierna derecha. Detalles se poors
pero las opiniones son muy
serias De Luis Héndes. gel Dr Juan Farill. Estoy preocupada, mucho, pero a la ver siento que serà una liberación. Ojala y preda ya Caminand dar Todo para Hodo para Diego.

II de Febrero de 1954. O la parem Sign sur dona and in la mod sperare

Estamos yar en Margo Princevers 2.8. HE Logrado mucho. Saguridad at comme Segurida o al pintas. Amo a Diego mas que a mi jujis ma. Sido This volunt at peru ance. Arazias al aja o anogmitted de Diego.

Out tratajo don rado

de inteli sente dell'
familie Ol intent.

Tan honesto y carinoso,

out to Pamento in Paminoso, M'al Barnioso For de toda minda David gusker y al Dr Eloesser.

Snitocapulina. Sheval 3

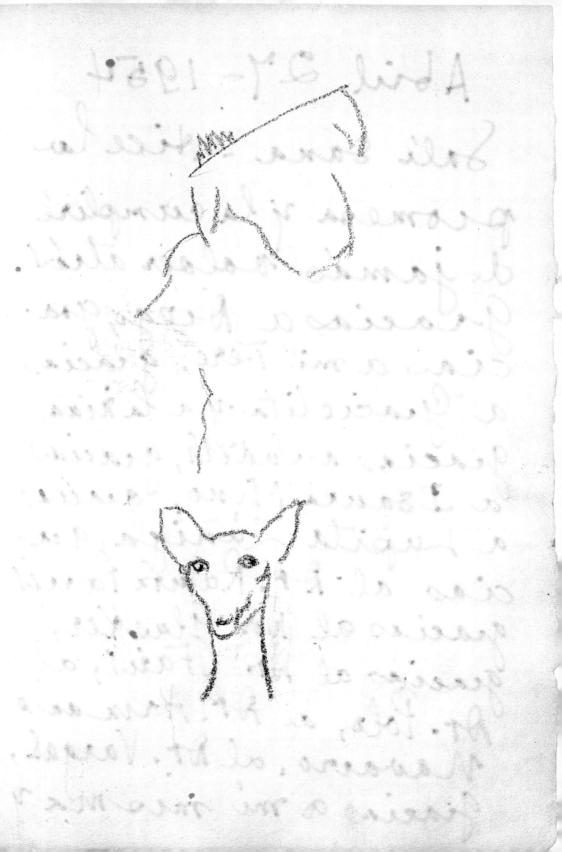

Abril 27-1954 Sali Sana - Nice la promesa y la cumpleré de jamés volver atrès. Gracias a Alego, gra-cias a mi Tere, gracias a gracielita y a la rina, gracias a Judith, gracias a Isania Mino, gracias a Lupita Zunigh, gra-cias al At. Ranta Pariel gracies al Nr. Glasker, gracies al Ar Faill, al Dr. Yolo, an Ar. Armans Navairo, al Dr. Vargas, gracias a mi mes ma y

a me volunted enorme de vivir entre todas las que me quieren y para totas los que yo ghiters. Que vioa la alequa, la vida, Niego, ere, mi Judith y telas las enfor meras que he tenido en mak vida que me han trataso tan maravillesamente bien. Gracia proque Sry Comunista y le Resiso tota me visto sous Gracias al pueble So vietier, al puelle chino chesoslovnes y polaco y al preble de Mexico, salae to so

de Coyacrean y donde nació mi plimera celuling que su incubo en Caxaca, en il vicentre de mi madre, que habis na-cido alí, cesara coa mi spakse guillermo Kaklo-mi makse Metilhe Calderón, morens campanita de Oceace: Tarke maravillon que pasamets aqui lu Coyoacaa; cuarts de teuse Arego, rere 4 40. Sota Capalinat Sm. Kostic

Esqueuna de mi nou. 1410. naci en el quatto de la esquina entre Dontos 7 A Den de Consasan. a la ma de la mana na. Mis abulos paterus Hugaros- nacidos en Aras Hungria - ya casast Sonde receirs varies de sur hijos entre ellos me padre, en Baden Baden alemania Suillerins Les Paula Mohrs. El, emps Radicio arm granger form muchorche, niers cana, ma dre de mir hermanitais

Luisita y Margarità. al morin muy joven sa son Ma pe cous cos na madr. Matica Calderin y gonges. Mi pa entre Socie de mis de Morelia de raya indigent mexicana michon Jama on de mi abuelité prise al moin puss a elle Chistina en el corrents on les visces nes de Prode

selie à les professes

while the warfs of the series has a

current professes de la commentante

current production de la

Mr miner me monavillora, porque ampre mi padre eras un en seras (tenia vestigos Casa mes y me sio. Fre en en menso ejagt pare me de tornors de Trabajo (Fotografo tantin y pris to) y sobre toto de congression Jose toolos mis problemas que deste los luctes ans friends de Recuerdo que 10 mia trajes. To premie en mis ojes la lucha Campisin 60 Zapala contre los caraan ontar. Mi Situación fra muy class. mi metre por Lan colle di Allende - abrient In belcome les das accesso a los lapatistos

prevende que los héristos y hantientes soltarion por los relcores de sir care para la "sola". Ellet des curats et les dats gorditas de mine unico aliment que en ese. entires el potra consequenta Conjucción. Enormes enotro hourans Matitz Adri Yo (Fride) y Oristi, La che family [las describing ment Tarke . La euron eler. Le le revoluer sur edat ingusper en ha frantis commesta.

nomes chiquestan las bales intervers en 1914. Digotodais Sa extraor dinais gonide. Se hacia propagandane el -tianguis- de l'orgoacin a favor de Zapata Con conists ôpe Posasa editada: Costabon le vienes tentas.

y 40 y Cristi les Cantabanas enerciales en un gran repen que dis a nozal. mientre sin madre y no padre velubra por nostis Joans no could be with se los querillers. Hone-cuerdo am a un horiso corranaista comonda hom Son fuerte et ris de Cogazain

Salar Control of the The state of the s The state of Chinas Carlo Riv. I while destrations lo depris y a ofor zaga tist en andillas primaris in hir aches nevier de suit 3 3

Olyer Siete de Mayo de 19053 al caerme en las baldoms de piedra. De mue en terors en una nalga (nalga de pers) mor ahija. The trajeror hun no di atamiento al Hisportal en ma ambilancia. Suprien Do lenor mer dolors Ja di casa al Hoypetel Ingles - me Formar or fura radografía - vanas Docadezaron la chieja y me la van a facar mol Pracial a mi Des Fracial a mi Des Fracial de Fifa mil a 182, Pracia a los Doctos

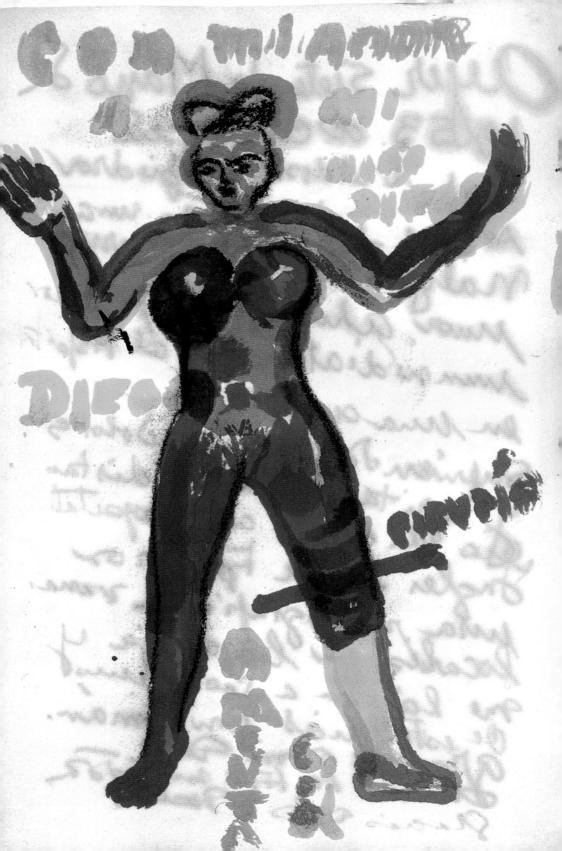

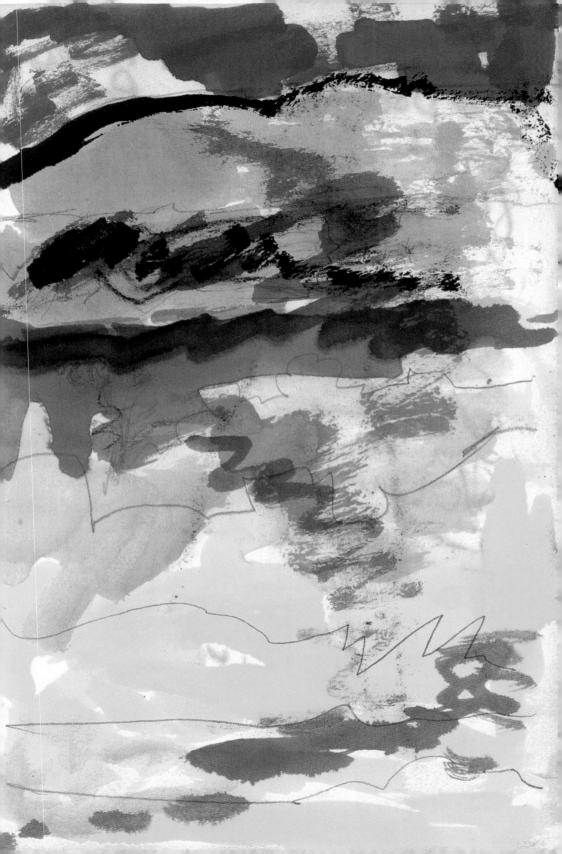

Farill-Gliester Parres Janche Palomera, Gracias a las en fermites Afanondom a mozer della sunsa Espero alegre la estpero la salista - y estpero no volver conners - PADA

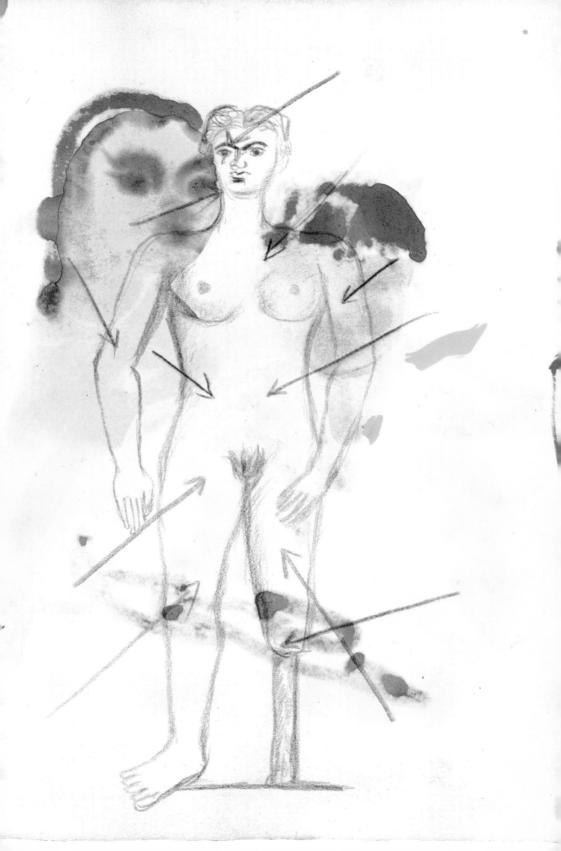

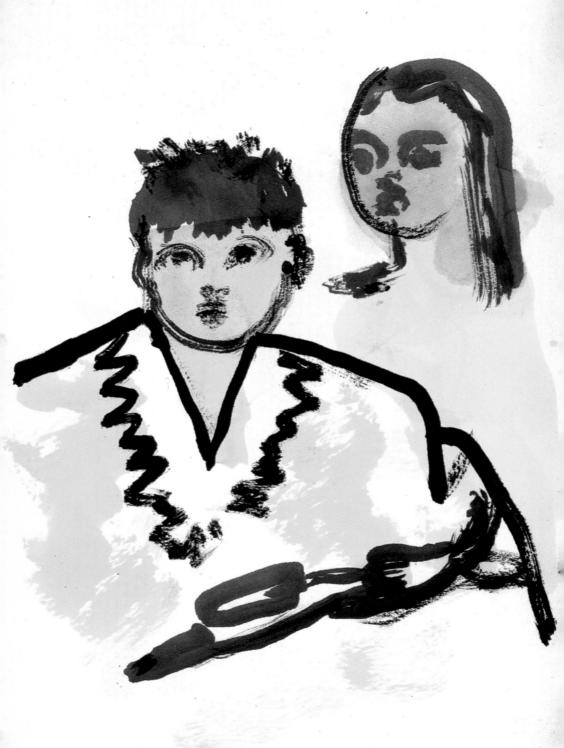

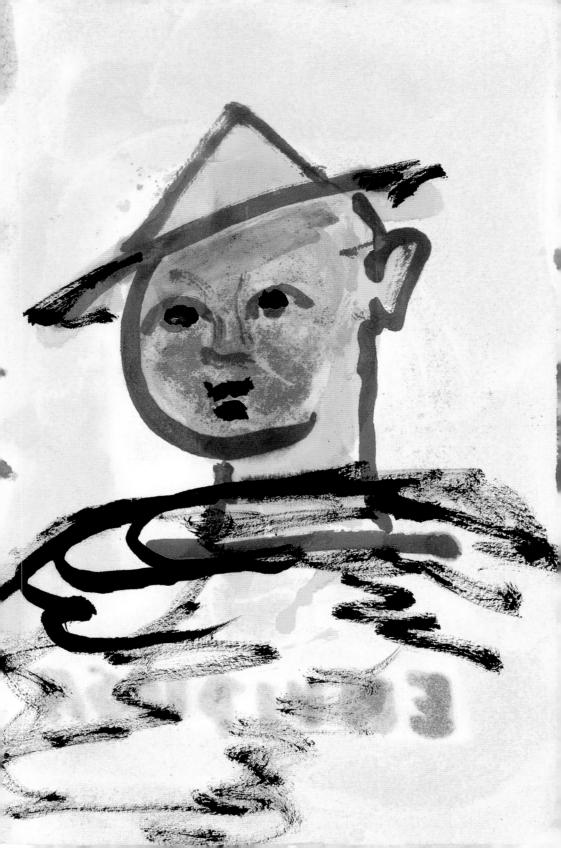

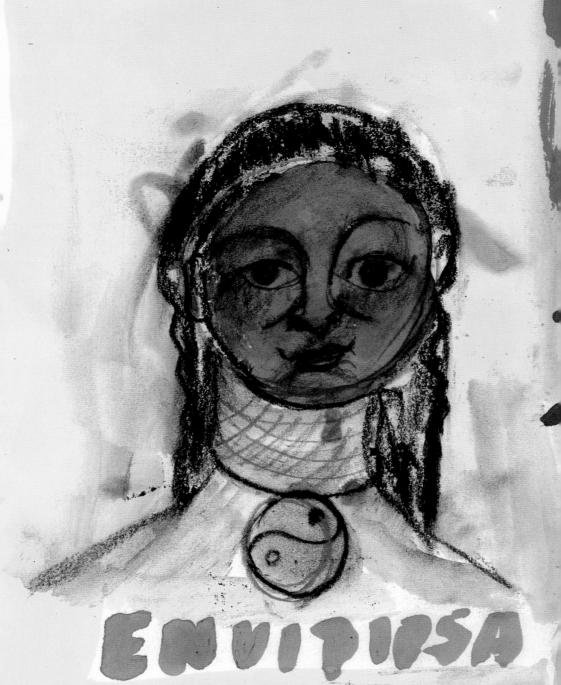

TRANSLATION OF THE DIARY WITH COMMENTARIES

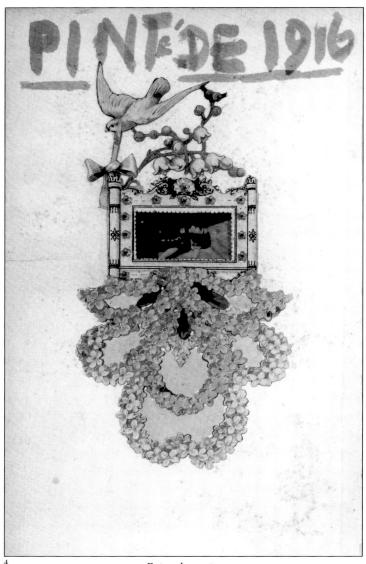

Painted 1916

The diary's first page (page 4) is a prelude to the journal and the Surreal world found within its pages. "Painted 1916," Kahlo announces in crimson, the year she was nine—an overt prevarication proclaiming her lack of concern for "rational facts." Compounding the sense of irreality, Kahlo's whimsical collage combines a sentimental illustration—complete with a wreath of flowers, a pink ribbon, and a bird—and a strange photographic portrait of herself, probably taken by her friend Lola Alvarez Bravo. The effect is both jarring and provocative, but it is a private joke the viewer is not entitled to understand fully.

The early entries in Kahlo's journal function as a kind of poetry, derived as much from the meanings of the words as from their relentless, almost hypnotic procession across the page. To read them aloud, in any language, is to be drawn into Kahlo's sphere, to be transported to a place where the intuitive and the unconscious predominate. There is, however, an unsettling incongruity between the carefully inscribed words and their content, suggesting this may be a transcription of a document written earlier. Kahlo's collection of words often makes no literal sense but is highly effective on a subliminal level. Her words appeal to the senses because her stream-of-consciousness style favors vivid colors, a jumble of objects, and short descriptive phrases virtually without verbs. Kahlo imposes no hierarchy: she juxtaposes the mundane with the sacred, the natural with the technological, the literal with the ideal, the beautiful with the ugly, the intimate with the public. Only one word has a specific reference. Kahlo makes a pun with the word olm, which means "elm" in English. By enlongating it, she makes the word Olmedo, a nod to one of Rivera's lifelong patrons, Dolores Olmedo.

no moon, sun, diamond, hands fingertip, dot, ray, gauze, sea. pine green, pink glass, eye, mine, eraser, mud, mother, I am coming. = vellow love, fingers, useful child, flower, wish, artifice, resin. pasture, bismuth, saint, soup tureen. segment, year, tin, another foal. point, machine, stream, I am. methylene, joke, cancer, laughter. warble - glance - neck, vine black hair silk girl wind = father grief pirate saliva hay clamp consumption lively wave - ray - earth - red - I am. April. 30th. . child-rennet, his, king, black radio poplar destiny I search - hands. today. Elm tree. Olmedo. Violet. canary buzzing - stoning - whiteness of gray

road - silhouette - tenderness ballad - gangrene - Petrarch sunflower - sinister blues. acute

lap - tumbling - I draw close visions - illusive - sleeping - pillar.

rosemary - circumlocutions - garbage - yesterday

The series, sot, diamante, manosyerna, serie, rage, gasa, mar.
rerds fino, vidrio rosa, ojo,
mina, gema lode, madre, roy.
ennor amarillo, dedos, itil
riño flor, deseo, ardid, resina.
sofrero, bismuto, santo, so sera.
gajo, año, estano, etro fotro.
suntilla, maquina, arreyo, soy.
metileno, quasa, cancer, risa.
gerjeo - mirada - ouelle, riña
pelo negro seda niña viento a
padre peda serata saliva
sacati mordaga consumo rivais
onda - rayo - hirra - rojo - soy.
Abril. dia 30..
Niño - cuajo, suyo, rey, radio negroalamo strue busco - manos hoye
Olmo. Olmedo. Violeta, canario
rumbido petrada - blanoor del gris.
Carnino - sibuela - ternura
corrido - canoruma - petrara.
mirasol - sintestros anules. aquelo
Romeros - ambres - basionas - ayor
risiones - iluso - dermina - feitar.

columnas amigas pumores au lo · abusos - cereanos - mentira · paston. areanos - millares - dinero - vigot. empalme conciencia - piruja palmar. La fuerza - marina - joroba controlmiradas que digo - ajado cubil mikado - marthio - gorjeado senil al rojo primor - al verde mentira derrumbe gangose sin silla place. agricado pricor o infamias homosas garganta naranja notunda pri esta pantión. granizo lunera cantado-brillante ademán alerta - candado - romano ardiente. cajita. lo pinto, maton. rino - rinito - rinote mi gris corazón. nevada graciosa. burbuja de Arión Jacia. milano. corriendo jarana sin cuento razon. gran prisa espejosa munica carton.

friendly columns - murmurs of glass

abuses - nearby - lies - passion.

Remates agudos con tierna emocion. buscaba - risuena - morena boton. gerundio gerona germana gorrion qualdada garganta gozada pasión. Abeja - cariño - perfume - cordon. migaja marmaja - saltante miron. Soldado soltura - solsticio girono. Cuadrante morado. abierto ropon. materia mierada martirio membrillo metralla micron. Ramas, mares, amargamente en-Traron en los ojos idos. Osas mayores. voz .. callada . vida . Thor. 2 Mayo. 4 mayo. 7 mayo. no ve al color. Tiene el color. Hago la forma. no la mira. No da la vidar que Time. Tune la vida. Tibia u blanca es su voz. Se quedo sin llegar nunca. me von.

Arcane - thousands - money - vigor. overlapping conscience - prostitute palm the strength - marine - hunchback control looks I say - withered lair mikado - martyrdom - senile gurgle = square bright star seized, at russet dawn - at the green lie landslide nasal without pleasure seat. first - decimated - pompous bitter precocious - beautiful infamies rotund orange throat what a thing. graveyard. moonlit hailstones singing brilliant gesture alert - padlock - roman fiery. little box he painted it. killer. child - little child - brat my leaden heart graceful snowfall - airplane bubble

I was lying - flaccid - running - revelry

without story reason. great haste mirrorlike

cardboard doll

Acute portraits with tender emotion.
searching - laughing - dark skinned - button
gerund Gerona
German sparrow
tawny throat
delighted passion.

Bee - fondness - perfume - cord crumb - fool's gold - jumping voyeur soldier ease - solstice strip. purple quadrant - open gown. microned matter martyrdom quince grapeshot micron.

Branches, seas, bitterly went into the faraway eyes. Ursas majors. voice . . hushed. life. Flower.

May 2nd. May 4th. May 7th.

He doesn't see the color. He has the color.

I make the shape. He doesn't look at it.

He doesn't give the life he has.

He has life.

Warm and white is his voice.

He stayed but never arrived.

I'm leaving.

This is the first of numerous letters in the journal Kahlo addresses to Rivera, letters that speak to the deep and abiding bond between them in spite of infidelities and a brief divorce. Perhaps Kahlo shared them with Rivera after she had set them down with pen and ink. They read much like her famous "Portrait of Diego," included in a catalogue for a retrospective of Rivera's work in 1949.

Kahlo's missives are love letters of a sort but many, such as this one, are filled with an unbearable anguish, a grieving fueled by desire, a suffering tempered by fulfillment. Kahlo expresses both a physical and psychical love for Rivera: her longing for him and devotion to him move to a mystical level, and the letters reveal as much as they obfuscate the powerful attachment they had to each other.

Diego.
Truth is, so great, that I
wouldn't like to speak, or sleep,
or listen, or love.
To feel myself trapped, with no fear
of blood, outside time and magic, within your own fear,
and your great anguish, and
within the very beating of your heart.
All this madness, if I asked it of you,
I know, in your silence, there would be
only confusion.

I ask you for violence, in the nonsense, and you, you give me grace, your light and your warmth.

I'd like to paint you, but there are no colors, because there are so many, in my confusion, the tangible form of my great love.

F.

Today Diego kissed me.
Every moment, he is my child.
my newborn babe, every little while,
every day, of my own self.

Diego. Verdad es, muy grande, que que no quisiera, ni hablar, ni dormir ni oir, ni querer. Sentirme incerrada, sin miedo a la sangre, sin himpo ni ma-gia, dentro de tu mismo miedo, 4 dentro de tre gran angustia, y en el mismo ruido de tre corazón. Toda esta locura : si te la pidiera. 10 se que seria, para Ju siancio, solo Aurbación. Te pido violencia, en la sinvazon, tis, me das gracia, tu lux y Pintarte quisiera, pero no hoy colores. por haberlos tantos, en mi confusion, la forma concreta de mi gran amos. Cada momento, il es mi nino, mi niño nacido, cada ratito, diario, de mi misma.

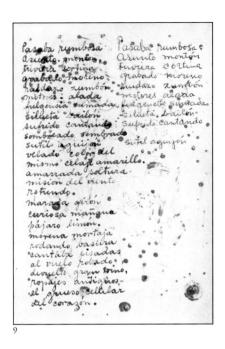

Passing through ostentatiously Business heap, Had I a curtain dark print noisy mocker winged with motors extra brilliance dancing silhouette suffering singing shaded planted subtle sting veiled color of the same cloudy yellow sky bound looseness mission of the wind rotund. maraca strip curious morning bird lemon. dark shroud tumbling rubbish singing footsteps stolen on the wing returned great birdsong, antique garments the coarse cells

of the heart.

Passing through ostentatiously business heap
Had I a curtain dark print noisy mocker winged with motors extra brilliance dancing silhouette suffering singing

subtle sting

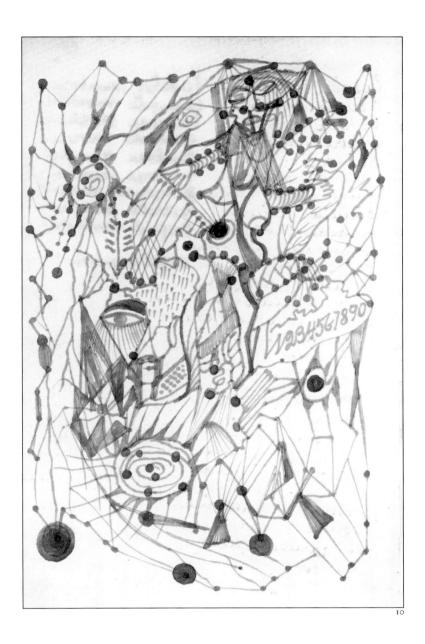

This connect-the-dots ink drawing has the quality of a doodle, but a second glance reveals an array of suggestive forms that are never completely legible: a solar system is just an eddy; the beard of the Aztecgod-like figure sprouts a hand; dashes in the center of the image might be multiwindowed skyscrapers; midway down and to the left is an eye with lashes on the lower lid, or is the eye upside down? Kahlo's use of automatic drawing gives a Surreal quality to this drawing. Indeed, automatic drawing, replete with accident and biomorphisms, was thought by the Surrealists to provide a direct route to the unconscious and thus bypass the "educated" part of the mind.

n this page and the two that follow is a melancholy letter in which Kahlo speaks of a sad parting at quayside. She recalls seeing the figure of the person addressed in the letter framed in a porthole, growing smaller and smaller, an effective Surrealist image. The letter was written to painter Jacqueline Lamba, a member of the Surrealist circle whom Kahlo had met in April 1938, when Lamba and her husband, André Breton, had come to Mexico. Kahlo and Lamba became close, in part as a reaction to the academic and theoretical discussions among Breton, Trotsky, and Rivera, from which they were excluded.

Kahlo accepted Lamba's invitation to visit her in Paris (Breton had promised to organize an exhibition of Kahlo's paintings), and after her one-person exhibition at the Julien Levy Gallery, in New York, in November 1938, she set sail for Europe. Kahlo left Paris at the end of March 1939, and wrote this letter then, and later transcribed it into her diary.¹

Kahlo had a number of close relationships with women, some consummated and others not. This letter is a tender remembrance of time spent together in Paris. The fragmentary and somewhat incoherent language conveys a sense of shared experience and an intimate communication.

The letter also throws light on one of Kahlo's paintings, *The Bride Who Becomes Frightened When She Sees Life Open*, dated 1943 but begun as a still life of fruit and animals in 1939. Later, Kahlo painted in the "bride" mentioned in the letter, which she and Lamba found at the Marché aux Puces, the Parisian flea market where the Surrealists sought objects deprived of their original context.

Carta:

Desde que no escribiste, en aquel dia tan elaro y lejano, he quindo explicate, que ho puede irme de los dias, ni regresar a tienpo al otro fichpo. No te he obvidado las no-ches son largas y dijectes.
El aqua. Il barco y el muelle y la cida, que te fue hacimdo tan chica desde mis ejos, encar eclados en aquella ventana redonda, que tu mirabas, para quardarme en tu corregión.
Todo eso esta intacto. Despuis. Vintron los dias, nuevos de tr. Hoy, que tra intacto. Despuis. Minora los dias, nuevos de tr. Hoy, questra que mi sol te tocara. Te digo, que fu nina es mi riña, los sersonajes teteres, arreglados en un gran cuarto de Adrios, om de las dos. Es trago el huipil con listones solvenos. Mias las plazas riejas de fu Paris, sobre todas ellas, los maravillosa. Des Vosges.

Letter:

Since you wrote to me, on that clear, distant day, I have wanted to explain to you, that I can't get away from the days, or return in time to that other time. I have not forgotten you - the nights are long and difficult. The water. The ship and the dock and the parting which made you appear so small, to my eyes, framed in that round porthole, and you gazing at me so as to keep me in your heart. Everything is untouched. Later, came the days, new of you. Today, I wish my sun could touch you. I tell you, your eyeball is my eyeball, the puppet characters all arranged in their large glass room, belong to us both. Yours is the huipil with magenta ribbons. Mine the ancient squares of your Paris, above all, the magnificent — [Place] des Vosges.

¹ Herrera, Frida: A Biography: 253.

tan dvidada y Fan Lirme. Los caracoles y la munica-novia es tuya tambilu. es decir, eres Fic. Su vistido, es el mismo que no grizo quitarse el dia de la boda con nadie, enando la macontramos casi dormida en el piso sucio de una calle. nis faldas con clams de encyc, y la blusa antiqua que siens fore el retrato austrite, de una Sola persona. Pero el color de ter piel, de tus ojos y tu pelo cambia con el viento de mivico. The much pil vice mo balls touched exces was wise organ halbones of telephones gusta Tu formbien sales que todo lo que mis ojos ven a que toco con migo misma, disde todas las distancias, es Prego. La caricia de las telas, el color del color, la

alambres, los nervios, los lapeas, las hojas, el polvo, las eclulas, la quina y el sol, todo le que se vive en los minutos de los no-relojes y los ne-calendarios y de las no-miradas vacias, es el. Tú lo sentiste, por los diparte que me trajera el barco dede el Havre donde Tú nunca me dijust adios.

Te tequiri escribicado con misojo, simpre. Besa a

so forgotten and so firm. Snail shells and the bride-doll, is yours too - I mean, it is you. Her dress, is the same one she wouldn't take off on the day of the wedding to no-one, when we found her half asleep on the dirty sidewalk of some street. My skirts with their lace flounces and the antique blouse I always wore xxxxxxxxx paint the absent portrait of only one person. But the color of your skin, of your eyes and your hair change with the winds in Mexico. The death of the old man pained us so much that we talked and spent that day together. You too know that all my eyes see, all I touch with myself, from any distance, is Diego. The caress of fabrics, the color of colors, the

wires, the nerves, the pencils,
the leaves, the dust, the cells,
the war and the sun, everything
experienced in the minutes of the
non-clocks and the non-calendars
and the empty non-glances,
is him. You felt it, that's why
you let that ship take me away
from Le Havre where you never
said good-bye to me.
I will write to you with my eyes,
always. Kiss xxxxxxx the little girl . . .

la menor esperanz todo se mueve al compas que enciera

> Numbers, the economy the farce of words, nerves are blue. I don't know why - also red, but full of color.

Through the round numbers and the colored nerves the stars are made and the worlds are sounds.

I would not wish to harbor the slightest hope, everything moves to the beat of what's enclosed in the belly T he immediacy of the words on this page is in striking contrast to previous passages which give the sense of being preconceived. Here Kahlo is inspired by an assortment of colored pencils, which prompt her to consider the symbolism borne by their various hues.

One at a time, Kahlo picks up a pencil, freely associates its meaning, and then writes it out in the same color. A few lines are accompanied by sketches that represent the associations (for example, electricity, leaves, distance, and blood). Some of the affinities Kahlo sees are lyrical. Others are drawn from her lexicon of specifically Mexican references: "mole" is the color of the deep brown, piquant chocolate sauce of that name used in Mexico for meats and poultry. Solferino (magenta) reminds Kahlo of the "blood of the prickly pear," that is, the juice of the nopal cactus flower. The flower appears in several of her paintings (My Grandparents, My Parents and I, and Fruit of the Earth, for example), where it bears a strong resemblance to female genitalia, thus reinforcing Kahlo's association between the red blossom and blood. Another theme Kahlo returns to again and again is madness, which she here associates with the color yellow.

I'll try out the pencils
sharpened to the point of infinity
which always sees ahead:
Green - good warm light
Magenta - Aztec. old TLAPALI
blood of prickly pear, the
brightest and oldest
color of mole, of leaves becoming
earth
madness sickness fear
part of the sun and of happiness
electricity and purity love
nothing is black - really nothing

leaves, sadness, science, the whole of Germany is this color more madness and mystery all the ghosts wear clothes of this color, or at least their underclothes color of bad advertisements and of good business distance. Tenderness can also be this blue blood?

Well, who knows!

This bit of verse, lyrics to the sinister song "Mack the Knife" in Brecht and Weill's *The Threepenny Opera*, is the lone example of Kahlo's copying a passage from a source other than herself. The place names below suggest she may have seen the play in New York or Paris during her 1938–39 trip out of the country. Kahlo writes out the words in their original German, presumably because she had some familiarity with the language through her father's birthright—though he would not have been proud of her numerous errors.

Her text reads: And the shark has teeth And he wears them in his face And Macky, he has a knife. But the knife one does not see.

Und asso Guilly so let solus was son son springs and marky Jak annount of the work of the the son gesicht and der marky hat ein messer doch das messer eint man mehr and der Heifisch er hat Jahne, und die tragt er hat Jahne und die tragt er hat man nicht. Misser sint man nicht. Paris. Pork. Misself.

Und der Heifisch er hat zähne und die tragt er ihm gesicht und Macky hat ein messer doch das messer siht man nicht. Saint Francis of Assisi Und der Heifisch er hat zähne und die tragt er ihm gesicht und Macky hat ein messer doch das messer siht man nicht.

Manhattan

Und der Heifisch er hat zähne und die tragt er ihm gesicht und der Macky hat ein messer doch das messer siht man nicht.

Mexico. Coyoacán.
Paris. New York.

An eight-page entry begins here with an amorous letter to Rivera. Kahlo's response to his sexual magnetism reveals another facet of her feelings toward her husband. While some of the imagery is unconventional, her unreserved passion is just barely concealed by her metaphoric prose.

Following the letter are several pages that may be addressed to Rivera as well. Kahlo's thoughts meander from succinct but vivid images — "Fingers of the wind," "the bleeding children"—to more meditative albeit vague reflections on art and color and the importance of the "golden section," a topic she returns to later in her journal (plate 121). The words "auxocromo" and "cromóforo" appear several times, and Kahlo defines them in terms of her relationship with Rivera. Art and love intermingle in her mind; there are no boundaries between her and Rivera.

Diego: nada comparable a tus manes ni nada igual al oro-verde de Tus ofos. In euros se lleva de ti por dias y dias. eres el sopejo de la noche. La lux violenta del relampaço. la hussedad de la tierra. El huseo de Tus axilas es mi refregio. mis yemas tocan to sangre. Toda un alegria es sentia brotar tu vida le In fuenti-for que la mia suarda para llenas todos los caminos de mio nervios que son los truyos. Hojas, navajas, armarios, gorison Vendo todo en nada no creo en la ilusion. Funas un horros humo. Marx. La vida. el gran vacilin. mada tima nombres. yo no miro formas. el papel amor. guerras grinas farras. garras. aramas sumidas vidas len alcohol. ninos son los dias y hast

Diego:

Nothing compares to your hands nothing like the green-gold of your eyes. My body is filled with you for days and days. you are the mirror of the night, the violent flash of lightning, the dampness of the earth. The hollow of your armpits is my shelter. my fingertips touch your blood. All my joy is to feel life spring from your flower-fountain that mine keeps to fill all the paths of my nerves which are yours.

Leaves. blades. cupboards, sparrow I sell it all for nothing. I do not believe in illusion. You smoke terrible. smoke. Marx. life. the great joker. nothing has a name. I don't look at shapes, the paper love. wars. tangled hair. pitchers. claws. submerged spiders. lives in alcohol. children are the days and here it stopped.

"horanis & more Francis Energy Ya llega. mi mans. mi koja: vision. más grande. mion suya. martirio del vidrio. La gran Sinpayon. Columnas y valles. lo dean del viento. Lo rivino. Sangrantes. La misa micron. Sanghands. La more micron. No se lo que piensa mi survio burton. La tienta, la men cha la forma el color. 301 ave. 301 toda, sin mas turbación. Todas las campanas. las reglas. Las tieras, la grando arbeleda. La mayor Permura: la immensa marea. basura. Finaja. cartas de carton. dordos dedos diros débil esseranza de haces cons trucism las telas. la reges. Tour touto. mis unas. el hilo y el pelo, el nervio zumbin yn me von connigo, un minu to ausente. te tungo robado y me von llorando. Es un vación.

It is coming. my hand. my red vision. larger. more his. martyrdom of glass. the great nonsense. Columns and valleys. fingers of the wind, the bleeding children. the mica micron. I don't know what my mocking dream thinks. The ink, the stain. the shape. the color. I'm a bird. I'm everything, without any more confusion. All the bells. the rules. the lands. the big grove, the greatest tenderness. the immense tide. garbage. water jar, cardboard cards. dice digits duets vain hope of constructing the cloths. the kings. so silly. my nails. the thread and the hair, the bantering nerve I'm going with myself, one absent minute. I have stolen you and I leave weeping. I'm just kidding.

Ouxscrimo - Cromitoro. Diego. Aquella que lleva el color. Wave ve weeler. Desde ex año de 1922. Harta todo to alas. Ahora en 1944. Despues de todas las novas proidas. Siguen los vectos per su dirección primera. nada los detiene. Sin más Conscimento que ha viva emoción. Sin más deses que seçuis hasta encontrarse. Lentamente. Con enorme inquietus" pero con la certera de que todo lo rige la sección de oro! Huy um acomodo celulas. Hay in movimiente a Hay lug. Todos Voi contros porte los retamos de Lo cursos no miste. Armos los manismo que ya funiso y sure. mos Son contas con al expusido A MANAGER MANAGER CHARLES COLLECTION TO BY

Auxochrome - Chromophore. Diego. She who wears the color. He who sees the color. Since the year 1922. Until always and forever. Now in 1944. After all the hours lived through. The vectors continue in their original direction. Nothing stops them. With no more knowledge than live emotion. With no other wish than to go on until they meet. Slowly. With great unease, but with the certainty that all is guided by the "golden section." There is cellular arrangement. There is movement. There is light. All centers are the same. Folly doesn't exist. We are the same as we were and as we will be. Not counting on idiotic destiny.

Mi Diego: Espejo de la noche. Tus ojos espadas verdes dentro de mi carne. ondes entre mues tras manos. Todo tu en el espacio lleno de souidos - en la sombra y en la luz. Tu Te llamaras AU80-CROMO el que capita el color. Yo CROMOFORD. la que de el eolor. Tu eras todas las combinaciones de la números. La vida. mi deseo es entender la linea la forma la somora el movimilnto. Tu llenas y 70 recibo. Tu palabra recore todo el espacio y blega a mis celulas que son mis astros y và a las tuyas que son mi lux.

My Diego: Mirror of the night. Your eyes green swords inside my flesh. waves between our hands. All of you in a space full of sounds - in the shade and in the light. You were called AUXO-CHROME the one who captures color. I CHROMOPHORE - the one who gives color. You are all the combinations of numbers. life. My wish is to understand lines form shades movement. You fulfill and I receive. Your word travels the entirety of space and reaches my cells which are my stars then goes to yours which are my light.

Ghosts.

Auxochrome - Chromophore It was the thirst of many years restrained in our body. Chained words which we could not say except on the lips of dreams. Everything was surrounded by the green miracle of the landscape of your body. Upon your form, the lashes of the flowers responded to my touch, the murmur of streams. There was all manner of fruits in the juice of your lips, the blood of the pomegranate, the horizon of the mammee and the purified pineapple. I pressed you against my breast and the prodigy of your form penetrated all my blood through the tips of my fingers. Smell of oak essence, memories of walnut, green breath of ash tree. Horizon and landscapes = I traced them with a kiss.Oblivion of words will form the exact language for

Era sed de muchos anos retem. da en muestro enerpo. Palabras encadenadas que no pudimos decir sino en lo labios del sue no. Todo lo rodeaba el milagro regetal del paisaje de tes energes. Tobre tre forma, a mi tacto respondieron las pestamas de las flores, los purnores de los ris. Todas las frutas habia en el jugo de tus labios, la san gre de la granada, el tramonto del maney y la piña acrisola das. Te oprimi contra mi pecho y el prodegio de tu forma penetro en toda mi sangre por La yema de mis dedos. Cora bencia de poble, a recuer. do de nogal, a verde aliento de fresso. Horizontes e paisa. Jes = que presorri con el oceso. Un olvido de palabras forma na el idioma exacto saran

understanding the glances of our closed eyes. = You are here, intangible and you are all the universe which I shape into the space of my room. Your absence springs trembling in the ticking of the clock, in the pulse of light; you breathe through the mirror. From you to my hands, I caress your entire body, and I am with you for a minute and I am with myself for a moment. And my blood is the miracle which runs in the vessels of the air from my heart to yours. WOMAN. xxxxxxxxxxxx xxxxxxxxxxxxxx MAN. xxxxxxxxxxxx The green miracle of the landscape of my body becomes in you the whole of nature. I fly

entender las miradas de muestro ojos cerrados. = Estas gresente, intangible a eres todo el universo que · formo en el espacio de mi cuarto, Tu ausensia brota temblando en el ruido del reloj; en el pulso de la luz; respiras por el espijo. Desdes. Ti hasta mis manos, recoro todo tou cuerpo, y estoy con tigo un minuto y estoy con migo un momento. y mi saligre es el milagro que va en las venas del aire de mi corazon al trujo. 1 A MUJER. POPPER AND THE PROPERTY OF THE PARTY OF THE PA A Thom bear home or the streething. The Marian Marian El milagro vegetal del paisage de mi cherro is en to la na tunaleza entrera. Yo la renis dedos los hedondos cerros, penetran mis manos los ima brisos valles en ausias de posesion y me cubre el abrego de las ramas sugves, verdes y frescas. Vo penetro el sero de la tierra entera me abrasa y calor y en mi cuerpo todo rosa la frescara de las he pos tiernas. Ser rocio es el sur feo de amante siempre muestra no es amos ni termera, ni caraño, es la vida entera la manos, en te bosa y en tes sanos. Tempo lu mi voca en tais manos, en te bosa y en tes sanos. Tempo lu mi voca el sabor almendrad de tus la seso muestros mundos no hau salido runea fuera. Solo um monte conoce das intrans de otro monte.

23

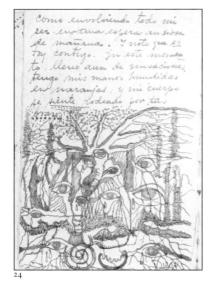

through it to caress the rounded hills with my fingertips, my hands sink into the shadowy valleys in an urge to possess and I'm enveloped in the embrace of gentle branches, green and cool. I penetrate the sex of the whole earth, her heat chars me and my entire body is rubbed by the freshness of the tender leaves. Their dew is the sweat of an ever-new lover. It's not love, or tenderness, or affection, it's life itself, my life, that I found when I saw it in your hands, in your mouth and in your breasts. I have the taste of almonds from your lips in my mouth. Our worlds have never gone outside. Only one mountain can know the core of another mountain. Your presence floats for a moment or two

as if wrapping my whole being in an anxious wait for the morning. I notice that I'm with you. At that instant still full of sensations, my hands are sunk in oranges, and my body feels surrounded by your arms

Two drawings that Kahlo fashioned out of doodles accompany this long passage. Here is a frieze of figures in outline and silhouette, a spectral parade she identifies as "ghosts." They relate to a line on plate 20: "My wish is to understand lines forms shades movement." In a second image on plate 24, eyes float, staring from the interstices of a web of lines that mutate from tree branches to roots to nerve fibers. A pair of full, unsmiling lips, most likely Kahlo's own, anchor the image. Teardrops fall from many of the eyes, a device Kahlo used repeatedly in her paintings (and in her diary on plates 100 and 101). They are intended as literal as well as symbolic tears, referring to the Christian Mater Dolorosa as well as to the Mexican legend of La Llorona, another mourning mother.

The aura of illness that permeates this page of text stems from Kahlo's choice of pencil—the color of dried blood (see the bottom of plate 15)—and her somewhat unsteady hand. Though Rivera was on her mind when she wrote this, her dedication (running vertically at the upper left) is an afterthought, written in a dissimilar ink at some other time, a practice visible throughout the diary (see plate 51 for another example). The passage reflects a moment of insight during a convalescence, a joy mixed with pain. She delights in a gift asked for and received on her birthday, which she celebrated on July 7, the day after her actual birth.

la vida callada ladora
de mundos, lo que mas
jungorta es la nos fusión.
las manana nase, los
agules hojas la las manos
spajaros fundoros, deales
lucha humana, su todes na
lucha humana, su todes na
locura de vientisma mo
entiquo, tormento en la
sanojas que entras por la
sanojas que entras por la
boca convoltara, ausurio
rusa y dunte unos indusas
de pirla, pura alguniagas
de un siete de julio, lo
pido, me llega, canto:
cantado, cantare desde
hoy miestra magia amor.

For my Diego the silent life giver of worlds, what is most important is the nonillusion. morning breaks, the friendly reds, the big blues, hands full of leaves, noisy birds, fingers in the hair, pigeons' nests a rare understanding of human struggle simplicity of the senseless song the folly of the wind in my heart = don't let them rhyme girl = sweet xocolatl [chocolate] of ancient Mexico, storm in the blood that comes in through the mouth - convulsion, omen, laughter and sheer teeth needles of pearl, for some gift on a seventh of July, I ask for it, I get it, I sing, sang, I'll sing from now on our magic - love.

Using a brown ink, Kahlo draws twigs, vines and leaves growing from a thick block of chocolate, *xocolatl* in Nahuatl, the etymological source of the New World plant known as cacao. Below the inscription, Kahlo places a metate, a stone utensil dating back to the ancients, used to grind corn and in this case chocolate.

In red pencil, under dense crosshatching in ink, Kahlo inscribes the words *auxocromo* and *cromóforo* (see plates 17–24). In the lower part of the slab of chocolate, Kahlo writes July 13, 1945, one of only a handful of dates that help situate her diary chronologically.

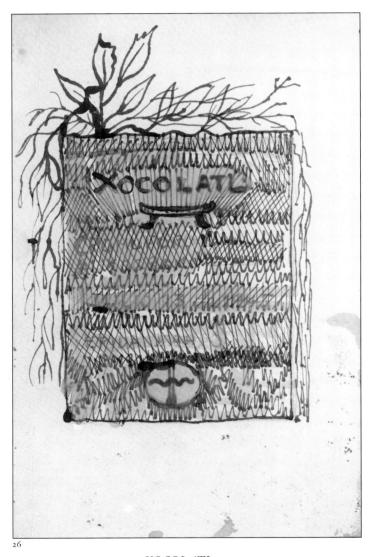

XOCOLATL CROMOFORO AUXOCROMO JULY 13 1945 FRIDA KAHLO

Ahlo's mesmerizing intonation of words beginning with the letter *a* is slightly demented. One of the words is *amarillo* (the Spanish word for "yellow"), which in her lexicon of color meanings is "madness and mystery" (see plate 15). Madness reigns above and below: in the lower register is an enigmatic drawing. The drawing on the following page seeps through and obscures the intelligibility of the image.

Adalgisa augurio aliento aroma amor - antenia o e- abismo - altura - arniga - azul arma - artigua astro axila - abierta - amarillo alegria - Almircle - Alucema America - America - America - Ancla "Artista aleacia - asombro - asi aviso - agata - ager - aurea alla - acierto - akija ara - alia - acierto - akija ara - alia - arma - alla - arma - a

A a A a A a A a A
Adalgisa [female chieftain] - augurio [augury] - aliento [breath]
aroma - amor [love] - antena - ave [bird]
abismo [abyss] - altura [height] - amiga [friend] - azul [blue]
arena [sand] - alambre [wire] - antigua [ancient]
astro [heavenly body] - axila [armpit] - abierta [open] - amarillo [yellow]
alegria [joy] - Almizcle [musk] - Alucema
Armonía [harmony] - América - Amada [loved one]
agua [water] - Ahora [now] - Aire [air] - Ancla [anchor]
"Artista [artist] - acacia - asombro [amazement] - asi [thus]
aviso [notice] - ágata [agate]] - ayer [yesterday] - áurea [golden]
alba [dawn] - apóstol [apostle] - árbol [tree] - atar [to tie]
ara [altar] - alta - [tall] - acierto [hit] - abeja [bee]
arca [coffer] - airosa [graceful] - arma [weapon] - allá [there]
amargura [bitterness]

This bizarre double portrait of the fictitious Neferisis brings to mind, by name and through their visual representation, Nefertiti and her consort, Akhenaten. Kahlo included the Egyptian goddess in her multifigured painting *Moses* done around this time and wrote, "I imagine that besides having been extraordinarily beautiful, [Nefertiti] must have been 'a wild one' and a most intelligent collaborator to her husband."² That Kahlo identified with Neferisis/Nefertiti is clear in the accompanying text. The art metaphor she used refers to her relationship with Rivera: "strange couple from the land of the dot and line."

Kahlo's conception of this stylized drawing is consistent with her approach in many of her paintings in which internal parts are made visible, and are thereby given an importance and prominence that would otherwise be impossible to achieve.

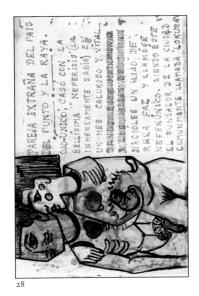

STRANGE COUPLE FROM THE LAND OF THE DOT AND LINE.

"ONE-EYE" MARRIED THE
BEAUTIFUL "NEFERISIS" (THE
IMMENSELY WISE) IN
A MONTH OF HEAT AND VITALITY. .
OF THIS UNION
BORN TO THEM WAS A BOY
STRANGE OF FACE AND HE WAS NAMED
NEFERÚNICO, AND IT WAS HE WHO
FOUNDED THE CITY
COMMONLY KNOWN AS "LOKURA."

² Cited in Herrera, Frida: A Biography: 482.

A gainst a regal purple background and packed into a geometric shape, this "portrait of Neferúnico" bears a stronger resemblance to Kahlo than it does to his mother, Neferisis, pictured on the previous page. In her bearded "self-portrait," Kahlo wears three strands of bone around her neck, and looks out from the page with a steady gaze under her trademark single eyebrow. The third eye Kahlo paints onto her forehead indicates the power of her intuitive insight as would befit the founder of Lokura (Madness).

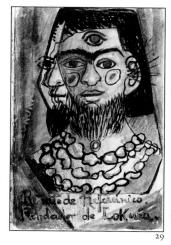

Portrait of Neferúnico. Founder of Lokura.

K ahlo's fixation with the family of Neferisis continues here with a portrait of Neferdós in which Kahlo conjoins three ancient cultures. Neferdós appears to be carved out of stone, resembling an Egyptian sculpture; his third eye is a Hindu symbol; and around his neck, he wears a human heart, an integral element in Aztec sacrificial rites. Kahlo has painted an icon of power, less comforting than awesome.

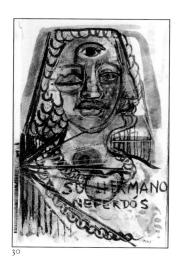

HIS BROTHER NEFERDÓS

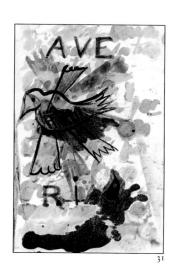

AVE [AVI-] RIA [ARY]

Dominating these disturbing, somber pages are large ink stains that Kahlo has fashioned, on the left, into a black canid of some kind. The animal's full teats recall the legend of Romulus and Remus, and they echo the large breasts of the ominous female figure in the top left-hand corner, a "third eye" peering out from her abdomen. Bodies and body parts are scattered across the page: the sexual organs and naked body seem more lewd than playful.

On the opposite page, a large Asian face dominates the image: it peers out surrounded by "strange animals" and an indecipherable black ink stain that Kahlo labels "fallen soldier." Despite the impression of a horizon line, Kahlo's indifference to spatial integrity on both pages is evident, and the relationship among the various figures is tentative at best, rendering the image's meaning rather puzzling.

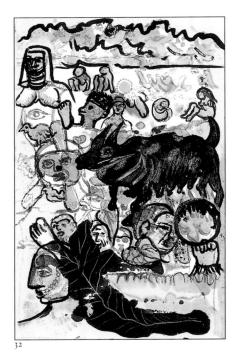

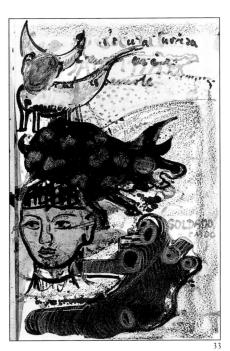

strange animal FALLEN SOLDIER

K ahlo resumes some of the visual themes from the previous page, but this time in a brighter key. The figures here are also more clearly defined though their precise meanings remain ambiguous. Ink spots that soaked through from the prior page are transformed into an angel and a Buddhist goddess, the focus of the image. Piled up behind are multiples of images that recur throughout the diary — feet and birds. Unusual for Kahlo is the defecating figure on the left side, which may be read as a response to the title of this page, the "real world."

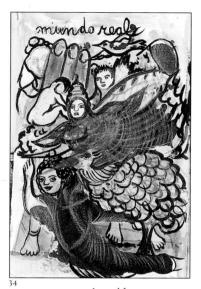

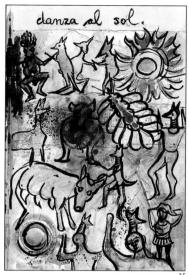

real world

dance to the sun.

ance to the sun" is more joyous than previous drawings, populated with real and imaginary celebrating animals. The jubilant mood is augmented by Kahlo's use of bright colors and her placement of the figures without regard to rational perspective. Familiar characters—two Aztec dogs and a Far Eastern statuette—fraternize with less recognizable figures. Across this sandy plane, all creatures rejoice and pay homage under the bright, warming rays of the sun.

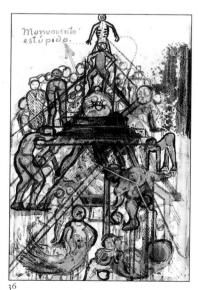

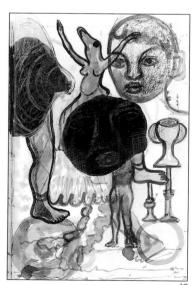

223

THE DANZANTES

The central figure of plates 40–41 on the opposite page is a Janus-like bull's head that alludes both to the Roman god and to Greek classical mythology via Picasso (whom Kahlo had met in Paris in 1939). The image of the Minotaur was an ideal Surrealist emblem, one Picasso utilized when he was associated with the group. Half man and half bull, this grotesque monster literally represented unleashed brutality or, in Freudian terms, the embodiment of the id.

Kahlo relished the idea of the hybrid (especially the hermaphrodite, evident in two paintings done in 1944 of herself and Rivera merged into a single face). And she may have been acknowledging Picasso's Minotaur, but she transforms "his" image into her own, painting her Minotaur with a woman's body.

Kahlo's reference to Janus is not incidental. Janus, god of the new year, is usually pictured looking backward and forward. What s/he sees in the past, on the left-hand page, is a proud, strong, imposing profile of a woman — Kahlo as figurehead on a Roman coin. But when Janus (and Kahlo) gaze to the right, into the future, they foresee disaster: The figure of Kahlo, looking like a marionette with disjointed limbs, teeters atop a classical column. Parts of her fall away — an eye and a hand — both used to make art. Above the precariously balanced figure Kahlo writes: "I am disintegration."

I am DISINTEGRATION. . . .

K ahlo labels the Surreal and somewhat grotesque drawing below left "the phenomenon unforeseen," and indeed, it is an image both strange and disturbing. The "figure" is a monstrous hybrid, multilimbed and many headed, with extra sense organs — an ear and eyes — and sexual parts distributed throughout. What Kahlo began as a doodle or an automatic drawing becomes a manifestation of her unconscious. In this as in many other images, both in her painting and in her diary, Kahlo's nude women are virtually never shown as objects of desire.

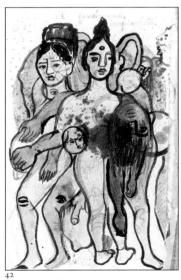

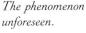

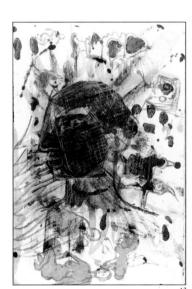

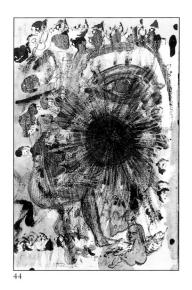

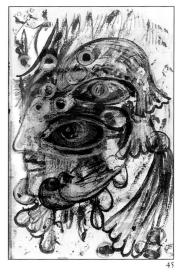

Dominating plate 46 is a stylized double self-portrait—a frontal and profile view combined—drawn with thick lines of ink and two black penetrating eyes beneath a single, nearly straight eyebrow, giving Kahlo a stony gaze. The impression that the face masks pain is underscored by the curious figure upon her forehead. Replacing a third eye is a face radiating half a dozen slender lines, unlabeled pointers, pins piercing the figure or fastening it to her brow.

Hovering around the massive head are symbols and animals; their proximity to her face underscores Kahlo's trancelike state. Some are recognizable—the Chinese yin-yang sign, below it an Egyptian bird, to the right a mythical griffin, and in the upper right, the outlined footprints often found in Mexican codices indicating the direction of events. Together they act as talismans, their magic powers warding off any further suffering.

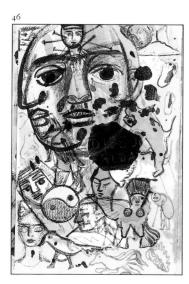

This is one of Kahlo's most illuminating statements with respect to her own creativity. In offering an exegesis of the ink blotches that occur regularly in her diary, Kahlo makes an explicit connection between ink and blood, an affinity which is specifically relevant to women's "productivity."

Kahlo's closing rhetorical question reverberates throughout her life and work: "What would I do without the absurd and the ephemeral?"

Who would say that stains live and help one to live?
Ink, blood, odor.
I don't know what ink he would use so eager to leave his mark in such a way. I respect his entreaty and I'll do what I can to escape from my world.

inky worlds - a free land and mine. distant suns that call to me because I am part of their nuclei. Rubbish. What would I do without the absurd and the ephemeral? 1953 for many years I have understood dialectical materialism.

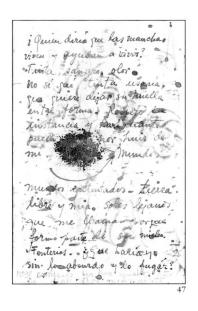

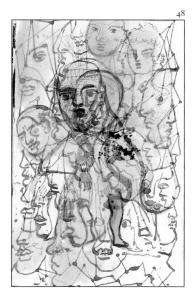

³ Susan Gubar, "'The Blank Page' and Female Creativity," in *Writing and Sexual Difference*, ed. Elizabeth Abel (Chicago: University of Chicago Press, 1982): 73–94.

Kahlo, ever conscious of how she presented herself to others, comments here—she "gave birth to herself"—a remark with numerous allusions. Through the act of painting Kahlo established herself as an artist, and her many self-portraits are manifestations of her need to demonstrate the various aspects of her self. Though unable to carry a child to term, she was nevertheless capable of inventing the event of her own birth (in *My Birth*, 1932), not to mention claiming to have been born three years later than she was so that her birth would coincide with the onset of the Mexican Revolution.

Several of the drawings on this page reiterate the theme of creation. The uppermost image appears almost biblical: out of a blob of red (clay) evolves a fully developed face in movie frame-by-frame fashion. The two drawings immediately below are pendants: a self-portrait on the left turns away from the head of a baby, a wash of red ink encircling it like a sack of amniotic fluid. The drawing on the lower right side bears an uncanny resemblance to a photograph Kahlo's father took when she was about seventeen years old, in which she decked herself out in a tight-fitting cap.

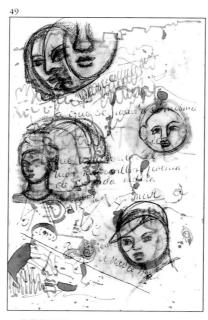

DESIRE
The one who gave birth to herself
ICELTI
who wrote me the
most marvelous poem
of her whole life

I'd . . give
sea
do
kiss
I love Diego and no one else

 ${f F}$ aces bubble up and fill this page of Kahlo's diary. With a single exception, each head is a fairly schematized drawing. Kahlo included one which appears to be an actual portrait, a fairly detailed image along the right edge which bears a resemblance to Rivera. Kahlo sketches various types, races, and genders, and their close proximity gives the sense of the masses. Each face is contained by a ring of black ink, isolating one from the other. Kahlo's comment, "How ugly 'people' are!" along with the suggestion that the black rings have the look of magnifying glasses, recalls the saying, "Familiarity breeds contempt."

How ugly "people" are!

September at night. Water from heaven. the dampness of you. waves in your hands. matter in my eyes. calm, violence of being, of one, who with two, without wanting to isolate oneself. Plant - lake - bird - rose of the four winds. blood river weapons, sun sings kisses. ruin. tears sisters, rare understanding. That's how life will be. glass - sea magic. Delaware and Manhattan NORTH dream valley. light. chant. gold. dream child silk. light chant satin. laughter. - it is all him. her. them, me, we are one line just one now.

STALIN (1953)
MALENKOV has gone 4 March
astonishing
the revolutionary world which is mine.
Long live Stalin. Long live Malenkov.

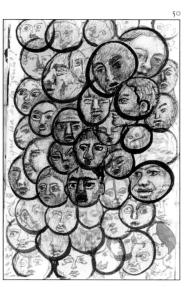

This is one of Kahlo's most haunting images, a double (or triple) portrait which recalls her large-scale painting *The Two Fridas* (1939). The floating face above appears as a material emanation of thought for the figure below, which vaguely resembles Kahlo herself. There is a mysteriousness to this drawing, the floating heads with deep-set eyes fading in and out of each other. Stylistically, the drawing elicits a feeling of nostalgia by evoking the faded glory of a Renaissance drawing. Many of the words are no longer legible. The effect of the blue-gray washes and the green and red inks, is eerie. The stages of a woman's life, from daughter to mother to grandmother, are made visible here.

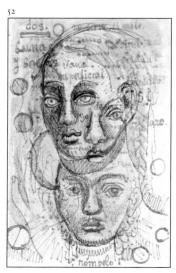

two. it's no use.
moon dreadful
and alone banal isn't it?
superficial - don't you think?
I desire clearly

break it!

You understand everything. The ultimate union. You suffer rejoice love rage kiss laugh. We were born for the same thing. To discover and love what has been discovered. hidden. With the grief of always losing it. You are beautiful. I endow you with your beauty. Soft in your immense sadness. Simple bitterness. Arms you against everything that does not free you. Rebellion against everything that chains you. You love. Love me as the center. Me as yourself. It won't achieve a prodigious memory of you passing through my life scattering jewels I'll only collect after you've gone. There is no distance. Only time. Listen to me caress me with what you're looking for and with what you search. I'm going to you and to me. Like all the whole songs seen.

A ahlo structures this drawing with a favorite device, ink strokes that form an undulating mesh of lines. In the uppermost register is a frieze of androgenous profiles, like a Greek chorus, shedding tears. They overlook one of Kahlo's more frankly amorous vignettes, perhaps an erotic fantasy dreamed by the inclined head to the right. Most disturbing are a pair of red legs, severed from their body, and between them, a pair of lips, one of Kahlo's forms of signature. The lower area is taken over by tendrils which grow from above. The red lines suggest veins, carriers of blood, while the others look like nerves, transmitters of sensation, both pleasurable and painful.

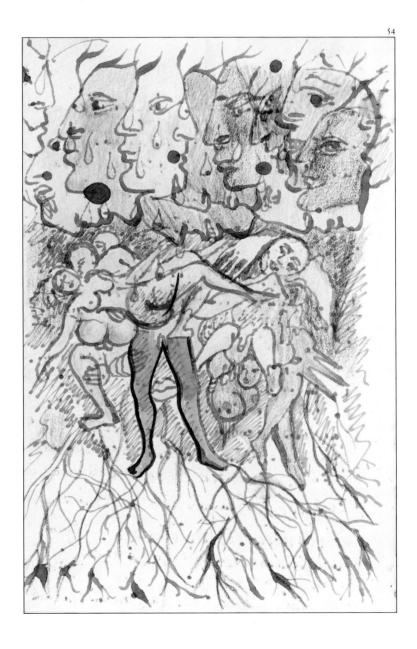

This is one of the few dated pages from the diary: Kahlo wrote this passage on Wednesday, January 22, 1947. The only previous certain date is on plate 26, which she inscribed July 13, 1945. During the intervening eighteen months, Kahlo had undergone several operations, and had painted three of her most vivid paintings that deal overtly with her illnesses, surgeries, and recoveries: Without Hope from 1945, and from the following year, The Tree of Hope Keeps Firm and The Little Deer and virtually nothing else.

Today Wednesday 22 of January 1947 You rain on me - I sky you You're the fineness, childhood, life - my love - little boy - old man mother and center - blue - tenderness - I hand you my universe and you live me It is you whom I love today. = I love you with all my loves I'll give you the forest with a little house in it with all the good things there are in my construction, you'll live joyfully - I want you to live joyfully. Although I always give you my absurd solitude and the monotony of a whole diversity of loves -Will you? Today I'm loving the beginnings and you love your mother.

K ahlo's inscription above this image is a play on words, an ironic comment on the nature of life and death. Since the English term "still life" resists direct translation into Spanish—the genre is known as *naturaleza muerta*, literally, "dead nature"—Kahlo's title may be understood to mean very still (or dead) life.

The drawing's density is a result of layers upon layers of color and lines. Beneath the surface, half a dozen profiles are legible, along with schematic, childlike drawings of flowers and other tangled strokes of ink. The image that finally emerges is haunting: one of the two vessels has a human face, a soul perhaps, while the clusters of dried flowers hold a human figure, a woman whose head peeks out from the bouquet. The hand, tied like a sack of grain, hangs unsupported, a useless appendage wrenched from its rightful place. It is a striking metaphor for Kahlo's increasing weakness and inability to function.

This image precedes a period during the early 1950s when she made thirteen paintings in less than four years. As her health declined, she ceased painting self-portraits, which required hours staring into a mirror, and turned instead to painting fruits and vegetables. Her painting *Naturaleza Viva*, from 1952, suggests that her endless days in bed led her to think of herself as a vegetable: the title translates as "living life" (or "living nature").

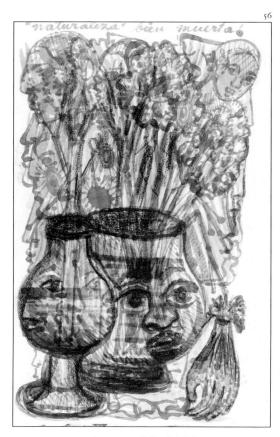

A very still "still life"!

T he still life on the previous page is permeated with Kahlo's preoccupation with death. Her fragile condition is confirmed by the anguish of her words on this and the next four pages. Kahlo's handwriting also betrays her state of weakness, as do the accidental ink spots, and the several passages obscured in retrospect.

The text speaks of Kahlo's frustration at being less than the perfect complement and mate for Rivera. These perceived failings torment her and send Kahlo into a reverie; her desire releases her from a world constrained by rational possibilities. Kahlo's message resonates on a psychological level, resisting logical explanation. She reveals her obsession with Rivera, with belonging to him and with him, forever.

The often-cited list on plate 60 is a private confession, written with intense emotion, which is as fantastic as it is real. Diego is virtually everything to her.

Then, as if doused with a splash of cold water, on the next page Kahlo comes to her senses: Rivera belongs not to her but to himself, she admits. The splotches of ink are coaxed into strange animals bolting across the bottom of the sheet.

Natu salin journe como genero

a Digo. No quies por na da

la huira e que trada lo molet

y la puir cuerça que el monsite para borre

site para borre

la para borre

acadon, comero derani, seu

toi so sorte, sentire aconjuntra sue fetencia tieste

so yo turira sales

qui suero dascha testa

y turira jaccorte

tia, la preha torur.

ho sory solumente loca

madre

Nobody will ever know how much I love Diego. I don't want anything to hurt him. nothing to bother him or to sap the energy that he needs to live To live the way he feels better. Painting, seeing, loving, eating, sleeping, feeling lonely, feeling accompanied - but I never want him to be sad and if I had my health I'd like to give it all to him if I had my youth he could have it all

I'm not just your — mother—

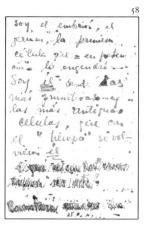

I am the embryo, the germ, the first cell which = potentially = engendered him - I am him from the most primitive . . . and the most ancient cells, that with time became him what do the "scientists" say about this?

° X	edoswa oka	· ·	Marie	UNITHER TURNE	
	MANAGER				
	Sentie			BELLINGA	Ma.
afo	there	loud	ente	·la	1
pal	abras	86	fuer	on Jus	-
Cul	Cerson.	0.00	1	9 9	
200	lad (2000	Cuta.	1	
	de he				
Toda	- Je 1	Care	abre.	Cano	
SC .	muere	, .Z	do ?	levy -	-
Jan C	lina.	magain.	Toda	P .	
Vlu	die y	. Va	10		

= sense =
fortunately, the
words kept forming ——
Who gave them the
absolute "truth"?
There is nothing absolute
Everything changes, everything
moves, everything revolves - everything
flies and goes away.

Why do I call him my Diego? He never was or will be mine. He belongs to himself.

> running giving out . . .

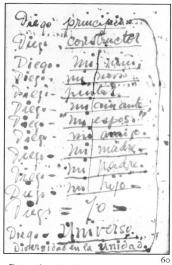

Diego beginning
Diego builder
Diego my child
Diego my boyfriend
Diego my lover
Diego my lover
Diego my friend
Diego my friend
Diego my friend
Diego my mother
Diego my father
Diego my son
Diego = me =
Diego Universe
Diversity within unity.

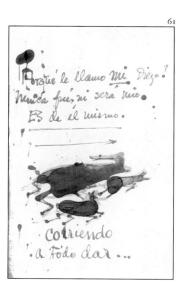

The ink stain on the preceding page leaks through and is transformed into a foot and an arctic bird. Two suns hover near the horizon of Kahlo's polar landscape but make no dent in the icy temperatures. The cold is conveyed by the brittle strokes that crackle across the frigid terrain. Visual references to feet, specifically Kahlo's right foot, are frequent throughout the diary: it is the one she suffered from most. The arctic scene suggests both the pain of cold and a remoteness toward her difficult foot.

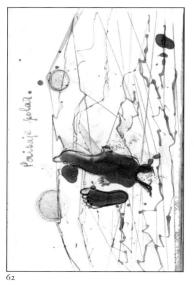

Polar landscape

 ${f I}$ n a more playful mood, Kahlo's colorful curlicue crayon lines animate the page. The pall of illness is gone, and one senses the simple pleasure Kahlo had watching her dogs roughhouse together, and committing their likenesses to paper.

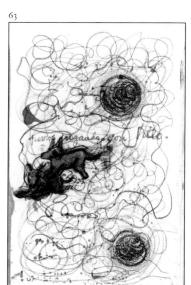

Dogs playing with thread.

A ahlo's doodles produce a weird green beast wrapped with red ribbons from his throat to his hooked tail. Its nose is unicorn-like and its headpiece like a jester's cap. Strange stubby legs propel it, and it sports a large, black eye. Thus Kahlo dubs her creation the Eyesaurus, which she tells us, flourished in ancient times. Its composite form and name recall the many creatures that populate Pre-Columbian myths, the most famous being Quetzalcóatl, the feathered serpent of Aztec legend.

The horrible

"Eyesaurus"

primitive

ancient

animal, which

dropped dead

to link up

the sciences.

It looks up . .

and has no name.

- We'll give it one:

THE horrible EYESAURUS!

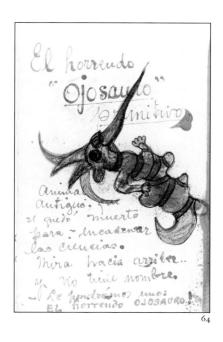

Astonished she remained seeing the sun-stars and the live-dead world and being in the shade

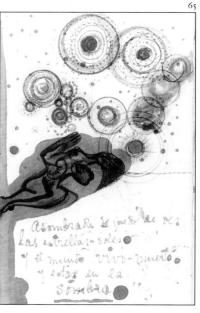

K ahlo draws her right foot, the offending one, which, since at least 1932, had been plagued with trophic ulcers. The delicate outlines are overwhelmed by the splotch of color she adds, causing her foot to bulge and swell, deformed.

Kahlo depicted the same foot in her most Surreal painting, *What the Water Gave Me* (1938). In the painting, a bloody fracture runs up to her big toe; in this drawing, the fiery heat of the blaze below signifies her pain. The setting of the earlier image is her bathtub. Here, the two feet float in space, the spots of ink read as celestial bodies, and Kahlo designates one constellation the sun. The heavenly context casts the image into the realm of myth so it comes as no surprise to see a figure in the flames, a phoenix perhaps, a sign of Kahlo's unyielding tenacity.

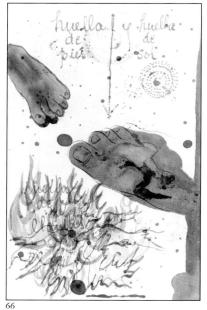

Footprints and sunprints

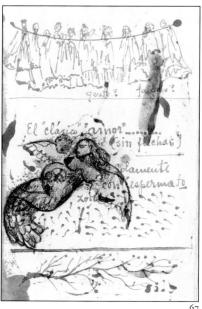

people? skirts?

The "classic" "love" (without arrows)
just with spermatozoa

A t first glance, the heavenly setting of the previous page appears to continue here, with an angel and putto adrift together in an unspecified space in the center of the paper. But Kahlo, with typical mischievous fun, replaces the stars with spermatozoa. Above, Kahlo notes the mutability of her delicate drawing of frocks on a clothesline. They metamorphose into ladies hanging or, perhaps, in keeping with the theme below, into seraphim.

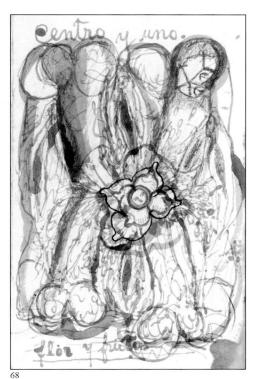

Center and one. flower and fruit.

There is nothing more precious than laughter and scorn - It is strength to laugh and lose oneself. to be cruel and light. Tragedy is the most ridiculous thing "man" has but I'm sure that animals suffer, and yet they do not exhibit their "pain" in "theatres" neither open nor "closed" (their "homes"). and their pain is more real than any image that any man can "perform" xxxx or feel as painful._

nada vale mas que la fisa Mullidentition as Lucrza vis. y abandonary sor themelings. ligero. La tragedia es lo mas ridiculo que tiene el hombre " pero estoy segura, de que los animales, anuque sufreu, no exiber su joena" en teatros abiertos, ni "cernados" (los "hogares"). I su dolor es mas cierto que cualquier mogen que paeda cada hombre representar ameno a senter somo dolorosa.

T his page of Kahlo's diary is engaging, as much for what it reveals as for what it hides. The multilayered effect Kahlo achieves is accomplished through her introduction of collage. By drawing into what looks to be a nineteenth-century erotic photograph Kahlo compounds the density of the image. She alters the entire photograph by literally defacing the woman with graffiti.

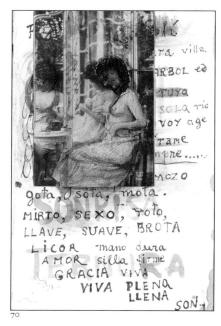

SMILE TENDERNESS drop, knave, mote, MYRTLE, SEX, broken, KEY, SOFT, SPROUTS, LIQUOR firm hand LOVE strong chair LIVING GRACE ALIVE PLENTIFUL FILLED THEY ARE...

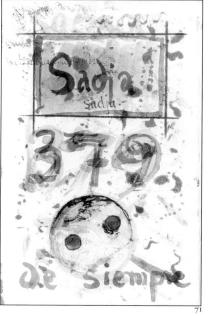

Sadja Sadja 379 forever

T he word "Sadja" appears several times in the diary; twice Kahlo used it as her own signature (plates 102 and 127). "Sadja" is a variation on the Sanskrit words Sadha, meaning heaven and earth, and Sadya, meaning genuine or sincere. Here, Kahlo links it with the numbers 3, 7, and 9 (which also had a mystical, as yet still undetermined, meaning for her), the yin and yang symbol, and the word "forever."

urning her journal on its side, Kahlo reorients the page from a "portrait" to a "landscape" format, giving the dancers more horizontal space. The figures are crowded into the very foreground of the image. with no horizon line to supply depth, and little room around the edges. Kahlo emphasizes the essence of their movement by using strong diagonals and heavy black parallel lines, which convey the sense of gesture learned and repeated. Her use of green and red, opposites on the color wheel, creates a visual dissonance that further activates the image.

The idea that different kinds of line can express emotion or affect the mood of a painting is not new. In the 1920s, Kandinsky codified his investigations in that area for courses he taught at Germany's Bauhaus. Closer to home, however, Kahlo may well have been familiar with Adolfo Best Maugard's distillation of Pre-Hispanic design into a basic group of lines, which was widely used in art education in Mexico.

1.947

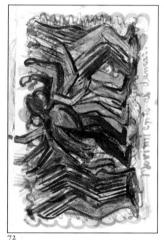

Motion in dance.

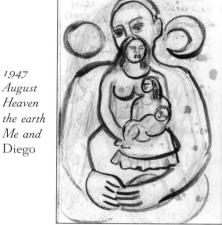

 ${
m K}$ ahlo dates this monochromatic drawing August 1947, and it is one of the very few images in the diary she eventually translated into a fullfledged oil painting. The overall structure of The Love Embrace of the Universe, the Earth (Mexico), Diego, Me and Señor Xolotl (1949) resembles this ethereal drawing, but the later work, though fascinating for the inclusion of numerous details, lacks the breathtaking economy of this image.

Kahlo sits on the lap of Mexico, personified as a woman; on her lap lies the baby Diego. The three of them are embraced by a beneficent Buddhalike being representing the Universe. The sun and moon, the yin and yang of Aztec thought, balance each other in the galaxy of Kahlo's cosmos.

The image recalls the passages she wrote on plates 57-60 of her journal. Kahlo envisions Rivera as both her child and her universe, but in fact, it is Kahlo who dominates: her voice and her vision in the diary speak to her conception of herself as firmly centered at the hub of a universe of her own creation.

K ahlo wrote this passage between August and November 1947, in the months following her fortieth birthday. Her handwriting is loose and somewhat uncontrolled, quite possibly the result of large doses of pain killers she began taking after a particularly gruesome operation and its painful aftermath in 1946.

Some now-unknown psychic pain caused Kahlo to erupt into her diary. She returned at some point later and crossed out a number of lines but what remains are references to themes that occur intermittently throughout the diary. For example, her relationship with madness (see plates 15 and 29), her attention to arranging flowers (plate 56), and her reflection on revolution as both a material reality and an ideal metaphor (plates 103–5). On the last two pages of this section, Kahlo concisely articulates her understanding of revolutionary process. Revolution, as Kahlo explains it, begins to take on the power of a religious belief system, and her words reveal a growing reliance upon this process to explain her existential isolation.

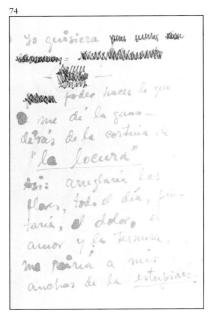

I wish xxxx xxxx xxx

xxxxxx = xxxxxx

- xxxxx
xxxxx I could do whatever I liked
behind the curtain of

"madness"

Then: I'd arrange

flowers, all day long, I'd

paint, pain,

love and tenderness,

I'd laugh as much as I feel like

at the stupidity

de los etros y Todos devian:

(sobre tero ma reina de Musicação
Construira mi mundo
que iminitras montra,
estana = de acuera = cos
todos des ministras provincias
Reina, e la hora, o exe
monieta, que viviera,
seria mio y de
70 dos Mic Locura, no seria
mu escape al
Trabajo

of others, and they would all say:
poor thing! she's crazy.
(above all I'd laugh at my own stupidity)
I'd build my world
which while I lived,
would be = in agreement = with
all the worlds
The day, or the hour, or the
minute, that I lived
would be mine and
everyone else's My madness, would not
be an escape from
"work"

mantacean ?

Thank on sa caso?

Thank the Manual Manual Party of the Manual Manual Party of the Manual Par

why did the others support me with their labor?

Ca produción 22 la color de de color de de color de color

xxxxxxx

Revolution is the harmony of form and color and everything exists, and moves, under only one law = life = Nobody is separate from anybody else - Nobody fights for himself.

Everything is all and one Anguish and

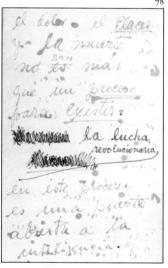

pain - pleasure
and death
are no more
than a process
for existence
xxxx the revolutionary
struggle
xxxxxx
in this process
is a doorway
open to
intelligence.

The date on this page is another marker to help orient the reader. It also marks the thirtieth anniversary of Russia's Bolshevik Revolution and was a day meaningful to Kahlo for another reason: Exactly ten years earlier, she had dedicated an exquisite self-portrait, dated November 7, 1939, to Leon Trotsky, a gift to remember her by.

Kahlo inscribed the words "Tree of Hope Stand Firm" on a flag she included in a painting with the same title, done in 1946. They were lyrics to a song she knew, words she adopted as her motto,⁴ and appear several times throughout the diary (plates 55 and 130).

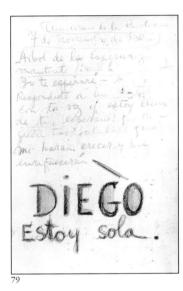

Anniversary of the Revolution
7th of November 1947
Tree of Hope
stand firm!
I'll wait for you You responded to a sense
with your voice and I'm full
of you, waiting for
your words which
will make me grow and
will enrich me

DIEGO I'm alone.

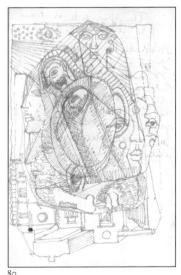

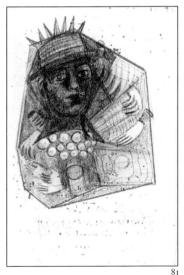

Who is this idiot?

⁴ See Herrera, Frida: A Biography: 355, and Herrera, Frida Kahlo: The Paintings: 193.

he text on these four pages is among the most intimate and revealing of Kahlo's diary. A private memory of a cherished childhood fantasy provided great comfort when she wrote it in 1950. The doubled entry first the small, scratchy words in blue ink, and then again with determination in a larger, brown-gray scrawl - underscores the importance of this recollection.

Kahlo tells a detailed story of her "descent" to a make-believe world where she found her imaginary friend (a narrative that resembles adventures of Lewis Carroll's Alice). During her ventures "through" the glass window, Kahlo finds ineffable freedom and security, feelings associated with the comforting assurances of a mother. One of the two Fridas may well be the child who is sustained by a mother's reassurance, while the other, realizing her autonomy, knows she is beyond consolation. Indeed, the drawing on the final page suggests this: the glass is opaque and offers no vista. The child Kahlo makes her own way, while keeping in touch with the other self.

Kahlo identified the figures in her enormous painting The Two Fridas, done in 1939, the year she divorced Rivera: one was the self Rivera once loved, the other the one he no longer loved. Her divided self from childhood thus reappeared at times when she felt the burden of her autonomy.

ORIGIN OF THE TWO FRIDAS.

= Memory =I must have been six years old when I had the intense experience of an imaginary friendship with a little girl . . roughly my own age. On the window of my old room, facing Allende Street, I used to breathe on one of the top panes. And with my finger I would draw a "door". Through that "door" I would come out, in my imagination,

cross all the field I could see until I reached

and hurriedly, with immense happiness, I would

a una lecheria que se llamaba PINZON ... Por 1 de PINZON ba, y bajaba al interior de la tierra, donde "mi amiga imaginaria" me esperada Siempre. No te-Cuerdo su imager ni su color. Pero si se que era alegre - Se reia mucho. Sin sovidos. Ena agil. y bailaba como si no Auviera pero nuguno. To la Segma en todos sus movimientos y le Contaba. mientras ella bailaba. mis problemas secretos. Ilua les? no recaesdo. Pero ella

a dairy store called PINZÓN . . . Through the "O" in PINZÓN I entered and descended impetuously

to the entrails of the earth, where "my imaginary friend" always waited for me. I don't remember her appearance or her color. But I do remember her joyfuless - she laughed a lot. Soundlessly. She was agile. and danced as if she were weightless. I followed her in every movement and while she danced, I told her my secret problems. Which ones? I can't remember. But

Salvia year mi voz todas nus Cosas ... Occarido ya rigre-Saba a las ventama, dixtraba por la misma puesta dilujada en el cristal. ¿ Cuardo? I Por creato termoo habia estado Con ella"? no se . Pudo. ser sin segundo o miles de ano: .. Jo era felir Desdi bujaba la puerta con la mano y "desaparecia". Corrid secreto y mi alegrea mada el retimo rincon del palio de mi casa, y. Scerepte lu el mismo-lugar, debajo de un arbol e. cedron, gritaba Meia Assombradas de esta

from my voice she knew all about my affairs. . When I came back to the window, I would enter through the same door I had drawn on the glass. When? How long had I been with "her"? I don't know. It could have been a second or thousands of years. . . I was happy. I would erase the "door" with my hand and it would "disappear." I ran with my secret and my joy to the farthest corner of the patio of my house, and always to the same place, under a cedron tree, I would shout and laugh Amazed to be

Alone with my great happiness with the very vivid memory of the little girl. It has been 34 years since I lived that magical friendship and every time I remember it it comes alive and grows more and more inside my world. PINZÓN 1950. Frida Kahlo

LAS DOS FRI-DAS

Coyoacán Allende 52

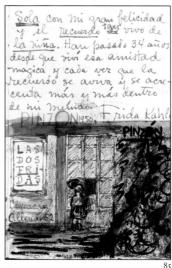

here is an eerie sequential progression to the images and words on this page. At the top of the page Kahlo admits, "This pen is no good for this paper," and gives it up. Reaching for another medium, she knocks over a bottle of ink, and then draws it, shattered and spilling its contents. Below is a brief but ardent statement about Rivera and his "tenderness" toward Mexican sculpture, over which is superimposed a disembodied hand, probably Rivera's, caressing an indistinguishable mass.

During this period of her life, Kahlo devoted herself to helping Rivera realize his desire to build a museum to house the nearly sixty thousand Pre-Columbian objects he had collected over the years. Rivera began thinking about the project in the mid-1940s, and Anahuacalli (meaning "house of the idols" in Nahuatl), was eventually built in the image of an ancient pyramid, and stands today in the southern part of Mexico City as a monument to Rivera and Kahlo's careful acquisition of their Mexican heritage.

This pen is no good for this paper.

I have never seen tenderness as great as Diego has and gives when his hands and his beautiful eyes touch Mexican Indian sculpture.

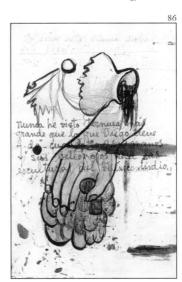

Madie et mat que un Sucreionamiento o parte de una frueron total. do va pasa, y da caminos, pe no se recorren vancons Pero nadie puede detina "libremente" a jugar un el sendero, porque retain no transforma el triaje atomico if general; De alli vera et descontento, de all la desespetano y la trettan so Todos y no el exeminata número. Los cambias y la lancha 3105 december to no aterion for court

No one is more than a function - or part of a total function. Life goes by, and sets paths, which are not traveled in vain. But no one can stop "freely" to play by the wayside, because he will delay or upset the general atomic journey. From this comes discontent From this comes despair and unhappiness. We all would like to be the sum total and not one of the numerical elements. Changes and struggles disconcert us, terrify us because they are con-

tes y por ciertos, bus carnos la Calma y la "paz" perque nos anticipamos a la muerte que morimos cada segundo. Los opuesto se unen y nara nuevo ni anitmico descubrimos. nos alamos in lo inacional, in lo inacional, in lo inacional, in lo inacional, in lo mágico, in lo anormal, por miedo à la extraordinaria belleja de lo cierto,

stant and certain, we search for calm and "peace" because we foresee the death that we die every second. Opposites unite and nothing new or arhythmic is discovered. We take refuge in, we take flight into irrationality, magic, abnormality, in fear of the extraordinary beauty of the truth

88

of matter and dialectics, of whatever is healthy and strong we like being sick to protect ourselves. Someone - something - always protects us from the truth — Our own ignorance and fear. Fear of everything - fear of knowing that we are no more than vectors direction construction and destruction to be alive, and

de la material y

bralitico, de la

Sano y frierte

nos grista ser informos fara protegnos.

Uguen algo - mos

rotas premare de la

propia ignorancia
y nuestra miedo.

miedo a todo - muos
a saber que no romo

vectores fue no romo

construcción y declaración
paras ser vivos, y

solos ser vivos, y

solos ser vivos, y

solos ser vivos, y

to feel the anguish of waiting for the next moment and of taking part in the complex current (of affairs) not knowing that we are headed toward ourselves, through millions of stone beings - of bird beings - of microbe beings - of fountain beings toward

senter la angustes de esperar al minuto se quente y partierpar en la cornente la cornente la complija de no salor que mos dirigimos a mosotros mismos, a través de millores de seres piedras- de seres de seres microbios- de seres microbios- de seres fuentes a .

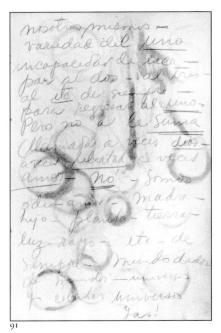

ourselves variety of the one incapable of escaping to the two - to the three to the usual to return to the one. Yet not the sum (sometimes called God sometimes freedom sometimes love - no - we are hatred - love - mother child - plant - earth light - ray - as usual - world bringer of worlds - universes and cell universes -Enough!

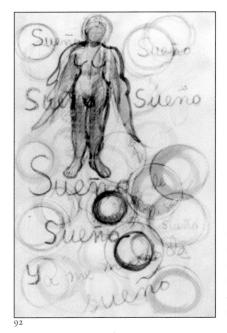

Sleep Sleep Sleep Sleep Sleep Sleep I'm falling asleep As a biographical source (although not wholly accurate), these pages reveal Kahlo's self-presentation and the manner in which she remembered many of the details of her life. Of particular interest is her explanation of her "revolutionary" devotion: she equates being part of the movement with being alive, and thus fuels herself at a time when her energy was draining away. On the verso Kahlo recounts her surgeries and expresses gratitude to her doctor, Juan Farill, to whom she dedicated a painting in 1951. Kahlo's inclusive dates, "1910–1953" (which read eerily as a life span), and the fact that the page is tipped in, suggest it was written later. The uncertain handwriting and the chronicle of her operations imply a concession to mortality.

12 Connector de que no este de acuerdo con las contrarendamen - lugarella manda de trucas de la constante de acuerdo con del constante de la constante de la contrarenda del contrarenda de la c

1st. I'm convinced of my disagreement with the counterrevolution - imperialism fascism - religions - stupidity - capitalism - and the whole gamut of bourgeois tricks -I wish to cooperate with the Revolution in transforming the world into a classless one so that we can attain a better rhythm for the oppressed classes 2nd. a timely moment to clarify who are the allies of the Revolution Read Lenin - Stalin -Learn that I am nothing but a "small damned" part of a revolutionary movement. *Always* revolutionary

never dead, never useless

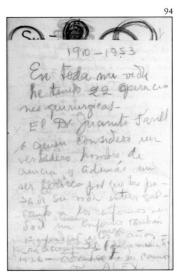

1910–1953
In all my life
I have had 22 surgical
interventions Dr Juanito Farill, whom I consider to be a
true man of
science, and also a
heroic being because he has spent
his entire life saving the lives of the ill when
he himself is ill also
1st illness, when I was 6
infantile paralysis (poliomyelitis)
1926 - bus accident
with ALEX

These pages dated 1950–51 begin with the sobering fact that she has had seven operations on her back in the course of a year, which explains the lapse in her diary. Kahlo, however, seems to believe herself somewhat on the mend, and summons the strength to paint. There is evidence that several pages have been removed at this point in the diary.

He estado emperación de consensa en la column respersa en la column de primar en la column de consensa en la column respersa en la column de la

1950-51 I've been sick for a year now. Seven operations on my spinal column. Doctor Farill saved me. He brought me back the joy of life. I am still in the wheelchair, and I don't know if I'll be able to walk again soon. I have a plaster corset even though it is a frightful nuisance, it helps my spine. I don't feel any pain. Only this . . . bloody tiredness, and naturally, quite often, despair.

pación Una deseggo, nación que mugura paladora punto de de la continente o terror. Ja comence o pondan El cuadrito que esta por facilita que estas hacindo con todo pur ocame para el Tengo mucha injunto de la classificada por todo por tod

96

A despair which no
words can describe.
I'm still eager to live. I've
started to paint again. A
little picture to
give to Dr Farill on which I'm working
with all my love.
I feel uneasy about my painting. Above
all I want to transform
it into something
useful for the Communist

to perolucionario comuanistro peres hacta abora
no he putade, seun
la expresión manada
de mi muema, per o
alizados aberlutamente
de lo que mi puntura
puedo serviro al parties.
pelo lucha; con toda
mi fuerza para que
ho poro de positivo seu
ni salud ane deje.
haces sea su direcció
a aquadas a la perilución. La truica
hacen. La fuera
hacen. La fuera
hacen. La fuera
hacen. La pera rivir.

revolutionary movement, since up to now I have only painted the earnest portrayal of myself, but I'm very far from work that could serve the Party. I have to fight with all my strength to contribute the few positive things my health allows me to the revolution. The only true reason to live for.

Pacing a strange image of a bearded man with an encased dog (did it begin as a self-portrait?) is another portrait, probably a self-portrait with lines enclosing the figure suggesting a veil of iron or the planes to be chipped away from a block of stone to make a statue, or even the dimensions of a coffin. Around her neck the zigzags look like jewelry but recall her painting *The Broken Column* from 1944. The look of distress is explained by the caption, "What a dish!" In other words, Kahlo, the beautiful, intelligent, passionate woman, has been barred from what other young women desire. Explaining the subjects she painted, she remarked: "Nothing seemed more natural than to paint what had not been fulfilled." 5

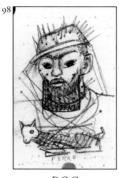

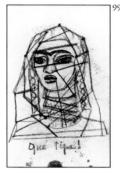

DOG

What a dish!

These pendant portraits repeat an image Kahlo used earlier (on plate 56), an anthropomorphic vase, here shown shattered. As vases, they make an unmistakable allusion to classical urns used as grave markers. The captions are suggestive of an interior monologue, or in Kahlo's case, dialogue. These are self-portraits, again the two Fridas: the red lips evoking Kahlo's lost youth and wasted womanliness. The tears are literal, referring to her immediate physical pain, and symbolic, underscoring her identification with the Madonna of Sorrows (the image of the Virgin Mary who has lost her Son), as well as with the Mexican legend of La Llorona (see plate 24).

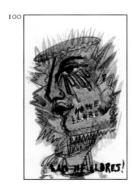

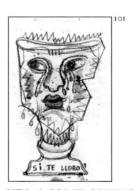

YES, I COME CRYING TO YOU

⁵ Herrera, Frida: A Biography: 317.

This page, and the next, are two of the few dated pages in Kahlo's diary.

They suggest that she made no entries during the first ten months of 1952. She had, however, produced four paintings.

Kahlo signs this page "Sadga," a variant of the signature she uses again on plate 127 as well as a variant of Sadja (see plate 71).

"Yrenáica" means "from Irene's place." Irene was Diego's assistant and lover during his brief divorce from Frida. After Trotsky's assassination, Irene helped Diego to escape the police hunt for him.

Noviembro 9-1959.

Niño - auror. Cuencia evacta.
voluntar de resistir viviends.
alegria Sana. Orati lud vistinita. Opos lu llas manos e y
tacto en la mirada. Tompiega
y termera brental. Exorme
Columna bontebral que es
base para todo la esternotura
humana. Ya verenos, ya
aprenderenos. Siengos hay cosos
nuevos. Siengos ligadas a las
antignas vivas.
Alado- mi Dida mi
amor de miles de ants
Comor de miles de ants

November 9-1951 Child-love. Exact science. the will to resist and still live healthy happiness. infinite gratitude. Sight in the hands and touch in the eyes. Neat and gentle as fruit. The enormous spine is the basis of all human structure. We shall see, we shall learn. There is always something new. Always tied to ancient existence. Winged - My Diego my love of thousands of years. Sadga. Yrenáica Frida. DIEGO

T he first page of this five-page text is dated November 4, 1952, but the different-colored pencils, the variation in her handwriting, and the two layers of narrative indicate that Kahlo wrote it over a period of time.

Most interesting is Kahlo's comment on the political content of her own work, which she refers to as "revolutionary realism." Until now, Kahlo's thoughts on painting tended toward poetic ruminations relevant mostly to her own personal cosmos. She seems now to yearn for a "scientific" peg on which to understand her own work. She has become preoccupied with a Marxist interpretation of her world, a fixation that is apparent throughout the rest of her diary.

How come numero entry acomejontrada la 19 a a anos ory
Mar yo committe

History comes authorized anomalto ten places animal.

He leids la fishinade in part
to ten todas la particle common of
the Mar conflicts to disce p

the Mar conflicts to disce p

the Mar conflicts to disce p

the Mar conflicts to the series

Mary 1 mg ll Series State

y Mar Title Nor amo temp
a los filosopher Compression

committee of a Maria Sopher Greatleyour and Maria Sopher Sopher

tradition of a maria true
tradition of a maria disc.

1952 November 4. Today I'm in better company than for 20 years) I am a self I am a Communist. I know I have read methodically that the main origins are wrapped in ancient roots. I have read the History of my country and of nearly all nations. I know their class struggles and their economic conflicts. I understand quite clearly the dialectical materialism of Marx, Engels, Lenin, Stalin and Mao Tse. I love them as the pillars of the new Communist world. Since Trotsky came to Mexico I have understood his error. I was never a Trotskyist. But in those days

1940 - my only alliance was with

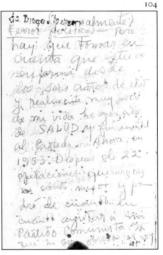

Diego (personally) Political fervor. But one has to make allowances for the fact that I had been sick since I was six vears old and for really very short periods of my life have I enjoyed truly good HEALTH and I was of no use to the Party. Now in 1953. After 22 surgical interventions I feel better and now and then I will be able to help my Communist Party. Although I'm not a worker, but a

artesang y aliant mevishiento re voluciorario
Comunista.
Por primatariora, en ince
troda la pintario inno
troda de agratario inco
limes transación por el
Bartisto. REALISMO
REVELUCIONIBRISTO LOS
SOYSOCAMENTE MAS
Colução del momplejo.
Naciones mo perolucioratio de la fondos
puedos nues sone to

craftswoman - And an unconditional ally of the Communist revolutionary movement. For the first time in my life my painting is trying to help in the line set down by the Party. REVOLUTIONARY REALISM Before it was my earliest experience -I am only a cell in the complex revolutionary mechanism of the peoples for peace in the new nations, Soviets -

col chinos chico esto vages professor la sangre a mun prolind general de prisons.

Entroples as flantes.

Entroples as flantes.

Jasia trastras most
maxima nomes de prief.

observanos de prief.

Chinese - Czechoslovakians - Poles - united in blood to me. And to the Mexican Indian. Among those great multitudes of Asian people there will always be the faces of my own -Mexicans - with dark skin and beautiful form, with limitless grace. The black people would also be freed, so beautiful and so brave. (Mexicans and negroes are subjugated for now

by capitalist countries above all North America - (U.S. and England). xxxxxxxxxxxxx

Three wonderful comrades came into my life -Elena Vazquez Gómez Teresa Proenza and Judy (the last was really my nurse) The other two are really astounding in intelligence and sensibility in the revolutionary cause in addition the three of them have collaborated so that my health has improved They are very good friends of Diego's and great friends of mine

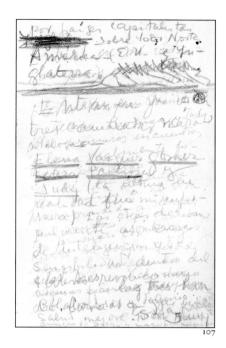

Friday 30 January 1953. In spite of my long illness, I feel immense joy in LIVING

DYING
Coyoacán
4 March
1953
THE WORLD MEXICO
THE WHOLE
UNIVERSE
has lost its bal-

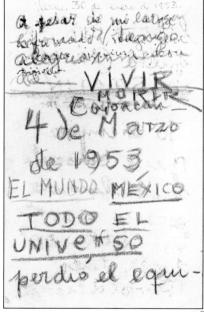

108

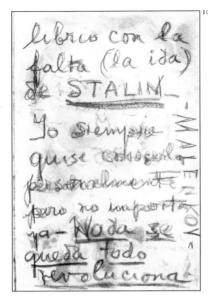

ance with the loss (the passing) of STALIN - I always wanted to meet him personally but it no longer matters - There is nothing left everything revolves

- Malenkov -

T he vile green background adds to the oppressive feeling of this ominous portrait. This iconic figure stares out intently, its large eyes giving the impression of youth. By some alchemical magic two halves are made whole: on the left, a female with long curly hair, and dressed; on the right, a male, hair cropped and flames surrounding his head like a halo, bare.

Kahlo painted two portraits in 1944 of herself and Rivera as a single head, but the features here are so stylized that an absolute correspondence is uncertain. The thick black lines of ink further obscure the identities: the enigmatic caption "wood 379" offers no clue, though it is a number Kahlo used earlier in her journal (plate 71).

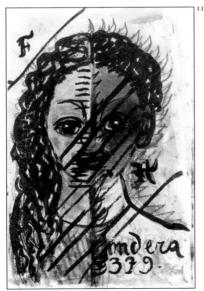

Madera 379 A mid self-descriptions and partisan slogans in ink and scratchy lines in green and red crayon are three images. The foot is the most resonant: the speckles and sectioning with arrows make clear that it alludes to Kahlo's infirmity. But since it is a left foot, not the one which was afflicted, it seems to be a symbol, looking at once like a fortuneteller's coded chart and like the outlined feet in Aztec codices used to indicate direction. Below it is a circle with a dot, an Aztec symbol signifying one unit, typically used in calendars to mark the number of days. The yin-yang sign next to it, which Kahlo uses liberally throughout the diary, visually completes the balance among the three objects.

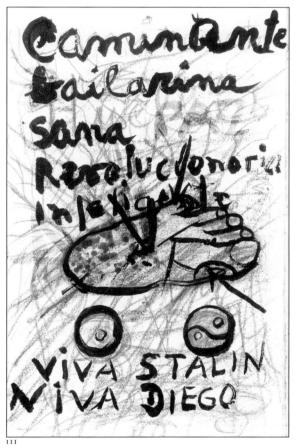

Walker dancer healthy PEACE Revolutionary intelligent

LONG LIVE STALIN LONG LIVE DIEGO T wo pages of devotion to Rivera: the visible wing of the misshapen angel is the same shape as the leaves opposite. The life force of the plant on the right is countered by the presence of the winged being on the left, an omen of things to come.

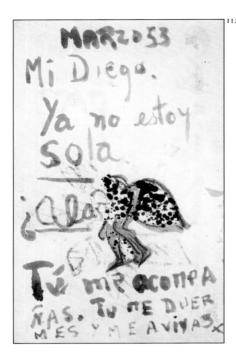

March 53
My Diego.
I'm no longer
alone.
Wings?
You keep me company. You lull me to
sleep and make me come alive

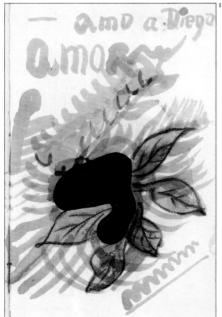

-I love Diego Love And pairs a powerful modern political system—Communism—with an ancient, longer-lived regime—the Aztec empire. The traditional Communist symbols of a crossed hammer and sickle arranged in placard fashion are appropriate to her message. Kahlo inscribes the names of her political heroes—Engels, Marx, Lenin, Stalin, and Mao—of whom two years earlier (plate 103) she had written: "I love them as the pillars of the new Communist world." Opposite, Kahlo's painting resembles the pictographic form of the Aztec codices which use both recognizable symbols and textual information. The somber colors intensify the barren terrain.

The words "MOON" and "SUN" relate to the two ancient Aztec pyramids at the site of Teotihuacán, thirty miles north of Mexico City. These celestial bodies were also integral symbols in Aztec culture and worship, and signified the cyclical changes of the seasons.

In the middle of the landscape is a curious form, a truncated figure with one arm exploding in a bouquet of ink splatter. The woman is dressed in a traditional Mexican costume typical of the kind Kahlo herself often wore. Is it Kahlo? Even she seems unsure, since at the bottom of the page she writes, "ME?"

About this time, Kahlo painted *Marxism Will Heal the Sick*, where she explicitly entrusts her fate to a political ideal after her faith in modern medicine has been shaken.

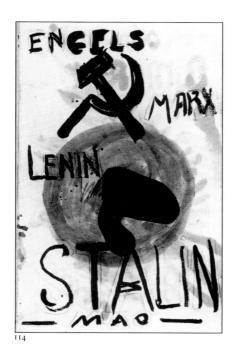

ENGELS MARX LENIN STALIN MAO

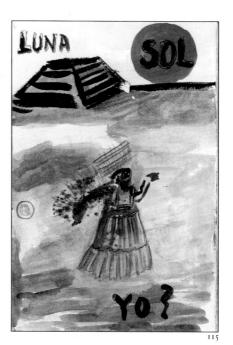

MOON SUN ME? It also shifts abruptly from ancient civilization to popular culture, filling this plate with images of skeletons called *calaveras*, meaning literally "skulls," or *muertes*, "skeletons." Toys, candies, and edible figurines in the shape of *calaveras* or *muertes* are produced for the Mexican observance of the Day of the Dead, on November 2. This national holiday is celebrated by taking offerings of food, flowers, and incense to the dead in cemeteries. The widespread presence of the *calavera* points up a Mexican attitude toward death which might be called national fatalism. Death is dreaded, but is also made fun of, made absurd through the replication of its image. There is something ominous, however, about the fact that Kahlo has placed the central, "female" *calavera* in the same position, but in reverse, as the figure on the previous page. The two even share a shattered arm.

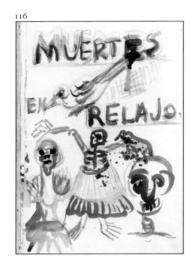

DEATHS IN A RIOT

"C ITLÁLI" is a Nahuatl word meaning "star."

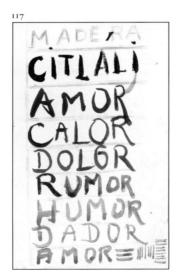

WOOD CITLÁLI LOVE WARMTH PAIN RUMOR HUMOR BRINGER LOVE And painted this dense, stifling landscape from a worm's-eye view, from the perspective of the interred. She reverses the role of roots, which usually convey sustenance: now these flashes of lightning nourish not lush vegetation but flames, which are beginning to engulf what appears to be a casket. The sun and moon appear, but now the moon, with its associations of death, predominates. No black humor here: the insouciance of the *calavera* is replaced by bleak reality.

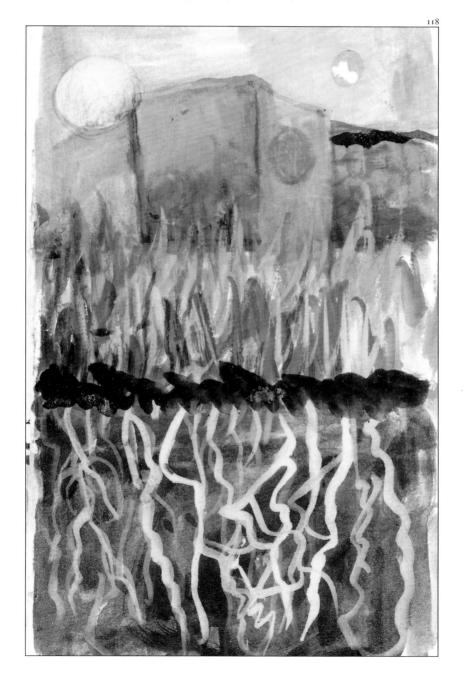

This grim drawing refers to the premature death of Kahlo's friend Isabel ("Chabela") Villaseñor to whom Kahlo devotes the next two pages. Villaseñor, seven years younger than Kahlo, was a precocious poet, graphic artist, and muralist. They met as early as 1928 when Villaseñor was associated with the vanguard artists of the 130–30! movement (after the designation of a rifle used in the Revolution). Her future husband, the painter, printmaker, and theater designer Gabriel Fernández Ledesma, was also a member of the group. In 1931, Sergei Eisenstein cast Villaseñor as the star of one of the four sections of his epic film *Que Viva México!* Kahlo's praise of her friend on plate 121' is thus not exaggerated. Her final mention of "your Olinka" is a poignant reference to Villaseñor's daughter.

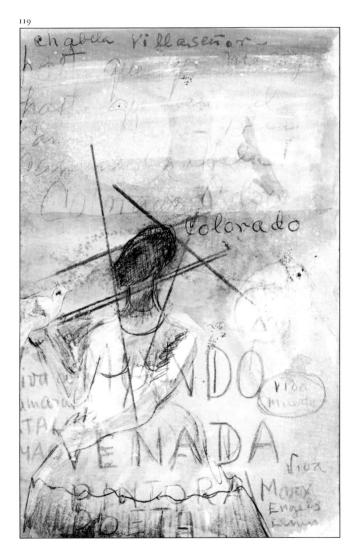

Chabela Villaseñor — Ruddy

Long live Comrades STALIN MAO

Life Death

WORLD DOE PAINTER POET

Long live Marx Engels Lenin Ahlo's poetic tribute to the death of Villaseñor (on the next page) has its counterpart in this simple but powerful painting of a deer, a symbol with special meaning for Kahlo. The deer was a recurrent theme in Pre-Columbian mythology, linked in fact with the right foot, Kahlo's diseased one, and in 1946, she painted her self-portrait on the body of a wounded deer in *The Little Deer*. On the preceding page, across a drawing representing Villaseñor, Kahlo writes in large, red letters "VENADA" (deer). The repetition of the word "colorado" (or "ruddy") in her testimonial finds a visual counterpart on this page in the intensely saturated painting. The young deer (modeled perhaps on Kahlo's own pet deer, Granizo) recalls the work of the German Expressionist Franz Marc, whose pictures of horses, deer, and foxes spoke both to his love of animals and to a vision of a utopian world. Kahlo, too, alludes to a greater being: in the center of the red orb is the word "TAO," the life force and principal being of Buddhism.

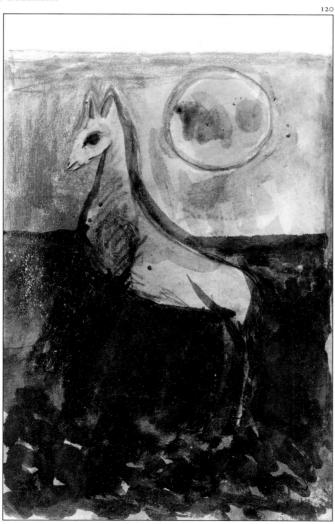

TAO

Below her moving elegiac verse to her friend Kahlo offers a "scientific" certainty in her diagram of the principles of the golden section (sometimes called the golden mean), a mathematical relationship thought to be inherently harmonic. The equation may be expressed in the following way: a line divided so that the smaller section is to the larger as the larger is to the whole. On the sides of her triangular diagram, Kahlo writes "S.O.," for "sección de oro," as she labels a still-life drawing on plate 135.

The eyes Kahlo draws on three sides of her tiny sketched still life here refer to the fact that artists have for centuries applied the laws of the golden section to their work in the belief that they would thereby ensure a more aesthetically pleasing composition.

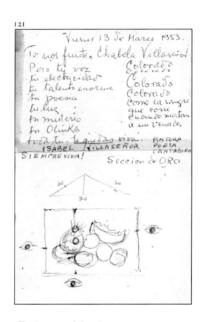

Friday 13 March 1953. You left us, Chabela Villaseñor

But your voice Ruddy
your electricity Ruddy
your enormous talent Ruddy

your poetry Ruddy
your light Like the blood

that runs

your mystery when they kill your Olinka a deer.
all that remains of you - is still alive.

ISABEL VILLASEÑOR PAINTER POET SINGER

FOREVER ALIVE!
GOLDEN Section

Allo's interest in artists' guidelines continues here. She transcribes a detailed recipe for a paint medium using damar gum, a resin harvested from trees native to the Pacific. Pigment would be added to the medium after completing the process. In her heading—"For the old concealer Fisita"—she refers to herself, using Rivera's nickname for her. Quite possibly, Kahlo wrote this out sometime earlier: it is unlikely at this late date that she would follow these elaborate directions.

FOR THE OLD CONCEALER FISITA. Distemper together 4 equal parts of egg yolks raw linseed oil

egg yolk = raw linseed oil = compound of damar gum blended in turpentine = water

damar gum dissolved in turpentine and distilled water. with disinfectant take = concentrated aldehyde alcohol. 1/2 gram. to a liter of water.

crushed damar inside of lemon [suspended in] turpentine for 8 to 10 days.

remove all the white from the yolk.

- 1. Make an emulsion of the ingredients
- 2. Grind the colors into the emulsion
- 3. If a glossy texture is desired, increase the amount of damar, up to two parts.
- 4. If an overall mat finish is desired increase the water up to three parts

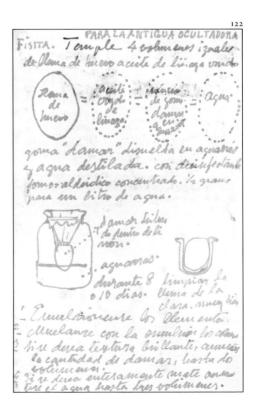

M r. Xolotl is the name of Kahlo's *itzcuintli* dog, whose image she draws at the bottom of the page. It is appropriate enough, since Xolotl was an Aztec god, the dog-headed aspect of Quetzalcóatl. Additionally, one group of nomadic prehistoric peoples that populated the Valley of Mexico were called the Chichimec of Xolotl, or the dog people. Kahlo had packs of these dogs, a breed with ancestry traceable to the Aztecs, hence their appeal to her. Kahlo painted herself with Mr. Xolotl several times, and her pet monkeys and parrots appear in dozens of self-portraits where they relate to the Aztec conception of a *nahual*, or animal alter ego. The ancient Mexicans believed their gods had the capacity to transform themselves into animals at will. In this case, Kahlo casts her favorite little dog as a stately ambassador.

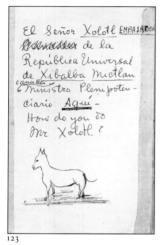

The Lord Xolotl AMBASSADOR
Chancellor of the
Universal Republic
of Xibalba Mictlan
Chancellor Minister Plenipotentiary Here—
How do you do
Mr. Xolotl?

I January 1953
xxxx 1953, Winter
Bernice Kolko
I think she
is a great artist. She photographs reality admirably. (she is not a
Communist) An
American
citizen - Hungarian Jew
She says she is for
peace. but ?

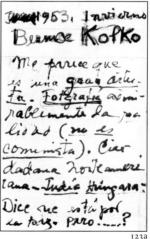

1230

This page, sealed by the previous one, was revealed after the first was removed. Here is another instance of two layers of writing: the paler one underneath impossible to read, the one on the surface in black ink now the only message legible. Bernice Kolko was a photographer who was born in Poland in 1905. She emigrated to the United States in 1920 and first visited Mexico in the winter of 1951. Her photographs were greeted warmly, and she was encouraged to stay. She traveled widely in Mexico documenting the condition of the people, especially women.

E nigmatic as the words on this page are, the drawing conveys Kahlo feeling most vulnerable. With her tiny head and broken wings, standing naked in the midst of what may be evergreen branches that appear to be on fire, she wonders if her time has come. Are you leaving? she asks herself. No, she answers, broken wings.

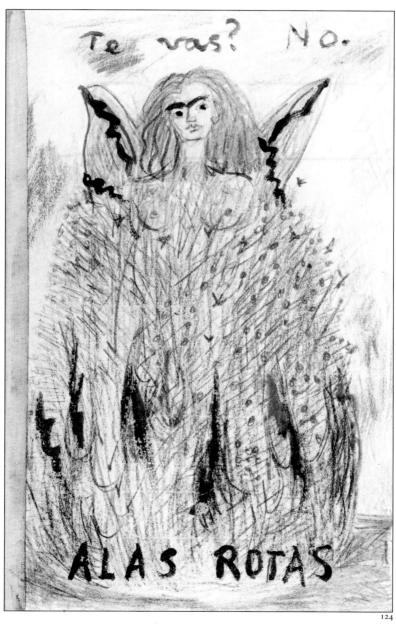

Are you leaving? No. BROKEN WINGS

This passage dated December 8, 1938, on a page taped into the diary, was written while Kahlo was in New York for her exhibition at the Julien Levy Gallery and during her affair with Nickolas Muray. Several pages of the diary were torn out at this point.

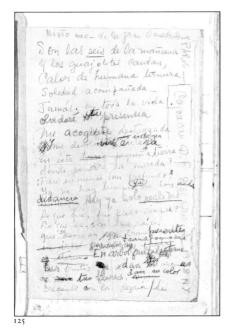

My own child - from the great Concealer PARIS - Coyoacan D.F. 8 Dec. 1938 N.Y. It is six o'clock in the morning and the turkeys are singing, Warmth of human tenderness Companionable solitude -Never, in all my life will I forget your presence You took me to you when I was shattered and you restored me to a complete whole In this small world where shall I turn my eyes? It's deep immense! There isn't enough time there isn't enough nothing. There is only reality. What once was is long gone! What remains, are the transparent roots appearing transformed into an eternal fruit tree Your fruits already give scent your flowers give color blooming in the joy of

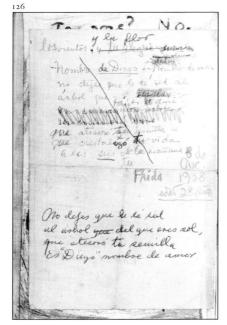

wind and flower and your happiness Name of Diego—Name of love.

Don't let the tree get thirsty it loves you so much. it treasured your seed it crystallized your life at six in the morning

Your Frida 8 Dec. 1938 age 28 years

Don't let the tree get thirsty, you are its sun, it treasured your seed "Diego" is the name of love. M arch 21 is probably the date she wrote this page; July 7 is the day she celebrated as her birthday; December 8 is Rivera's birthday. She signs her name Sadga, as she had on plates 71 and 102, but here, in conjunction with a date, it means "here and now."

A fact Diego told me
Diego lived in Paris:
26 Rue du Départ, next
to the Montparnasse railway station.
21 March. Springtime
Tao MAO
7 July. Sadga 1953

8th. December Diego. LOVE

Will the year 1953 end in a war between the imperialists? Very likely. NAME OF WATER

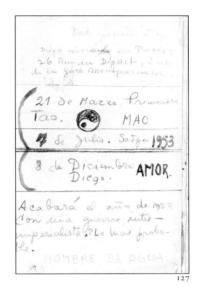

K ahlo must have been in an especially black mood when she painted this. Everything is backward, she laments. A threatening sun looking truly the "color of poison" hovers above Kahlo's reclining body, posed like a figure on an Etruscan sarcophagus. Her lower extremities are not delineated, but matching the color of the toxic sun, run off into the ground soaked with blood, where roots have turned black with rot.

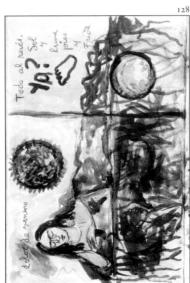

Color of poison.
Everything upside down.
ME? Sun
and
moon
feet
and

Frida

27 I

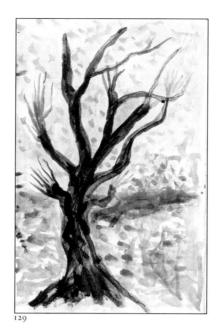

44 L a niña Mariana," "the child Mariana," probably refers to Mariana Morillo Safa, whose portrait Frida painted in a Tehuana blouse in 1944. Since Frida wrote this poem after her exhibition opened in Mexico City in 1953, presumably Mariana, whose parents were collectors, was at the opening.

La vida callada. dadora de mundosa. O Venados heridos Ropas de Flantama Rayos, Modnato, Soles reitmos escondidos La niña Mariana frutos ya muy 2700). la muerte se aleja linear, formas nidos. las manos construyen los ojos abiertos las Diego Sentidos lágrimas enteras todas son muy claras Cosmicas verdades que viven sompuidos. Arbol de la Esperanza mantente firme 130

The quiet life . . giver of worlds . . Wounded deer Tehuanas Lightning, grief, suns hidden rhythms "La niña Mariana" to lively fruit death goes away lines, forms, nests. hands build wide open eyes the Diego I felt whole tears all very clear, cosmic truths that live soundlessly.

Tree of Hope stand firm.

My exhibition in Mexico. 1953.

Months later -For H. Quietly, the grief loudly the pain. the accumulated poison love faded away. Mine was a strange world of criminal silences of strangers' watchful eyes misreading the evil. darkness in the daytime I didn't live the NIGHTS. You are killing yourself!! YOU ARE KILLING YOURSELF!! With the morbid knife of those who are watching! Was it

Mises dispuis - Para H Calladamente, la pena mis somente el dolov. el venino a en mulado. me fue dejanos damos Mundo extratio ya era il mice de Silencios criminales de alertas of sajenos males equi vocano de maren son besteridad en el dia Te estás matandi! TE ESTAS MATANDO Wester Marchas of The San 188 SACO SOME TOPPETTION SPACES Con tel cuchi le aution de que estavigi lando! La culpa la

there yo?

Admite me culps gain
tan grande cono el dodo
era una Salidi enerus
por donde pose, mi anor.
Salidi muy sileneusa.
Que me elevalna la mente
controleras tan obrotisti
que esta era mi mejor senti
Te esta matand!
TE ESTAS MATANDO
Hay Gennes yee 20
Te obordan!
Acepte son mano fueste
aque estry, paraque vivan.

my fault? I admit, my great guilt as great as pain it was an enormous exit which my love came through. A very quiet passage that was leading me toward death I was so neglected! that it would have been best for me. You are killing yourself! YOU ARE KILLING YOURSELF There are some who will never forget you! I took their strong hands Here I am, for them to live. Frida.

Experience on la augustia
quardada, la columna
quota, y la numera mirada,
Sin andar, en el vasto
Estatoro de grando mi viole careada
de acero
propriendo mi viole careada
de acero
propriendo monos propriendo
la acero
la

Years.
Waiting with anguish hidden away, my spine broken, and the immense glance, footless through the vast path . . . Carrying on my life enclosed in steel.

Diego!

A lthough the gangrene detected on Kahlo's right foot appeared not to have progressed for several years, by August 1953, the extent of its damage made amputation inevitable. The right leg was removed at the knee.

This drawing is one of Kahlo's most compelling and, unlike many others in her diary, appears preconceived and complete, not the outcome of doodling. It is premonitory and liberating, as if by visualizing her greatest fear, Kahlo could exorcise her dread of it. She gives us two disembodied feet upon a dais, and though statue-like, their yellow tint suggests anemia rather than cold stone. Emerging from the leg are not life-carrying veins, but thorny, leafless vines. The blood which should animate instead fills the page.

Kahlo's references to wings throughout her journal are half-serious, half-doubting entreaties to angels or for some other kind of divine intervention. The feet in this image appear like the amulets or votive offerings the Mexicans call *milagros* (miracles). Tiny silver (in Kahlo's day; nowadays they are tin) replicas of afflicted parts of the body were left at an image of a patron saint or worn around the neck to ensure recovery.

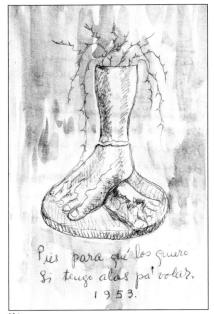

Feet what do I need them for If I have wings to fly.
1953.

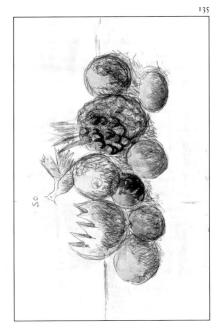

If only, I had his caresses upon me As the air touches the earth the reality of his person, would make me merrier, it would take me away from the feeling which fills me with gray. Nothing inside me would be so deep, so final. But, how can I explain to him my need for tenderness! My loneliness over the years. My structure displeases because of its lack of harmony, its unfitness. I think it would be better for me to go, to go and not to run away. If it were all over with in an instant. I hope so

Si tan solo tuniera cerca de mi su caricia el au se la di Como a la Fiera manusca Marion Windster La realidad de en persona, me haria mas alegre, me alejana del sentido que une Rosserston di gris. Nada ya seria my tan hordo tan final. Pero como le explico mi nucesidat enorme de termita! Mi Soledad de aros. Mi estructura meon forme por inarmornica. por madaptasa. To creo Sue es mejor suga, wasay no escaparme. que todo pase un un instante. Ojala

K ahlo painted the sun and Pre-Columbian pyramids dozens of times, using them symbolically as distilled emblems of both Pre-Columbian majesty and the concept of cyclical transformation it proclaimed. The sun's rising anew every day was of crucial importance to the Aztecs, signifying rebirth. In plate 137, however, Kahlo depicts its fantastic demise and the destruction of the monumental structure built to venerate it. The drawing would appear to be a pointed metaphor for Kahlo's own condition. Nothing less than ruin would result from the sun crashing out of the sky; nothing less than ruin will result when her own support is removed.

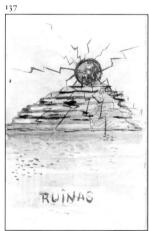

RUINS

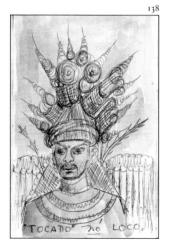

NOT AS MAD AS A HATTER.

K ahlo here plays on the meanings of the Spanish verb *tocar*: "to be crazy" and "to arrange the hairdo or headdress."

Puntos de apoyo.
En me figura completa
Solo hay uno, y quiero
dos.
Para tener yo los dos
me trêmen que cortar uno
Es el uno que no tengo el
que tengo que tener
Para poder caminar
el otro será ya muerto.
A mi, las alas me
sobran.
Que las costen.
10

July 1953. Cuernavaca Supporting points In my entire figure There is only one, and I want two. For me to have two they must cut one off It is the one I don't have the one I have to have to be able to walk the other will be dead! I have many, wings. Cut them off and to hell with it!!

Hieronymus Bosch is often evoked as an influence on Kahlo, and her high regard for his bizarre imaginings is confirmed here. Indeed, their work manifests a number of shared features, for example, the depiction of metamorphoses and the evocation of the fantastic. Further, the paintings of each give rise to simultaneous feelings of revulsion and fascination. Brueghel, the other Northern painter Kahlo mentions here, was, along with Bosch, known for his moralistic allegories.

HIERONYMUS BOSCH

MUNICIO EN HERTOGENBOSCH

AÑO 1516.

HIERONYMUS AQUEN

alian BOSCH

pintor maravilloso.

quiza nació en Aacheu.

Me inquieta mucho que

no se sepa cam nava de

este hombre faistaitico por

de gluio. (así un sigle

dispuis, (mono) vivis el

magnifico BREUGEL, EL

VIEJO. Mi amado.

HIERONYMUS Bosch Died in HERTOGENBOSCH in the YEAR 1516. HIERONYMUS Aquen alias BOSCH. wonderful painter. perhaps born in Aachen.

It disturbs me very much that there is so little known about this fantastic man of genius. Almost a century later, (less) lived the great BREUGHEL, THE ELDER, my loved one. There is something horrifying about this carefully drawn image and its attention to details; how, for instance, the feathered wings of this figure unfold naturally from the curved "under arm"; or how the shattered spinal column of this headless woman, now visible through a body held together by a wide belt, ends at the shoulders, a dove resting above. The thin spiral line encircling the left leg is reminiscent of Kahlo's etching *Frida and the Miscarriage*, from 1932, in which an infant's umbilical cord is wrapped around Kahlo's leg in a devastating self-portrait. No less jarring than the image is Kahlo's doleful refrain, "The pigeon made mistakes. It made mistakes," which is then ominously repeated on the next page.

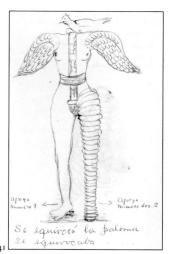

support number 1
support number two. 2
The pigeon made mistakes.
It made mistakes

August 1953.
It is certain that they are going to amputate my right leg. Details I don't know much but the opinions are very reliable. Dr. Luis Mendes and Dr. Juan Farill.

I'm very very, worried, but at the same time I feel it would be a relief. In the hope that when I walk again I'll give what remains of my courage to Diego. everything for Diego.

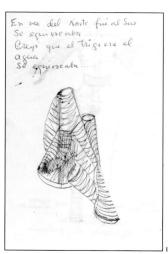

Instead of going North it went South
It made mistakes
It thought the wheat was
water
It made mistakes

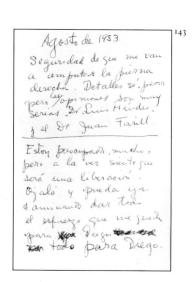

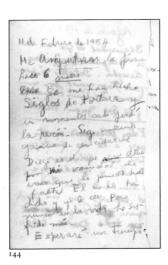

It February 1954
They amputated my leg
6 months ago
It seemed to me
centuries of torture and
at times I nearly went
crazy. I still feel like
committing suicide
Diego prevents me from doing it in the vain
belief that maybe he will
need me. He has told me
so and I believe him. But
I have never suffered so
much in my life.
I'll wait a while.

A number of sheets between plates 144 and 145 have been torn out of the diary, and there is no certain explanation for their disappearance. It has been said by some that Kahlo gave drawings from her diary to friends; this may have been true for those missing after plate 35, or this could refer to pages from other journals. The pages that fell here were more likely to have been replete with suffering. This suggests an alternative account: that someone wanted to preserve Kahlo's dignity, or perhaps shield him/herself, and so removed them from all other scrutiny.

Kahlo expresses her thanks to several doctors who have helped her: David Glusker was the husband of Anita Brenner, the Mexican-born American writer who promoted Mexican culture through her books such as *Idols Behind Altars*.

Estanos you en Ma Princeres He Logando mucho Seguridad at Cammar Segurida o al pintar. Anno a Diego mas que a mi misma. proling of o sa crante valintal borns andes. Prazias al amos ico de Diego ratago dontado Farille al intent. nonento a carinoso, all Da Paurle lange Mal Carnioso for de Guskery as 200 Floesdet.

It is already March Springtime 21 I have achieved a lot. Confidence in walking Confidence in painting. I love Diego more than myself. My will is strong My will remains. Thanks to Diego's magnificent love. To the integrity and intelligent work of Dr Farill. To the earnest and affectionate efforts of Dr Ramón Parrés and to the kindness of David Glusker who has been my doctor all my life and to Dr Eloesser.

 ${
m M}$ iss Capulina (meaning blackberry) was one of Kahlo's dogs. She has sketched her in a number of endearing attitudes.

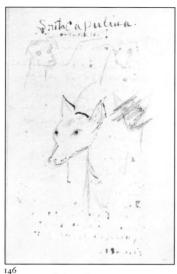

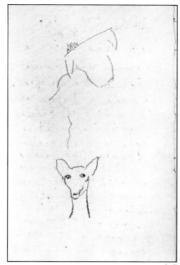

Miss Capulina

The last three written entries are spaced a month apart, marking an extremely trying period for Kahlo. Thanks to the support of Rivera, her doctors, and a circle of friends, she has moments of joy and gratitude, which she expresses in her journal. Among her intimates at this time were Teresa Proenza ("Tere"), who was active in politics, and Judith Ferreto, one of the nurses who cared for her.

April 27-1954 I am well again - I've made a promise and I'll keep it never to turn back. Thanks to Diego, thanks to my Tere, thanks to Gracielita and the little girl, thanks to Judith, thanks to Isaura Mino, thanks to Lupita Zúñiga, thanks to Dr. Ramón Parrés thanks to Dr. Glusker, thanks to Dr. Farill, to Dr. Polo, to Dr. Armando Navarro, to Dr. Vargas, Thanks to myself and

Abid 27-1954
Sali Sana. Nice la
promesa y la cumpliri
de jamás volver atris.
Gracias a Dergo, gracias a mi Tere, gracias
a Gracielita y a la riña,
gracias a Subith, gracias
a I sama Mino, gracias
a Lupita Zuniga, gracias al Ar. Ranta farris
gracias al Ar. Faid, al
Ar. Polo, a Ar. Armano
Navarro, al Ar. Vargas,
fracias o mi mis ma y

a mi volunted enorme de vivir entre tohes has que me quieren y para tohes los que yo quiero. Que vioa la alegria, la vida, viego, ere, mi Jutith y tohas las enfermida que me ha a trataso tan maravillasamente base Comunista y la hesiso toha mi vista y la hesiso toha pueblo So vietiero, al pueblo chiaso chesoslovaes y pelaco y al paeblo de Mexico, sobre to o

to my powerful will to live among those who love me and for all those I love. Long live joy, life, Diego, Tere, my Judith and all the nurses I have had in my life who have taken care of me so marvelously well. Thanks for being a Communist as I have been all my life. Thanks to the people of the Soviet Union, to the people of China Czechoslovakia, and Poland and to the people of Mexico, above all

sel de Coysèrean y Loude nació mi pli. mera celula, que se inento en Odxaca. en el vicatre de mi madel, que habia na cido ahi, casala coa mi yorke guillerno lo - mi madre the. tilde Calderón, morena campanita de Oaxaca: Tarde marcaellosa oyonean; cuarto de tresa niego, lere y Scha Capalia Era. Kostic.

those of Coyoacán where my first cell was born, which was conceived in Oaxaca, in the womb of my mother, who was born there, married to my father, Guillermo Kahlo - my mother Matilde Calderón, dark-skinned Tinker Bell from Oaxaca. Wonderful afternoon we spent here in Coyoacán; in Frida's room Diego, Tere and myself. Miss Capulina Mr. Xolotl Mrs. Kostic

150

K ahlo begins a six-page autobiographical section upon which biographers have relied for information about her earliest years. Her handwriting is extremely unsure, though her determination to relate her history is intense, and her story is both lucid and vivid. She ends this with a feeble sketch, graphic enough to convey her childhood memory of violent, bloody deaths among the Zapatistas and the Carrancitos, but very unlike her characteristic drawing style.

Esquema de mi nol. 1910. - naci en el custo de la esquina enta Dontos of A Benthe Corporasion. a la juna de la maña ma. His abulo paterum trugaros nacidos en Aras Hungria .. ya .casast fueron a vitor a Alenia Sonde nacions varios se sus hijos cratro ello, me padre, en Balen Balen alconamia - Smillerino Kom No. Maria - Envigueto Paula Motors. El, emplo a Mexico en el Sisto 19 1000 Radier agua sienja de sura muchardre nicker down ; man dre de mir permanelas

Luisita y Margarita.

al morir muy journ su seno,
ra el cous con mi madr.

Matich Calderry y gongal.

hi ja ento soce de mo
Atrich futorios Caldern

Atrich futorios Caldern

Mila ento soce de mo

Atrich medicana michon

coma y de mi abuelith

Sakel gonede y reado

inin de un gueral topanol

cura al mon puso a elle

y to a su humanith

Las viscai ner de socenti su

anich de profesion

Arich a lascre un me

alich de profesion

Loran Acaria emson mo

cuale Acaria emson mo

cuale Acaria emson mo.

Outline of my life. 1910 - I was born in the room on the corner of Londres Street and Allende in Coyoacán. At one o'clock in the morning. My paternal grandparents Hungarian - born in Arat Hungary - after their marriage they went to live in Germany where some of their children were born among them my father, in Baden Baden Germany - Guillermo Kahlo, María - Enriqueta Paula and others. He, emigrated to Mexico in the 19th century. He settled here for the rest of his life. He married a Mexican girl, the mother of my sisters

Luisita and Margarita. When his wife died - very young he married my mother Matilde Calderón y Gonzalez, one of twelve children of my grandfather Antonio Calderón from Morelia - a Mexican of Indian race from Michoacán and my grandmother Isabel Gonzalez y Gonzalez daughter of a Spanish general Who died leaving her and her little sister Cristina in the convent of the Biscayne nuns, which she left to marry my grandfather - a photographer by profession, who still made daguerreotypes, one of which I have kept to this day.

Mi niper me manavillora, porque augue mi padre era un enference (tend vestiges care mes y medio. The en unneredo ojemple port mi de tornors de Arabajo (Folografo tambin y pris to of sobre toto de congranion pose toolor sines problemens que deshe loi Cuater anos fristiga de Recuerdo que yo toma es anos. in place social. To premio en mos ojos la lucha Campisina & Zapala contre los caracan onta. Hi sinación fre muy clare. mi makre por han calle de Allende - abrando In falconing les dates occess a la rapidistro 153

My childhood was wonderful even though my father was a sick man (he suffered from vertigo every month and a half). He was the best example for me of tenderness and workmanship (also a photographer and painter) but above all of understanding for all my problems which since I was four years old were of a social nature. I remember I was 4 when the tragic ten occurred. I saw with my own eyes the clash between Zapata's peasants and the forces of Carranza. My position was very clear. My mother opened the balconies on Allende Street getting the wounded and hungry and to allow the Zapatistas

prevendo que los hibristos 4 la ambrailles soldarin for Los valdores de sin cara prais la " solar. Eller des curat. of les data gooditas de mine renico afimento que en esc Interior at poten consequer or Conjuction. Engineer curation werenes Martis Yo (Frids) y Oristi, La che James Van discribing met vante. La enveron ela. of precisa que you grantos Let la reprodución servi Course . for the best para. Ofthe a son 13 anos de edat inguste en la Lugenty & Commission.

to jump over the balconies of my house into the "drawing room." She tended their wounds and fed them corn gorditas the only food available at that time in Coyoacán. We were four sisters Matita Adri me (Frida) and Cristi, the chubby midget (I'll describe them later). The clear and precise emotions of the "Mexican Revolution" that I keep were the reason why, at the age of 1,3, I joined the Communist youth.

154

the bullets just screeched past then in 1914. I can still hear their extraordinary sound. They used to praise Zapata in the Coyoacán marketplace with songs published by Posada. On Fridays they cost 1 cent and Cristi and I would sing them hiding in a big wardrobe that smelled of walnut. Meanwhile, my mother and father watched over us so that we wouldn't fall into the hands of the guerrillas. I remember a wounded Carrancista running toward his stronghold by the river in Coyoacán

homas ofisieneban has bales interver en 1914. O'scotobais In extraor dinario gonido. consanaita esmonta Son fuesto el ris de

1914 The window from where I spied him. and another Zapatista squatted to put on his "huaraches" wounded in one leg by a bullet.

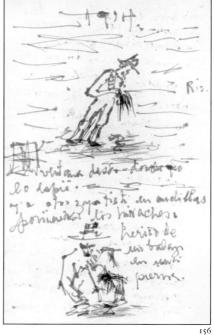

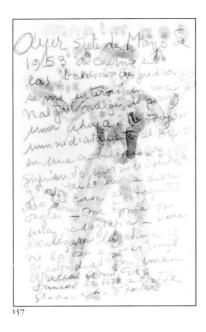

Yesterday, the seventh of May 1.953 as I fell on the flagstones I got a needle stuck in my ass (dog's arse). They brought me immediately to the hospital in an ambulance. suffering awful pains and screaming all the way from home to the British Hospital - they took an X ray - several and located the needle and they are going to take it out one of these days with a magnet. Thanks to my Diego the love of my life thanks to the Doctors

The impact of plate 158 is made more dramatic by the fact that it follows Kahlo's sketchy images of dying soldiers doubled over in pain from their wounds. Kahlo, replacing her ink pen with a crayon and brush, broadly paints a self-portrait that is simultaneously jubilant and devastating. Despite her disfigurement, Kahlo appears whole, a line marking where she has lost her leg. Her stance and large round breasts denote Kahlo as Superwoman. But doubt lingers, for example, in the ambiguous gesture of her arms: do they signify joy or resignation? The coloring of this drawing contributes to its equivocal message: the complementary colors orange and blue are difficult for the eye to take in at the same time, and the purples and mauve washes are reminiscent of bruising and dried blood.

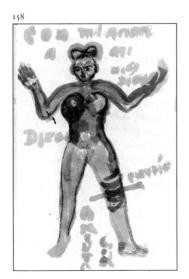

with my love to my little boy Diego Diego

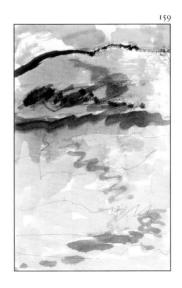

his is the last written passage in Kahlo's diary. Having succumbed to some now-unknown setback, Kahlo lists those who have helped her through another relapse. As she awaits discharge from the hospital, her words have a double meaning: "I hope the leaving is joyful - and I hope never to return."

Thanks to the doctors Farill - Glusker - Párres and Doctor Enrique Palomera Sanchez Palomera Thanks to the nurses to the stretcher bearers to the cleaning women and attendants at the British Hospital -Thanks to Dr. Vargas to Navarro to Dr. Polo and to my willpower. I hope the leaving is joyful - and I hope never to return -**FRIDA**

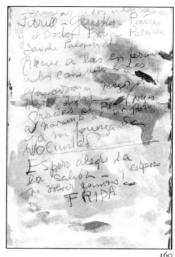

 $ilde{ au}$ ahlo's full-length, nude self-portrait is related to the figures on plates ▶ 124, 141, and 158. Seen as a series, they give the sense of sequential deterioration, until Kahlo appears nothing more than the site of pain. The arrows point at her vulnerable, naked self and the parts of her body where she has undergone surgery. Rather than surrender to abject self-pity, Kahlo copes with her worsening condition by presenting her infirmities "objectively." The teardrop is only a symbol on her masklike face, and this drawing, only an emblem of suffering.

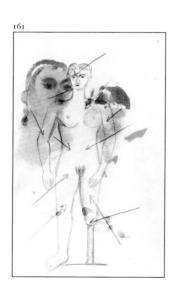

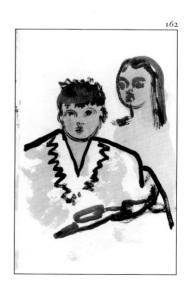

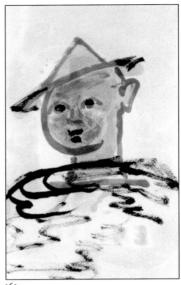

This stylized portrait recalls the split portrait on plate 110, and in both, color plays an important role. The green of the background on the earlier page now tints the woman's face, and the caption, "Envious one," invokes the expression "to be green with envy." The sickly yellow against which the figure is placed reminds us of Kahlo's definition of yellow from plate 15: madness and mystery.

What is this figure envious of? Perhaps the peace and equanimity of those who are able to fully embrace the balance implied by the yin-yang sign.

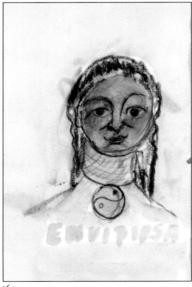

164

ENVIOUS ONE

This eerie painting is unlike any Kahlo had ever made. With broad black lines, Kahlo divides the page in half and summarily paints the outlines of a landscape with a building and a running horse. The deep blue sky is unmodulated, as are the green and pink areas of the structure. The image is virtually flat; only the shadow of the horse signifies depth. With a few brushstrokes Kahlo has rendered an incredibly oppressive scene; one can hear the steady hoofbeats of the horse, feel the sun bearing down, sense the isolation here at the ends of the earth, at the end of time.

Diary pages 166–69 are blank.

Below is the last image in Kahlo's diary and, one may suppose, the last painting she ever made. It is an image of apocalyptic chaos and reckoning, of transfiguration and transportation. The heavens open, the sky is bathed in a pink light, rain and sunshine occur simultaneously. Who is the green-winged creature who floats toward the edges of the page? The crown implies it is a sovereign of heaven, but its blackened, wrapped legs and trail of blood speak to Kahlo's wholly subjective image of herself. The death she mocked but also feared, the end she longed for but fought valiantly against, is upon her. Few artists have had the audacity to picture their own departure from this world, but then few faced death on so regular a basis. Never had the often-quoted statement by Kahlo seemed more appropriate: "I never painted dreams. I painted my own reality."

⁶ Time, April 27, 1953: 90.

CHRONOLOGY

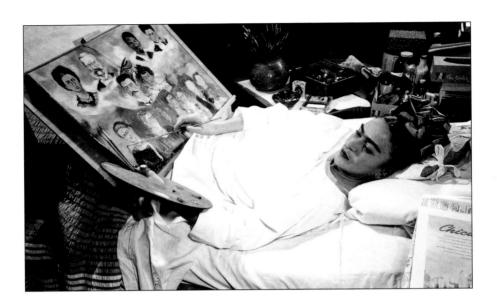

1907

Magdalena Carmen Frida Kahlo y Calderón is born on July 6 to Matilde Calderón y González, a Catholic *mestiza*, and Guillermo Kahlo, photographer, a Jew of German-Austro-Hungarian descent, in Coyoacán, then on the outskirts of Mexico City; in later life she celebrated on July 7

1910

The Mexican Revolution breaks out; Kahlo claims it as the year of her birth

1914

Kahlo contracts polio

1922

The Mexican mural movement begins; the government sponsors murals to be painted in churches, schools, libraries, public buildings

Kahlo commutes to Mexico City to begin classes at the National Preparatory School, a state-run postsecondary school; her program of study is designed with medical school in mind

Kahlo makes the acquaintance of Diego Rivera who is painting a mural at her school

1925

Kahlo apprentices with the commercial printer Fernando Fernández, a friend of her father's

Returning home from school on September 17, Kahlo is in a bus accident: she sustains a broken pelvic bone, spinal column, and other severe injuries. During her convalescence, she begins to paint

1926

Paints Self-Portrait Wearing a Velvet Dress, the first of many self-portraits

1927

Joins Young Communist League

1928

Rivera paints Kahlo in his fresco Distribution of Arms at the Ministry of Education

1929

Six weeks after her twenty-second birthday, Kahlo marries Rivera

Rivera is expelled from the Communist Party after accepting a commission from the Mexican government

In January, Kahlo and Rivera move to Cuernavaca, where Rivera has a commission to paint murals for the American ambassador, Dwight W. Morrow, at the Palace of Cortés

In November, the couple leaves Mexico for a three-year sojourn in the U.S. They first visit San Francisco, where Kahlo meets photographers Imogen Cunningham and Edward Weston; art patron Albert Bender; and Dr. Leo Eloesser, who would become her lifelong friend and medical adviser

1931

In June, Kahlo and Rivera return to Mexico for five months; in November, they sail to New York. Kahlo's *Frida Kahlo and Diego Rivera* is shown at the "Sixth Annual Exhibition of the San Francisco Society of Women Artists"—the first public showing of her work

On December 22, Rivera's retrospective opens at The Museum of Modern Art, New York. Kahlo meets Georgia O'Keeffe

1932

In April, Kahlo and Rivera travel to Detroit, where he has a commission from the Ford Motor Company to paint a mural at the Detroit Institute of Arts

Early in July, Kahlo miscarries; spends thirteen days in the Henry Ford Hospital. In September, Kahlo and Lucienne Bloch travel to Mexico, where Kahlo's mother is ill. Matilde Calderón y González dies on September 14; Kahlo and Bloch return to Detroit in October

1933

In March, Kahlo and Rivera arrive in New York City, where he has agreed to paint a mural at Rockefeller Center

On May 9, Rivera's Rockefeller Center commission is rescinded because of his use of Lenin's portrait. Four days later General Motors cancels his Chicago World's Fair commission. In June, Rivera accepts a mural commission for the New Worker's School

In December, they return to Mexico and move into the double house in San Angel designed for them by Juan O'Gorman

1934

Kahlo undergoes an appendectomy, an abortion, and an operation on her foot

During the summer, the couple separates after Kahlo discovers that Rivera is having an affair with her sister Cristina

1935

Kahlo moves into an apartment on Avenida Insurgentes in central Mexico City; in July, she travels to New York with Anita Brenner; by the end of the year, she returns to the house in San Angel

Kahlo meets sculptor Isamu Noguchi, in Mexico on a Guggenheim Fellowship. He creates a concrete mural in relief at the newly renovated Mercado Rodríguez. Kahlo and Noguchi have an affair

1936

The Spanish Civil War breaks out in July; Kahlo and Rivera work on behalf of the Republicans, raising money for Mexicans fighting against Franco's forces

Rivera joins the Mexican section of the Trotskyite International Communist League in September

For two years, Rivera is plagued with eye and kidney problems, which require hospitalization and extended bed rest

1937

In January, Leon Trotsky arrives in Mexico, where he has been granted political asylum, largely through Rivera's intervention. He and his wife, Natalia, live for a time in Kahlo's Blue House, in Coyoacán; Kahlo and Trotsky become close for a few months

Four of Kahlo's paintings are included in a group exhibition at the Galería de Arte at the National Autonomous University of Mexico

1938

In April, poet André Breton and his wife, the painter Jacqueline Lamba, visit Mexico; Rivera, Breton, and Trotsky publish "Toward an Independent Revolutionary Art" in the *Partisan Review*

Actor Edward G. Robinson purchases four paintings by Kahlo; this is her first major sale

Kahlo meets Hungarian-born Nickolas Muray, a well-known photographer visiting Mexico from New York

Kahlo travels to New York in October for her exhibition at the Julien Levy Gallery; begins an affair with Muray

November 1–15: Twenty-five of Kahlo's paintings are exhibited at the Julien Levy Gallery, New York; André Breton writes the catalogue preface

1939

Early in the year Rivera resigns from the IV International after differences with Trotsky; Trotsky and his wife move out of the Blue House

Kahlo sails to France in January; stays with the Bretons in Paris, where he has promised her a show. After she is hospitalized for a kidney inflammation, she moves into the apartment of Mary Reynolds, a close friend of Marcel Duchamp. She meets Kandinsky and Picasso and many in Breton's Surrealist circle, including Max Ernst, Paul Eluard, Joan Miró, Yves Tanguy, and Wolfgang Paalen

Marcel Duchamp helps arrange her exhibition, which is called "Mexique." It opens at the Galerie Renou & Colle on March 10 and includes the work of photographer Manuel Alvarez Bravo and Breton's own collection of Mexican popular art

On March 25 Kahlo sails to New York; breaks with Muray and returns to Mexico in April

During the summer, Kahlo and Rivera separate; she moves into the Blue House In the autumn, Kahlo suffers from a fungus infection on her hands and experiences severe pain in her spine; Dr. Juan Farill prescribes bed rest and traction. Emotional and physical pain drive her to drink copious quantities of brandy

In December, her divorce from Rivera is finalized

1940

Kahlo's reputation as an artist burgeons; in January, her two largest canvases, *The Two Fridas* and the now-lost *The Wounded Table*, are included in the "International Exhibition of Surrealism" organized by Breton and Paalen, at the Galería de Arte Mexicano; exhibits work in "Contemporary Mexican Painting and Graphic Art," at the Palace of Fine Art, San Francisco, and in "Twenty Centuries of Mexican Art," at The Museum of Modern Art, New York

Kahlo applies for a Guggenheim Foundation grant; among her supporters are Meyer Schapiro, Duchamp, Breton, Walter Pach, and Rivera; she does not receive the funding

An unsuccessful attempt is made on Trotsky's life in May by, among others, the muralist David Alfaro Siqueiros; Rivera, wanted for questioning, goes into hiding, then travels to San Francisco

On August 20, Trotsky is assassinated; Kahlo's past association with him and Rivera's public rift provoke the police to hold her for two days' questioning

Kahlo travels to San Francisco in September to see Dr. Leo Eloesser, who rejects the Mexican doctors' recommendation for surgery. His tests of Kahlo reveal a severe kidney infection and anemia. Meets Heinz Berggruen and begins a brief affair with him; they travel to New York where Kahlo tries to arrange for another (unrealized) exhibition at the Levy Gallery

Returns to San Francisco; reconciles with Rivera, and on December 8, his fifty-fourth birthday, they remarry. Kahlo departs for Mexico before the end of the year

1941

In February, no longer under suspicion, Rivera returns to Mexico, joined by his California assistant, Emmy Lou Packard; he lives in Coyoacán with Kahlo, using the San Angel house as a studio

Three months before Kahlo's thirty-fourth birthday, her father dies; Kahlo suffers depression which exacerbates her ill health

Kahlo is one of twenty-five artists and intellectuals chosen by the Ministry of Education to be founders of the Seminar of Mexican Culture

Kahlo is included in the exhibition "Modern Mexican Painters," at the Institute of Modern Art, Boston

1942

Construction begins on Anahuacalli, a museum to hold Rivera's collection of Pre-Columbian artifacts; Kahlo raises funds for it by selling her apartment and by writing to government officials for public support

Kahlo's work is included in two New York exhibitions: "20th-Century Portraits," at The Museum of Modern Art, and "First Papers of Surrealism," sponsored by the Coordinating Council of French Relief Societies

1943

In January, Kahlo is included in "Exhibition by 31 Women," at Peggy Guggenheim's Art of This Century Gallery, New York

Kahlo joins the faculty of the Education Ministry's School of Painting and Sculpture known as "La Esmeralda." She remains affiliated as a painting instructor for a decade, but poor health prevents her from traveling to Mexico City; she holds classes in her Coyoacán home. Eventually only four students come regularly: Fanny Rabel, Arturo García Bustos, Guillermo Monroy, and Arturo Estrada. They become known as "Los Fridos"

1944

Kahlo's physical decline becomes more acute over the next few years; she undergoes spinal taps, confinement in a series of corsets, and several radical operations on her back and leg over the next decade

Kahlo begins a diary, which she will keep until her death

She reduces her teaching schedule but remains committed to her students; over the next few years she finds commissions, apprenticeships, and exhibitions for Los Fridos

1945

After reading Freud's *Moses and Monotheism*, Kahlo paints her ideas about it. During this and the previous year, Lola Alvarez Bravo takes a series of photographs of Kahlo

1946

The Ministry of Education awards Kahlo the National Prize of Arts and Sciences Kahlo begins an affair with a Spanish refugee, which lasts until 1952

In June, Kahlo undergoes a bone-graft operation in New York. She returns to Mexico in October; large doses of morphine are prescribed for her pain

1947

In March, Rivera is hospitalized with bronchial pneumonia

On July 6, Kahlo turns forty years old (though she celebrates it as her thirty-seventh birthday)

1948

At Rivera's request, Kahlo reapplies to the Communist Party; her membership is approved. Rivera is not accepted back until 1954

Rivera has a public two-year affair with actress Maria Félix

1949

Kahlo's "Portrait of Diego" is published as the introduction to his fifty-year retrospective held at the Palace of Fine Arts in Mexico City

Gangrene is apparent on Kahlo's right foot

1950

During the course of the year, Kahlo has six operations on her spine, her hospitalization due in part to a severe infection in her bone grafts. She spends most of the year in the hospital; most nights Rivera sleeps in a room next to hers. When well enough, she paints

1951

Kahlo is confined to a wheelchair; full-time nurses are hired to care for her and give her injections of pain killers

1952

Kahlo begins a series of still-life paintings; she produces thirteen over the next two years

1953

Kahlo's first one-person exhibition opens in April, at Lola Alvarez Bravo's Galería de Arte Contemporáneo, Mexico City

In August, Kahlo's gangrenous right leg is amputated

1954

On July 2, Kahlo and Rivera attend a demonstration protesting the United States CIA's intervention in Guatemala

Frida Kahlo dies July 13; cause of death is officially reported as "pulmonary embolism," but suicide is suspected

1955

Rivera is diagnosed with cancer; he marries his art dealer Emma Hurtado. He puts Anahuacalli and Kahlo's Coyoacán home in trust as public art museums

1957

Diego Rivera dies of heart failure

SELECTED BIBLIOGRAPHY

Ades, Dawn. Art in Latin America: The Modern Era, 1920–1980. New Haven and London: Yale University Press, 1989.

The Art of Frida Kahlo. Exhibition catalogue. Essays by Teresa del Conde and Charles Merewether. Adelaide: Art Gallery of South Australia, 1990.

Ashton, Dore. "Surrealism and Latin America," in Latin American Artists of the Twentieth Century. New York: Museum of Modern Art and Harry N. Abrams, Inc., 1993: 106–15.

Borsa, Joan. "Frida Kahlo: Marginalization and the Critical Female Subject," *Third Text* 12 (Autumn 1990): 21–40.

Chadwick, Whitney. Women Artists and the Surrealist Movement. Boston: Little, Brown and Company, A New York Graphic Society Book, 1985.

Frida Kahlo and Tina Modotti. Laura Mulvey and Peter Wollen. Exhibition catalogue. London: Whitechapel Art Gallery, 1982.

Frida Kahlo: Exposición Homenaje. Exhibition catalogue. Mexico City: Palacio de Bellas Artes, 1977.

García, Rupert. Frida Kahlo: A Bibliography and Biographic Introduction. Berkeley: University of California, Chicano Studies Library Publications Unit, 1983.

Herrera, Hayden. Frida: A Biography of Frida Kahlo. New York: Harper & Row, 1983.

——. Frida Kahlo: The Paintings. New York: HarperCollins, 1991.

Kahlo, Frida. "Portrait of Diego," Calyx 5/2-3 (October 1980): 93-107.

Lowe, Sarah M. Frida Kahlo. New York: Universe, 1991.

Prignitz-Poda, Helga, Salomón Grimberg and Andrea Kettenmann, eds. Frida Kahlo: Das Gesamtwerk. Frankfurt am Main: Verlag Neue Kritik, FG, 1988.

Raoul, Valerie. "Women and Diaries: Gender and Genre," *Mosaic* 22/3 (Summer 1989): 57–65.

Smith, Terry. "From the Margins: Modernity and the Case of Frida Kahlo," *Block* 8 (1983): 11–23.

-----. "Further Thoughts on Frida Kahlo," Block 9 (1983): 34–37.

Sullivan, Edward. Women in Mexico/La Mujer en Mexico. Exhibition catalogue. New York: The National Academy of Design, 1990.

Tibol, Raquel. Frida Kahlo: Crónica, Testimonios y Aproximaciones. Mexico City: Editorial de Cultura Popular, 1977.

-----. Frida Kahlo: Una Vida Abierta. Mexico City: Editorial Oasis, 1983.

Zamora, Martha. Frida Kahlo: The Brush of Anguish. San Francisco: Chronicle Books, 1990.

For more comprehensive bibliographies, see García, Lowe, and Prignitz-Poda.

INDEX

Pages on which illustrations appear are italicized.

Α

Alvarez Bravo, Lola, 202, 202; 1 Anahuacalli (museum), 247, 291, 292 Aztec culture, 7, 8, 13, 20, 28, 207, 237, 259, 261, 268

B

Bosch, Hieronymus, 14, 15, 276 Brenner, Anita, 278, 289 Breton, André, 17, 26-27, 208, 290, 291 Breughel, Pieter, the Elder, 11, 14, 15, 276 Bride Who Becomes Frightened When She Sees Life Open, The, 208 Broken Column, The, 13, 253

Cachuchas, Las, 11 Carranza, Venustiano, forces of, 281–84 Communism and Communist Party, 17-20, 28, 251, 255, 256, 261, 280, 282, 289, 290, 292

D

Day of the Dead, 262 Diary, 10, 24, 25-26, 29; autobiography, 281-83; colors, 28, 211, 214-15, 286; language, 21, 28, 29, 203, 240, 254, 271; and Mexican culture, 28, 261, 262, 268; and politics, 28, 242-44, 251, 252, 255-57, 261, 280, 289; style, 203, 230, 231, 241; symbols, 216, 226, 240, 253, 259, 261, 265, 275, 285. See also Kahlo, Frida; Surrealism

Duchamp, Marcel, 290, 291

E

Egyptian deities, 220–21

Eisenstein, Sergei, 264 Eloesser, Dr. Leo, 278, 289, 291

F

Farill, Dr. Juan, 11, 251, 252, 277, 278, 279, 285 Fernández Ledesma, Gabriel, 264 Fernández Ledesma, Olinka, 264 Frida and the Miscarriage, 277 Frida Kahlo and Diego Rivera, 289 "Fridos, Los," 291 Fruit of the Earth, 211

G

Glusker, Dr. David, 278, 285 "golden section," 212, 214, 266 Gómez Arias, Alejandro, 18, 21, 251

Н

Herrera, Hayden, 16, 29n., 244n., 253n. Hurtado, Emma, 292

Judith (Judy; nurse), 257, 280, 297

K

Kahlo, Cristina (sister), 282, 289 Kahlo, Frida: accidents, 11-12, 29, 288; birth, 228, 281, 288; death, 23, 287, 292; and Diego Rivera, 9-10, 19-20, 26, 28, 205, 212-216, 234-35, 241, 288-92; divorce, 26, 290; doctors, 251, 278, 279, 285, 289, 290; dress, 7-8, 22-23, 28; education, 10, 11, 288; exhibitions, 26-27, 208, 289, 290, 291, 292; family, 13, 280-83,

288, 289, 291; influences on, 11–15, 28, 29; love affairs, 18, 20, 289, 290, 291, 292; miscarriages, 26, 289; personality, 10, 11, 21–22, 29; pets, 24, 268, 279, 280; photographs of, 1, 6, 32, 202, 288; and politics, 9, 11, 18–19, 21, 28, 288, 290, 292; sale of paintings, 26, 289, 290, 292; self-portraits, 14, 16, 25–26, 288; students, 291; style, 21, 22, 24, 26–27, 220, 222, 225. See also *Diary*; Surrealism

Kahlo, Guillermo (father), 13, 280, 281

Kahlo, Matilde Calderón y González de

Kahlo, Matilde Calderón y González de (mother), 280, 281, 289 Kandinsky, Wassily, 241, 290 Kolko, Bernice, 268

L Lamba, Jacqueline, 208–9, 290 Levy, Julien, Gallery, 270, 290, 291 Little Deer, The, 232, 265 Llorona, La, 216, 253 Love Embrace of the Universe, the Earth (Mexico), Diego, Me and Señor Xolotl, The, 241

Μ Mao Tse-tung (Mao Zedong), 255, 261, Marx, Karl, and Marxism, 17-18, 195, 255, 261, 264 Marxism Will Heal the Sick, 261 Mexican culture, 9, 10, 11, 13, 16-17, 19, 22, 274, 288, 291. See also Aztec culture; Pre-Columbian mythology Mexican Revolution, 9, 11, 18, 282-83, 288 Moses, 220 Muray, Nickolas, 270, 290 My Birth, 228 My Grandparents, My Parents and I, 2 I I

N Naturaleza Viva, 233 Neferdós, 221 Neferisis/Nefertiti, 220, 221 Neferúnico, 220, 221 Noguchi, Isamu, 289 O Olmedo, Dolores, 203 Orozco, José Clemente, 7, 17, 19

P
Packard, Emmy Lou, 291
Parrés, Dr. Ramón, 278, 279
"Portrait of Diego," 205, 292
Posada, José Guadalupe, 13–14, 15, 283
Pre-Columbian mythology, 237, 265
Proenza, Teresa ("Tere"), 257, 279, 280

Rivera, Diego: exhibitions, 289, 292; and Frida Kahlo, 19–20, 288–92; and Leon Trotsky, 290; love affairs, 20, 289, 292; marriages, 289, 291, 292; murals, 7, 8, 19; and Pre-Columbian art, 247, 291, 292; style, 19, 28; in U.S.A., 289. See also Kahlo, Frida, and Diego Rivera

S
Sadja (Sadha, Sadya, Sagda), 240, 254, 271
Self-Portrait Wearing a Velvet Dress, 289
Siqueiros, David Alfaro, 7, 17, 19, 291
Stalin, Joseph, 20–21, 229, 251, 255, 258, 259, 261, 264
Surrealism, 14–15, 17–18, 26–27, 207, 208, 224, 238

T
Threepenny Opera, The, 212
Tree of Hope, 13, 232, 238, 244
Trotsky, Leon, 18–19, 20, 244, 254, 255, 290, 291
Two Fridas, The, 230, 245, 290

m VVillaseñor, Isabel ("Chabela"), 264–66

W What the Water Gave Me, 238 Without Hope, 232 Wounded Table, The, 290

Z Zapata, Emiliano, forces of, 281–84

PHOTOGRAPH CREDITS

- Page 1: © 1944 Lola Alvarez Bravo, courtesy Throckmorton Fine Art, Inc., New York, and Carla Stellweg, New York
- Page 6: © 1952 Bernice Kolko, courtesy Throckmorton Fine Art, Inc., New York
- Page 32: © Gisèle Freund, courtesy Photo Reseachers, Inc., New York
- Page 288: © Juan Guzmán, courtesy Fotos Archivo CENIDIAP-INBA, Mexico City.
 - The photographs of the diary pages for this facsimile edition were made by Bob Schalkwijk.